Songlines and Dreamings

Songlines

Patrick Corbally Stourton
Edited by Nigel Corbally Stourton

and Dreamings

Contemporary Australian Aboriginal Painting

The First Quarter-century of Papunya Tula

Lund Humphries Publishers • London

First published in 1996 by
Lund Humphries Publishers Ltd
Park House
1 Russell Gardens
London NW11 9NN

Songlines and Dreamings
Contemporary Australian Aboriginal Painting
© 1996 Patrick Corbally Stourton

All reproductions of works
© 1996 Aboriginal Artists Agency Limited, Sydney

British Library Cataloguing in Publication Data
A catalogue record for this book is available from the British Library.

ISBN 0 85331 691 0

Designed by Chrissie Charlton & Company

Printed by Midas Printing Limited in Hong Kong

Distributed in the USA by
Antique Collectors' Club
Market Street Industrial Park
Wappingers Falls
NY 12590
USA

The publishers gratefully acknowledge
Corbally Stourton Contemporary Art
160 New Bond Street
London W1Y 9PA
for all their help with this book.

This book is dedicated to the Aboriginal
artists of the Central Western Desert, past
and present, who have done so much to
increase the world's appreciation and
enjoyment of contemporary Australian
painting.

Contents

Acknowledgements

I have had much help in the writing of this book, and first I must thank my immediate family. My father, Nigel, has done much of the research and has also edited the text. He has been at all times erudite and patient and his guidance has been of great help, not only with this book but also with the running of the gallery over the years. My brother, Edward, has also been greatly supportive and helpful, not least by managing the gallery while I have been occupied by the book, but also in his contributions through his great knowledge of the subject. My thanks also go to my brother Nicholas who, living in Australia, has helped in a hundred different ways especially when we have all been on the other side of the world. I would also like to thank my good friend and fishing companion from the Hellenes and his lovely Australian wife for their help, support, hospitality and encouragement, especially in difficult times. To you all I am deeply grateful.

Many other people have helped me in some way over the years, and particularly in the writing of this book. Some are friends, some are colleagues, some are clients, many of whom have allowed me to reproduce their paintings; others I have pestered for information, particularly those from the museum world. I salute you and thank you all for your encouragement and for sharing your knowledge with me. I have listed those who come to mind and ask to be forgiven by those whom I may have inadvertently left out.

Mr and Mrs J. Abensur
Charles Ackland
Vivian Anderson
Karen Andrews
Giles Auty
Geoffrey Bardon
Sonia Barrow
David and Anne Bennett
Mrs Aino Block
Ace Bourke
Mr and Mrs D. Burleigh
Mr and Mrs W. Burrell
Jo Caddy
Viscount Carlow
Mrs M. Carnegie OA
Michael Carr
Wally Caruana
Mr and Mrs Chan Boon Yong
Chrissie Charlton

Alvin Chereskin
Mr and Mrs R. Chisholm
Kim Clarke
Mr and Mrs F. Cohen
Roberta Cremoncini
Mr and Mrs G. Darling
Lauraine Diggins
Mark Dineen
Stella Downer
Neville Drury
Lady Dunsany
Ms P. Duxbury
Dr Robert Edwards
Libby Fam
R. Fane
Alison French
Mr and Mrs D. Gibbs
Dr J. Gilbert
Rodney Gooch
Tim Goodman
Mr and Mrs I. Gowrie-Smith
Dr Gorg
Michael Grace
Capt. J.S. Greenwood
Bill and Anne Gregory
Sandie Griffiths
Chris Hodges
Mrs I. Harvey
Doug Hall
J. Hammond
Sally Hardy
Mrs E. Harrington
Ms Shaughna Heneage
The Rt Hon. Sir W. Heseltine
Rupert Heseltine
Rebecca Hossack
Mr and Mrs O. Husum
Digby and Geraldine Hyles
Jane Hylton
Terry Ingram
Mr T. Jefferies
Michael and Margo Johnson
Tim Johnson
Vivien Johnson
Philip Jones
Mr and Mrs D. Kahn
Kate Khan
Richard Kelton
Duncan Kentish
T. Kilkenny
Dick Kimber
Lady Kleinworth
Lou Klepak
Tim Klingenden
Helen Lalas
Mr and Mrs C. Lanceley
Mr and Mrs A. Lewis
Mrs J. Lewis
Bill Lieberman
Catherine Lillico-Thompson
Michael Love
Edward Lucie-Smith
Dr Luer
R. Lumley
Bernard Lüthi

Dr and Mrs C. McDonald
Ms Elle Macpherson
Mary Macha
Mary Manolias
Mike Margolis
Dominic Maunsell
Mr and Mrs R. Meinike
Max and Janie Miller
Justin Miller
William Mora
Djon Mundine
Lucy Myers
Mr and Mrs G. Nash
Desmond Nolan
Mike O'Ferrall
John Olsen
Tim Olsen
Jeanne Oppenheim
Lord Palumbo
Anne Phelan
Ms D. Pictet
Laura Pinchbeck
Gabrielle Pizzi
Ron Radford
Mr and Mrs J. Rendall
S. Rich
The late G. Roberts
Tim Robertson
Jennifer Ross
Peter Ross
Gabriella Roy
Judith Ryan
John Salm
Adam Sangster
A. Sassoon
N. Sibley
Dennis Savil
S. Schmit
Dr S. Sherwood
Lara Speicher
Mrs Janis Stanton
Simon Staughton
Tim Storrier
David Tang
Luke Taylor
Peter Tillou
Maurice Tuckman
Peter Tunnard
Grenville Turner
N. Waddleton
Mr and Mrs A. Waldergrave-Knight
Anthony Wallis
L. Warrender
Lucy Wastnage
Annabelle Weedon
Greg Weight
Jorg Werner
Margie West
A. Whitley
Daphne Williams
Lynne Williams
Nat Williams
J. Wolfensohn
T. Wolkind
William Wright

Foreword

Oddly enough, the author of this book is at least indirectly responsible for my coming to Australia to work, since an introduction he made led to my doing a lecture tour here in 1994. This, in turn, led to my being offered a post as national art correspondent for *The Australian*.

Thus it is I find myself, as an English-born art critic, writing from a base in Sydney about all the art exhibited and produced in this most isolated of continents. Part of the art I cover is that produced by the Aboriginal peoples, who first settled Australia some 50,000 years ago. Their art and culture remain mysterious and complex and it is to the author of this book's great credit that he makes the subject so clear and comprehensible. Regrettably, art of all kinds lends itself today to a convoluted writing which often confuses and conceals rather than illuminates. Patrick approaches his complicated subject with the quiet belief that he can make it clear to the rest of us. The spirit which inspires him to do this is enthusiasm. He is determined that his readers will share his passionate interest which is both obvious and infectious. He states the known facts about Aboriginal culture clearly and simply and these, in turn, form an essential prelude to grasping the meanings and intentions of the art he describes.

At least some of the latter is familiar to me and I, too, have experienced something of the haunting nature of Aboriginal settlements. The timeless muddle of babies, children, adults and dogs reminds me of Romany encampments I visited in England as a child. In an Aboriginal community one is suddenly in direct contact with the immemorial and more aware than ever of the pace, evanescence and frequent futility of 'advanced' Western life. As Patrick makes clear, there is much that we can learn from the complex traditions and attitudes of an ancient people who could live comfortably in and cleverly conserve a minimal and often harsh environment. A man who taught me painting when I was a boy used to encourage microscopic examination of the appearance and workings even of tiny organisms. The more one does this the more a sense of wonder is instilled about the physical make-up of our planet. Those who live very close to nature develop skills, such as tracking, which the city-dweller looks on as near miraculous, yet their origin lies simply in acute development of all the senses. It is probably axiomatic that modern urban living is desensitising in its effects and the realisation of this drives increasing numbers of people to re-assess their relationship to life and to the world we live in.

By writing this clear and intelligent primer to the subject of Aboriginal art, Patrick Corbally Stourton opens another door to interesting insights about the human condition. By learning to understand the origins and meanings of these strange and beautiful art forms, we can also gain richly in understanding of ourselves.

Giles Auty, Sydney, February 1996

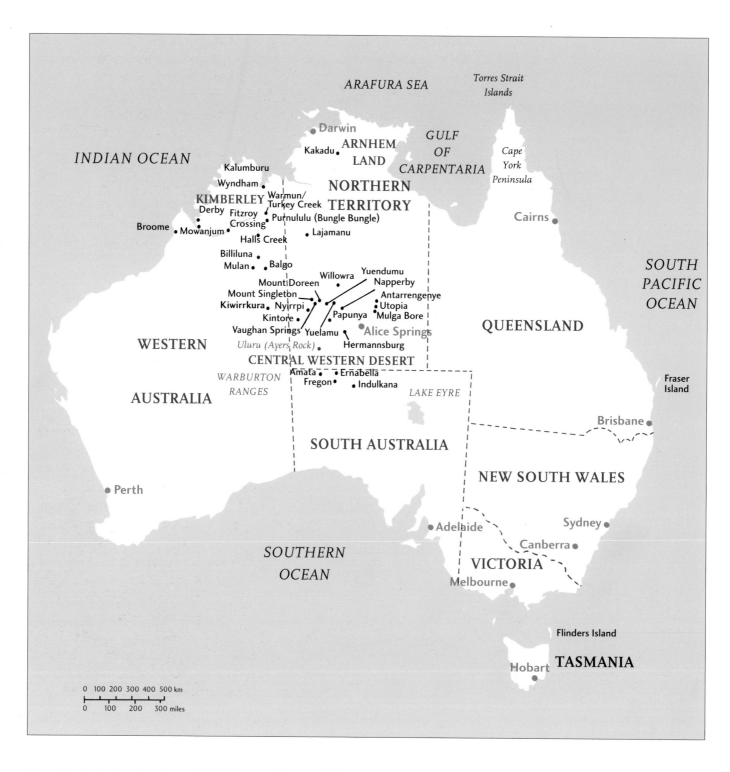

Map of Australia showing places of significance to the story of Aboriginal art

Introduction

The art of the Australian Aborigines is widely accepted in anthropological and scholastic circles as being the oldest art form in the world, preceding that of the Americas and Europe by many centuries. It is therefore a strange irony that the most widely read book about the Australian Aborigines and their ancient art tradition is a novel about an Englishman's travels in Australia and not a book about painting. Bruce Chatwin's novel *The Songlines* was published in 1987. Chatwin was a travel writer, a novelist and an antiquarian who had worked at Sotheby's in London for some years. He had long been fascinated by the subject of nomadic people, and *The Songlines* is to hundreds of thousands of people around the world their first introduction to the strange and fascinating world of the original inhabitants of Australia.

The title of my book, *Songlines and Dreamings*, has been chosen with care. These are words of crucial significance in Aboriginal mythology, as will be seen later in these pages. Songlines and Dreamings are not just romantic notions; they are the English words used to describe an integral part of this traditional mythology which dates back to prehistory and spans to the present day.

The culture of the Australian Aborigines constitutes one of the oldest and richest sources of philosophy, oral tradition, practical knowledge and images that has ever existed, and this culture has proved its ability to survive the most difficult of political and social conditions. Aboriginal paintings not only communicate tangible evidence of a very distinctive cultural identity, but they also convey a message of hope.

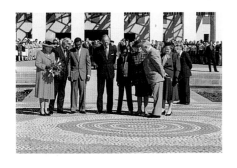

Michael Nelson Tjakamarra with Her Majesty the Queen and former Australian Prime Minister Bob Hawke, explaining the mosaic he designed for the forecourt of the new National Parliament House, Canberra, 1988
Courtesy Department of Foreign Affairs and Trade, Parliament of Australia
Photograph by Bruce Moore

I first saw an Aboriginal painting while in the outback near Alice Springs. I had just spent two years travelling extensively in Africa and had become interested in nomadic people. My old Holden car had broken down in the desert and I was befriended by a charming Aborigine who was passing by. He took me to the nearest settlement, Papunya, where I stayed for two days. It turned out that my Aboriginal friend was none other than Michael Nelson Tjakamarra, one of the best-known Aboriginal painters, whose work we will see much of later in this book.

I loved the paintings that I saw in those two days. What struck me most was the power of the imagery, coupled with the technical brilliance and richness which emanated from a people whose material circumstances contrasted so harshly with the world for which these paintings were almost certainly destined. There and then I decided to learn more about the Aborigines and their quite extraordinary ability to paint. It was not long before I came to realise that this was not 'ethnic art' or 'tribal art'. Here was a very sophisticated form of

contemporary painting, visually exciting and clearly deserving far greater exposure to the educated art world.

Shortly afterwards I read *The Songlines,* which had just been published. Living at the time in Alice Springs, I soon recognised, and indeed got to know, most of the scarcely disguised characters of Bruce Chatwin's book. Its descriptions of life in Alice and its humour make it a classic, and I am never surprised to see it still prominent in bookshops, libraries and airports around the world. I was sorry I did not meet Bruce Chatwin, who died the following year.

This book concentrates on the contemporary work of the Papunya Tula artists of the Central Western Desert of Australia. However, the ancient art tradition of the Aborigines, dating back more than 50,000 years, is pan-Australian, and rock painting, bark painting, sand painting, body painting and wood carving were the only art forms practised by the Aborigines during these many centuries.

It was only in 1971 that the Aborigines of the Papunya Tula settlement started to paint using modern materials. Here, for the first time, they were painting specifically for a Western audience and on a medium which was portable. This was the start of a painting movement which, in a very short time, has made an enormous impact on the contemporary art scene the world over. The twenty-fifth anniversary of this movement is imminent, so it seemed an appropriate time to publish the first book specifically written to give a comprehensive survey of Papunya Tula painting and to celebrate this rich and productive period in the history of contemporary Australian art. My book is written as a salute to the desert artists. But it is also written in the hope that it will encourage more people to open their eyes to the wonders of contemporary Australian Aboriginal art, or even to visit Australia and to see the museums, collections and galleries for themselves.

The best of the Aboriginal desert painters, as they are sometimes known, are now considered just as important to Australian contemporary painting as other leading Australian artists such as Arthur Boyd, Sidney Nolan, Fred Williams, John Olsen and Tim Storrier. As the late Sir Sidney Nolan himself wrote many years ago, 'The Aboriginal is probably the best artist in the world – they have a wonderful dreaming philosophy which all Australian artists should have'. Certainly many of Australia's painters have been greatly influenced by Aboriginal culture and art.

Sir William Heseltine, an eminent Australian who had previously been Private Secretary to Sir Robert Menzies, then Private Secretary to Her Majesty the Queen, opened my first London exhibition of Aboriginal paintings in 1990. This was the first comprehensive selling exhibition of contemporary Aboriginal art to be held in Europe. Sir William Heseltine spoke of his hopes that the art of the Aborigines, seen as a positive aspect of the often unhappy story of a dispossessed

people, would flourish and become accepted in the Western world. Little did I realise how fast this would happen, and that the number of collectors, both public and private, would grow apace during these last few years.

The appeal of Aboriginal art may lie in the fact that some of the work has an ostensible similarity to such Western movements as pointillism and minimalism. This might lead a casual observer to believe that the artists have been influenced by such movements. This, however, is not the case. The artists of Papunya Tula have not experienced a Western-style art-school training. They are natural artists and are not inspired by Western movements – in fact, most have never seen Western art and know nothing about its developments. Their skills are grounded in ancient tradition, based on centuries of accumulated knowledge which has been handed down over the generations – anything they have learnt will have been acquired from their elders. They produce sophisticated art forms, neither ethnic nor artefact; theirs is meaningful contemporary painting of an immensely rich intellectual order.

I have spent much time in Australia. I have travelled all over the country and have lived with the artists in the desert communities. I have slept in the outback under the open sky and listened to what could be described as the silence of eternity. I have seen sunrises and sunsets that defy description and have woken with ice on my swag. I have seen desert after the rains and witnessed its extraordinary abundance of colour. Despite the extremes of heat and cold, I believe few people who visit such places could fail to fall in love with them. I have my own favourite places, painters and paintings, many of which are illustrated in the following pages.

The more time I spend in Australia, however, the more I continue to be surprised by the number of Australians whose education has not included learning about the original inhabitants of their continent, or about their highly sophisticated art and culture. I have noticed some change in this situation during the last few years, but it still astonishes me that so many people in Australia are unaware that their country was formerly the home of one of the most sustainable and successful styles of human existence the world has known. As we move into the third millennium, with a global population which has trebled in one generation and with all the associated horrors of conflict, starvation, deforestation, pollution and rape of the natural world, there must be something we can learn from the Aboriginal way of life, which is infinitely older, more durable, and better managed than our own.

Sadly, many Australians seem to have closed minds when it comes to the Aborigines and their precolonial past or their wonderful contemporary paintings. We must hope that this situation will change even faster than in recent years, and that when we come to celebrate fifty years of the Papunya Tula art movement, a new generation of Australians will be far more aware of this once magnificent people, unique in the history of our planet.

1 The Aboriginal People:
The Original Inhabitants of Australia

Any study of contemporary Aboriginal painting would be incomplete without some basic knowledge about the Aboriginal people and their little known past, as well as their more recent history. Some say that these people came from southern Asia about 50,000 years ago, when the mainland of Australia was still joined to what is now Papua New Guinea. Others believe that the Aborigines have been in Australia far longer, and there is also a view that *Homo sapiens* originated here. One day we may know the answer, but suffice to say that Aboriginal culture is now generally accepted as one of the most ancient and enduring of all time.

When the Europeans arrived in Australia at the end of the eighteenth century, the Aboriginal population was thought to number around half a million people. How the population varied before this is unknown, but it is thought never to have exceeded a million people. Today there are about 250,000 Aborigines, or people of Aboriginal descent, in Australia, the great majority of whom have assimilated a modern Australian way of life. They live in the cities and have a Western education, and many of these people are no longer of pure Aboriginal blood. Then there are those who can be described as still being of Aboriginal culture. These people, of pure Aboriginal blood, some 10,000 of whom still live in the desert areas of central Australia, have not fully accepted the contemporary Australian way of life, and continue to speak the old languages, practise the ancient traditions and, as far as possible, live the old life. It was in the 1950s that the campaign began to bring all Aborigines into Western style settlements, but in 1984 a group of seven people came into a settlement having never seen or been influenced by Western man. One of these people returned to the desert and has never been seen again. Some believe that he has joined up with other Aborigines who have avoided contact with the white man to this day.

The Aborigines, sometimes described as the best-known but least-understood people of the world, are of ever increasing interest to anthropologists and archaeologists. This interest is generated in no small part by the enthusiastic reception and publicity given to Aboriginal paintings by the Western world during the last twenty-five years.

Aboriginal culture, however, is one which must be studied in the absence of a written or even a common language, and with no form of records outside rock paintings and oral tradition. Where no written language exists, art, music and dance take on even more importance as forms of communication. The archaeologist will not find great ruins here, as these hunter-gatherers did not construct such

Aboriginal cave paintings at
El Questro Station, Kimberley Plateau,
Western Australia (detail)
Photograph by Grenville Turner

monuments. What will be found are very early examples of human cremation; almost certainly the oldest examples in the world of rock and cave painting, some dating back around 40,000 years; and tools and weapons such as boomerangs, spears and axes from even earlier times. They will also find the remnants of an ancient people still practising many facets of an old way of life.

A total population of half a million or even a million people in a country much the same size as the United States of America meant that the Aborigines were widely spread. They lived in many differing environments, ranging from the tropical north around the Gulf of Carpentaria and the harsh dry deserts of central Australia, to the more temperate regions of the south and Tasmania. A sophisticated tribal structure evolved over the thousands of years of coming to terms with these diverse and often extreme surroundings. During these centuries there was almost no progress in terms of technology: here was Stone Age man, living as he always had right into the twentieth century. Despite this apparent lack of progress and change, subjects which have always obsessed Western man, this was a dynamic society driven by a rich and subtle culture.

The Aborigines did not live in large tribal groups. Society was based on smaller units which shared cultural, economic and religious traditions and ideas with other groups within their tribal bounds. Although these groups met for specific occasions such as rituals and ceremonies, tribes did not join together for reasons of economics or to make war. We tend to think of the Aborigines as a homogeneous united race, but this was not the case. In precolonial times it is thought there were about 700 Aboriginal tribes and more than 200 languages, each with many dialects, and each with its own formal grammatical structure. (Today only about fifty of these languages survive – the rest are extinct and will never be heard again.) Similarly, Aboriginal culture and religious beliefs were not uniform throughout Australia, and there was considerable variation in social and economic practices from tribe to tribe.

The Aborigines lived by hunting and gathering rather than by cultivating crops. Although theirs was a nomadic life, it was disciplined by ancient traditions and land laws under which certain groups and tribes had rights over defined areas. Their deeply spiritual relationship with the land, coupled with their fervent belief in ancestral laws, created a psychology that had no desire to acquire and possess material things. They were and still are very much a sharing society. For example, when artists today get paid for a painting, they will share the proceeds among the group in which they live.

Respect for and knowledge of the natural world are key to this ancient culture. As we will see in the following chapters, relationship with the land remains, to this day, absolutely basic to Aboriginal life. Their very purpose in life is to preserve the land in its original purity, and their vision is one in which the earth and their spirituality are

inseparable. Their religious beliefs, economic activity, art and aspirations invariably reflect this.

In 1788 the British declared Australia to be 'terra nullius' – land belonging to no one. The invaders looked upon the Aborigines as savages and treated them accordingly. Their customs, beliefs, art and, above all, relationship with the land were ignored. Fighting and killing took place throughout the next century as the invaders penetrated the continent. The entire Aboriginal population of Tasmania was destroyed and tribes were moved from lands where they had once roamed freely. Mortality was high, not only from slaughter, but also from European diseases against which the Aborigines had no resistance. Thus social and cultural dispossession gained pace.

Despite more than a century of persecution and disruption, the Aborigines maintained their identity and dignity. By the 1930s they had begun to organise themselves politically. Petitions and demonstrations took place, demanding equality and social and political rights. By 1967 the right to vote had been won, and the early 1970s saw a further change in government policies when the right to self-determination was granted to the Aboriginal people. These advances slowly led to the granting of limited land rights, and now real progress is being made in this vitally important aspect of Aboriginal life. These politically led social advances have meant that an increasing number of Aboriginal people have returned to a more traditional way of life. One result is that painting has flourished and continues to do so.

2 Aboriginal Art before 1971

Although this book is primarily about the Papunya Tula art movment of the last quarter-century, it is important to know something of the traditional art forms that were practised by the Aborigines for thousands of years, long before the days of canvas and acrylic paint. These included rock painting and carving, bark painting, sand or ground painting, and body painting. Contemporary Aboriginal paintings, using modern, portable materials, are an extension of this ancient artistic tradition.

One interesting comparison which can be drawn between European and Aboriginal culture is the relationship between art and religion. Like so much of the great early art in Europe, Aboriginal art is a manifestation of religious beliefs. In Italy, for example, Renaissance painting and sculpture in churches and basilicas were created at a time before literacy was widespread. Art created a form of visual literacy, its purpose to help and encourage worshippers to understand matters of an intellectual and spiritual nature, and to remind them of their beliefs without the aid of the written word. Literacy never developed among the Aborigines, therefore the importance of their art as a form of religious communication never diminished as it did in Europe. It grew.

The mystical nature of Aboriginal beliefs about the ancestral past is examined in the next chapter. However, the extraordinary antiquity of Aboriginal culture and art leads one to believe that religion, that quest of mankind about whence he came and whither he is going, played a major part in Aboriginal life many thousands of years before such activity existed in the Western world.

The map on page 8 shows places of significance to the story of Aboriginal art. Rock paintings and rock carvings are found all over the world, but in Australia they are peculiarly prolific. Because of their physical qualities and the fact that they are usually in caves or other sheltered places, they can be of great antiquity. From the earliest times, man has made visual statements about his religious, cultural and social environment, and many of those recorded on rocks have survived. The best examples of Australian rock art are in the north. In western Arnhem Land and Kakadu National Park there is possibly the largest concentration of rock art to be found anywhere in the world. In Kakadu alone there are at least 5000 sites. While some of these paintings may be quite recent, others are over 40,000 years old. This makes them considerably older than the cave paintings of Altamira in northern Spain, or Lascaux in the Dordogne in France, which have been dated at 15,000-10,000 BC.

A corroboree participant at Yuelamu,
Mount Allan, Northern Territory, 1988
Photograph by Grenville Turner

Bark painting is a tradition found mainly in northern Australia. People living some 2000 kilometres north of Papunya are very different people to those of the Central Deserts. Their languages were as different to those of central Australia as French is to Russian. Their painting is different too. Because bark is a perishable material it is difficult to establish how old the tradition of bark painting may be. In very recent years, however, paintings have been executed on bark which has been treated to make it last, and thus a market for the Western world has been created.

Ground paintings, or sand paintings, are produced mainly in the deserts. They are rarely seen because they are destroyed immediately after the ceremonies for which they are created. In the preparation of ground paintings, a space is cleared, traditionally by burning the scrub and grass, and this is then smoothed out using water and the edges of boomerangs and sacred boards to obtain a flat surface. Then the designs are laid out using ochres, charcoal, wild desert cotton, twigs and feathers, with the participants singing throughout. These same designs recur in all Aboriginal art forms – from the ancient rock paintings to the paintings being produced today in acrylics on canvas.

Body painting is also associated with ceremonial activities, and once again the same designs and motifs appear. Early photographs and paintings by Europeans give us an idea of how magnificent a large corroboree of painted Aborigines could look. Today, body painting still takes place and remains an integral part of initiation ceremonies. As in all forms of Aboriginal art, some of the images are secret and may only be seen only by the elders of the group. Body painting is looked upon as a great skill, and women practise it widely in most communities.

Other forms of art were (and still are) also made, such as ornaments, wooden sculptures, painted shields and boomerangs. What they all have in common is a theme based on Dreamings and the ancestral past, a cycle of myths which has been passed down through the ages in painting and song. We will observe this in the following chapter.

Aboriginal rock carvings at Ewaninga
in the Northern Territory
Photograph by Grenville Turner

3 The Mythology of Dreamings

Many definitions of Dreamings have been written. None is easy to understand, largely because the concept itself is difficult to grasp. The concept of Dreamings is central to the religious beliefs of all Aborigines. Dreamings, or Dreamtime, as it is sometimes called, is the English word used to describe Aboriginal beliefs about the mysterious and intangible process of the creation of the world, and it relates at the same time to the present and the future. Dreamings are also ancestral beings who were born, have lived and died, yet nevertheless still remain present.

Aborigines believe that in the beginning the supernatural creator ancestors rose from under the ground and roamed the world creating everything from the animals and plants to the features of the earth, as well as making the laws which bind human society. This accomplished, these ancestral beings returned back into the earth from whence they came, and where they rest now in eternal sleep. Thus every feature of the land has some particular meaning or story attached to it, relating the activities of the ancestral being who once roamed there.

Dreamings provide a religious ideology which dictates how human beings should interact harmoniously with their surrounding environment. The Dreamings are, in reality, Aboriginal law, a basic universal law, and one which must be followed eternally. It is a law that is shared by all Aboriginal tribes despite different ritual, social or linguistic characteristics and practices.

At the places where the ancestral beings emerged and then sank back into their subterranean world, and at other places where they left their imprints, secret initiation ceremonies and rituals take place. Even today, these sites are kept secret and are rarely disclosed to outsiders. It is at these sacred sites that the Aborigines find a life-force and spiritual power which is central to their ceremonial traditions and fertility rituals. Authority over these ritual and ceremonial traditions lies in the hands of the senior men who are responsible for protecting and maintaining the integrity and secrecy of ancient laws. The senior men also see that these traditions are explained and passed down to younger generations over an appropriate period of time. Punishment for transgressing the rules of secrecy concerning these ancient rituals is extreme. Until very recently death was the usual consequence.

Every initiated male Aborigine is granted special responsibility for a Dreaming, and there is a spiritual connection between that man and his family and the land for which the Dreaming is hereditary. These

men are the custodians of Dreamings and their associated stories and songs, which have been passed down through thousands of generations. Every Aboriginal painting relates to a particular artist's Dreaming, and as a result has a sense of feeling for a specific place. In a sense, the paintings are religious maps of what each artist calls 'my country'. The artist does not have total artistic freedom in the Western sense, for he or she must only paint Dreamings of which their particular family has custody. The system of ownership and granting of rights to paint another person's Dreaming is complex and often controversial, and varies throughout Australia.

According to Aboriginal mythology, each person's particular Dreaming is determined by the spot on the ground where his or her mother experiences the first signs of pregnancy. At this place, the unborn foetus is entered by the spirit of the ancient being, a Rainbow Serpent, Honey Ant or Waterhole for example. When the owner of the Dreaming dies, he will be reunited with that spirit in the earth.

Despite the lack of communication between Aboriginal tribes in Australia, due to distance and the lack of any common or written language, the concept of Dreaming is, nevertheless, shared by all Aborigines. The most important of the creation myths is the Tingari myth, a subject chosen by many artists of the Central Western Desert. The Tingari were a particular group of ancestral beings, both male and female, who travelled all over Australia at creation time. Their activities encompassed extremes of good and evil, sexual excess, greed, theft of sacred objects and many other human weaknesses. There is great secrecy about some of the rituals and ceremonies connected with the Tingari Cycle, as their adventures are known.

The Aboriginal world abounds in such stories, unwritten tales which have been sung down the generations for thousands of years. As every story or Dreaming relates to a particular feature of the landscape, series of stories create a track across the land connecting these places and the mystical happenings associated with them. These ancient tracks, which are called Songlines, go in all directions crossing the entire continent and initiated men and women can travel along these Songlines and interact with people from other tribes. Aborigines were not a trading people in a materialistic sense. Exchanges which took place existed at a spiritual and cultural level, and their motivation was a quest for more knowledge and understanding of the Dreamings, and the laws governing all humanity.

4 The Interpretation of Desert Paintings

At first sight, desert paintings give the impression of being abstract. In some cases, particularly where the images are powerful, it is not readily apparent that this combination of dots, circles, lines and symbols is in fact representational. Each desert painting is a deliberate transformation of a ritual or ceremonial design relating to the ancestral past, a tangible representation of mythological legends or of the landscape of the Central Western Desert and the particular artist's relationship with the features of the land, which he or she will describe as 'my Dreaming' or 'my Country'. Thus Dreamings provide the basic themes for paintings and every painting has a Dreaming and a story which relates to it.

Why then are contemporary desert paintings, which are fundamentally a religious form of landscape, so attractive to the world of contemporary Western art? Part of the answer must lie in the fact that in that world great emphasis is placed on meaning, and these paintings are resonant with meaning since they are renderings of artists' personal Dreamings. Another reason must surely be that desert paintings are so distinctive and different; their sheer vitality and technical brilliance make them stand out in a way which places them in a category of their own. Each one is unique.

Motifs, symbols or graphic elements as they are variously described, feature in most, but not all, of the work of the desert artists. Western viewers often make the initial mistake of seeing these motifs as standard. There are not only many different meanings to each motif, but their use in combinations can also result in different and quite varied interpretations. For example, a series of concentric circles can mean a waterhole, a camp fire, a mountain or a tree. One way to describe this is to say that the text of the picture is written in code. Combinations of designs provide the artist with an endless fund of meaning plus the opportunity to disguise those meanings if, for sacred and secret reasons, they are not to be revealed either to the public or to uninitiated fellow Aborigines.

When seen from an aeroplane flying at a great height, Australian deserts often appear to be a series of patterns and colours which closely resemble the desert paintings. This is merely coincidental, although these paintings are always carried out from above, the artist working on a canvas which lies flat on the ground, never upright or on an easel. Desert paintings do not feature horizons or perspective in

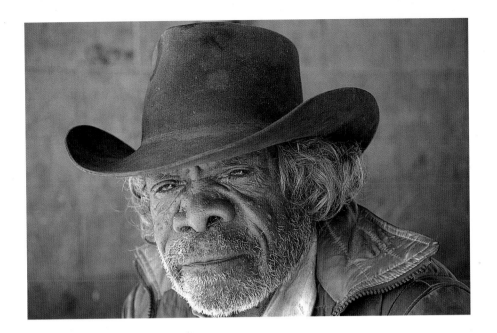

The artist Mick Namarari Tjapaltjarri, 1990
Photograph by Grenville Turner

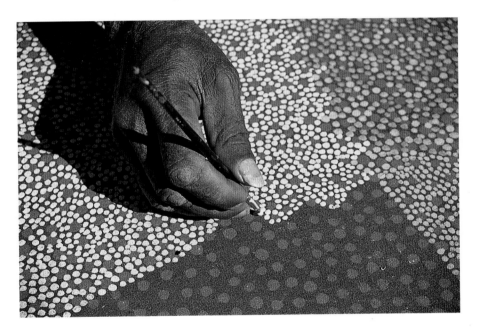

The artist Mick Namarari Tjapaltjarri at work, 1990
Photograph by Grenville Turner

the Western sense of the word. Theirs has been described as a hunter's eye view of the world, since the motifs used often resemble, and indeed represent, the marks that people and animals leave in the ground.

One can only ever hope to gain a superficial knowledge of the iconography of the desert paintings, as so much of the meaning can only be known to initiated Aborigines. However, perhaps it is enough to appreciate the basic mythology underlying each work which, coupled with the symmetrical designs, patterns and arrangement of motifs, creates paintings which so strongly convey the ancient and enduring mythology of the Aborigines.

5 Papunya Tula: The Start of the Movement

The first Aboriginal artist to be widely recognised in Australia and in the rest of the Western world was Albert Namatjira, who died many years before the painting movement at Papunya started. He was encouraged to paint by a white Australian artist, Rex Batterbee, at the Lutheran mission at Hermannsburg, west of Alice Springs, in the 1930s. Namatjira painted watercolour landscapes in the European style and his mastery of this technique quickly became evident. His first exhibition in Melbourne in 1938 was an immediate success. Although Namatjira's style of painting is quite different in every way to that of the Papunya Tula artists, there is an interesting connection. Namatjira chose his landscapes not for their natural beauty as places, but for their traditional religious significance. The places he depicted were sacred sites and in his work he was expressing his Dreaming, although in a non-Aboriginal, European style of painting. When the Papunya Tula painters started to express their Dreamings through painting in 1971, this time it was in the Aboriginal style.

Few schools of art of world acclaim can be said to have started at a certain place on a certain date. However, this was true of the Papunya Tula school. The story of the birth of this school of painting has been told in many publications. The man responsible as the catalyst for this movement was Geoffrey Bardon, and the full story can best be learnt from his book *Papunya Tula: Art of the Western Desert*, in which he tells of the early days. Bardon had been an art teacher at a school in Sydney, and in 1971 he accepted a post as art teacher in an Aboriginal settlement some 250 kilometres west of Alice Springs called Papunya.

Papunya was the site of the Honey Ant Dreaming and was chosen as a settlement because it had plentiful supplies of water. In 1971, some 1400 demoralised Aborigines lived here. They had been herded into the settlement as part of the government's attempt to assimilate Aborigines into an Australian lifestyle. The main tribes living there were the Warlpiri, Pintupi, Aranda, Anmatyerre and the Luritja. They were in a state of distress as their nomadic way of life, which had changed little over thousands of years, had been ended abruptly at the whim of the white man. Above all, these people had been separated from their beloved land and the spiritual power and inspiration which they drew from it. Everything was foreign to them: European food from communal kitchens, buildings, tin huts to live in and, worst of all for this nomadic people, a feeling of imprisonment.

Bardon noticed that some of the Aborigines, while telling stories about their creation ancestors and the Dreaming, made drawings in the sand, and that these patterns of circles and tracks were similar to

paint these symbols and designs on boards and walls. They were too young for initiation, however, and their knowledge was therefore very limited. Some of the men saw the children at work and started to paint themselves. The first painting, done on the outside wall of the school house, was a Honey Ant Dreaming, and so it all began. More materials were acquired and Bardon encouraged other people to paint. He had great empathy with the early artists and they liked and trusted him. Enthusiasm for painting grew as the men felt some welcome form of pride and self esteem returning to their lives. Certainly the morale of the whole settlement improved as more men began to paint, sometimes with help from the women. The Aborigines realised that painting gave them an opportunity to translate their ancient myths, stories and religious beliefs onto the new and portable medium of boards and canvas. Bardon also realised that without this new movement, much that had been passed down through the generations over thousands of years might disappear forever, along with the sand paintings and body paintings of the tribal rituals performed no more.

The artists were encouraged in many ways, particularly to paint without any Western influence. Some extraordinary work was produced, and by the time Bardon left in mid-1972 about 1000 pieces had been completed. Of these, 622 were catalogued at the Stuart Art Centre in Alice Springs. Sadly, most of the remainder was burnt and the original Honey Ant mural was deliberately destroyed by the local authorities at Papunya after Bardon had left. These early desert paintings are arguably some of the most important paintings in the history of Australian art, and they are greatly sought after today. Most of them are owned by museums in Australia.

In 1972 the artists formed their own company, the Papunya Tula Artists Company, which still exists today. Over the next decade many of the original residents of Papunya left the settlement to live in communities closer to their traditional tribal lands, taking with them a newly acquired painting tradition.

6 Papunya Tula: The First Quarter-century

Even a brief glance through the paintings reproduced in this book will almost certainly leave the reader with some feeling of the extraordinary diversity of the work of the desert artists. During the twenty-five years in question, the visual emphasis has been constantly changing, with some artists maintaining their distinctive styles throughout, and others adapting, sometimes dramatically, to fall in line with external demand, in some cases by relating their Dreamings to features of the modern world. However, what remains constant with every artist and in every painting is the powerful, and indeed overriding, influence of ancient Aboriginal mythology: every painting relates to a Dreaming and a story whose origins lie buried under the dust of time.

The contemporary Aboriginal artists of central Australia are variously decribed as Western Desert artists, dot and circle painters or desert painters. During the last twenty-five years, many of the Papunya Tula artists have moved from Papunya back to their traditional lands, forming new painting communities. Some of these have established themselves successfully and have developed distinctive styles of their own. There are such painting communities at Yuendumu, Balgo Hills, Kintore, Kiwirrkura, Lajamanu, Fitzroy Crossing, Ernabella, Tennant Creek and Utopia.

In the first decade of the Papunya Tula movement the number of artists did not increase dramatically beyond the original core group of thirty. When the art market began to realise the significance of these paintings, Papunya Tula suddenly found a larger audience and thus a growing market. This was marked by an explosion of growth, both in the volume of work produced as well as the number of people painting. Some of these artists can best be described as occasional painters, but many others have become important and prolific artists. Sadly, records have not been kept of all the Western Desert painters.

It would be close to impossible to do justice to the subject of contemporary Australian Aboriginal art or to all of the Western Desert painters in a single book. I therefore decided that this work would cover only artists from the Papunya Tula school of painting – those who have painted under the auspices of the Papunya Tula Artists Company. I have included some artists who painted only a very few paintings for Papunya Tula and then moved on to other communities and continued to paint there. Even so, it has not been possible to include work by all the Papunya Tula artists as they number well over 200. I have chosen the works of some eighty artists, and I believe the selections I have made give a comprehensive and balanced view of this quarter-century of extraordinary artistic output. As many of the

Papunya Tula artists fall into the category of occasional painters, their output is low. However, it would be quite wrong to assume that the work of these painters or, indeed, that of artists whose work it has not been possible to include in this book, is by definition inferior to that of more prolific artists. Some occasional painters have produced some quite remarkable and greatly sought after works.

Early Papunya Tula paintings were all done on boards, as canvases were not widely available until the mid-1970s. These boards were small and the paintings were very different to those produced towards the end of the decade. A raw simplicity and religious intensity spring from some of these early works. They adhere to the graphic designs and symbols used in ritual and ceremonial ground and body paintings. Spears, shields and sacred objects such as *coolamons* and *tjurungas* painted with secret designs were featured, and lines and concentric circles represented a specific creator ancestor or sacred site. In these early pictures such symbols predominate over dots. The paintings were generally severe and the dots had little intrinsic importance other than to enliven and highlight lines and edges. This is well illustrated in the early works of Kaapa Tjampitjinpa (see Plates 83 and 85).

By the mid-1970s, however, a number of easily perceptible changes had taken place. The Papunya Tula Artists Company had become established and the more senior members agreed officially that no more secret and sacred images should be painted for viewing by a white populace or by uninitiated Aborigines. Artists began to hide the more secret features of their work by dotting over them to disguise elements which should not be seen by the outside world. Many of the early paintings can no longer be reproduced or exhibited as they are considered too secret and sacred.

The availability of acrylic paint in a large range of colours has meant that the artists of today respond more readily to the requirements of the art market than they did in the early days at Papunya Tula, and larger canvases have given the artists still further scope. Some of the early artists, however, have felt a duty to keep to the original desert colours. These naturally available colours, used prior to the coming of acrylic paint, were reds and yellows derived from ochre, white from pipe clay and chalk, and black from charcoal. Whether working in acrylics or these natural colours, most of the artists nevertheless still adhere to their traditional motifs and designs.

Many a visitor to Australia will come across desert paintings in galleries and shops which, even to the relatively inexperienced eye, look brash, over-coloured and even vulgar. These are sometimes known as 'Airport Art' and are an inevitable product of an expanding art movement serving an increasingly large tourist trade. (I hasten to add that certain airports in Australia, notably Darwin and Alice Springs, have commissioned or purchased desert paintings and other quite outstanding works by some of Australia's best known artists.) It hardly needs saying how far removed these 'Airport Art' paintings are from the fine works of Papunya Tula or the many other painting communities. To the experienced eye the former paintings lack any form of spirituality. While they could clearly not be anything but desert paintings, they fail to convey any message of the ancient traditions of Aboriginal life and its links with the land. In complete contrast, when an authentic Aboriginal artist paints one of his Dreamings, that painting conveys its meaning in a way that only a genuine believer in a mythical past could possibly achieve.

7 The Artists and Their Paintings

Sequence of Artists

The artists whose works appear on the following pages are arranged alphabetically by first name. This might appear unconventional, or even illogical, to a Western reader, but the system of naming in Aboriginal society can be complicated, and does not follow the Western system of Christian name and surname.

Painters will often adopt a Western name as an 'identity' to facilitate dealings with the English-speaking world, but they will not necessarily be known by these names in their own communities. The order of an artist's Aboriginal and Western names is not fixed, which makes alphabetising difficult.

The reader may notice that the same 'surnames' recur, such as 'Tjupurrula' or 'Tjapangati' (female versions of these names commence with 'Na' or 'Nu'). These names indicate one of eight kinship groups which are inherited patrilineally. The spellings of these names may vary, as they are merely phonetic transcriptions of Aboriginal names. Thus 'Tjapangati', for example, may appear elsewhere as 'Japangati'.

For these reasons, the author feels that to alphabetise by first name is the most user-friendly system.

Artists' Biographies

Biographical details in the conventional sense are not available for the Papunya Tula artists. This is due not simply to lack of records, rather to the profound cultural differences which exist between Aboriginal and Western societies.

The information we use in the West to identify ourselves, such as date of birth, education or artistic influences for example, simply have no currency in Aboriginal society.

The author has therefore concentrated on giving that information which is of greatest relevance to the lives of the artists themselves, and, therefore, to the understanding of their paintings.

The Paintings

Papunya Tula paintings can in most cases be viewed from any angle, and the choice of position in this book does not reflect any 'proper' way round of viewing the paintings. They are very often symmetrical, and do not conform to Western ideas of perspective.

Anatjari Tjakamarra
(c.1930-92)

Also known as *Anatjari No. 3*

Anatjari Tjakamarra was born of the Pintupi tribe near the Pollock Hills, in the Baron Ranges of Western Australia, and was one of the last Aborigines to be brought out of the desert in the 1960s. He and his family feature in Douglas Lockwood's book *The Lizard Eaters,* and in Ian Dunlop's film *Desert People*. One of the founding group of painters at Papunya, Anatjari Tjakamarra painted Tingari Stories and Snake, Water and Dingo Puppy Dreamings. His *Tingari Cycle Dreaming* was the first work by a Papunya Tula artist to be purchased by one of the world's major international art collections, the Metropolitan Museum of Modern Art in New York. Other collections that own his work include the Burke Museum, University of Washington, Seattle, the National Gallery of Victoria and the National Museum of Australia.

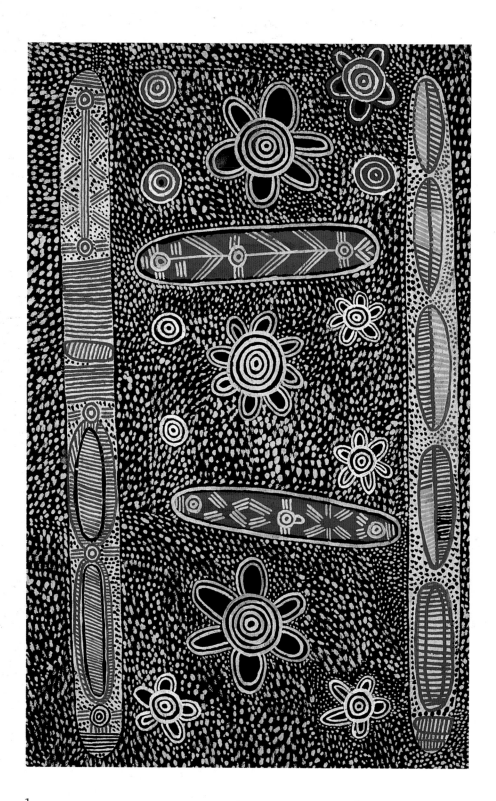

1

Anatjari Tjakamarra
Bush Tucker Dreaming 1971
Acrylic on canvas 46 x 30cm (18 x 11¾in)
Private collection

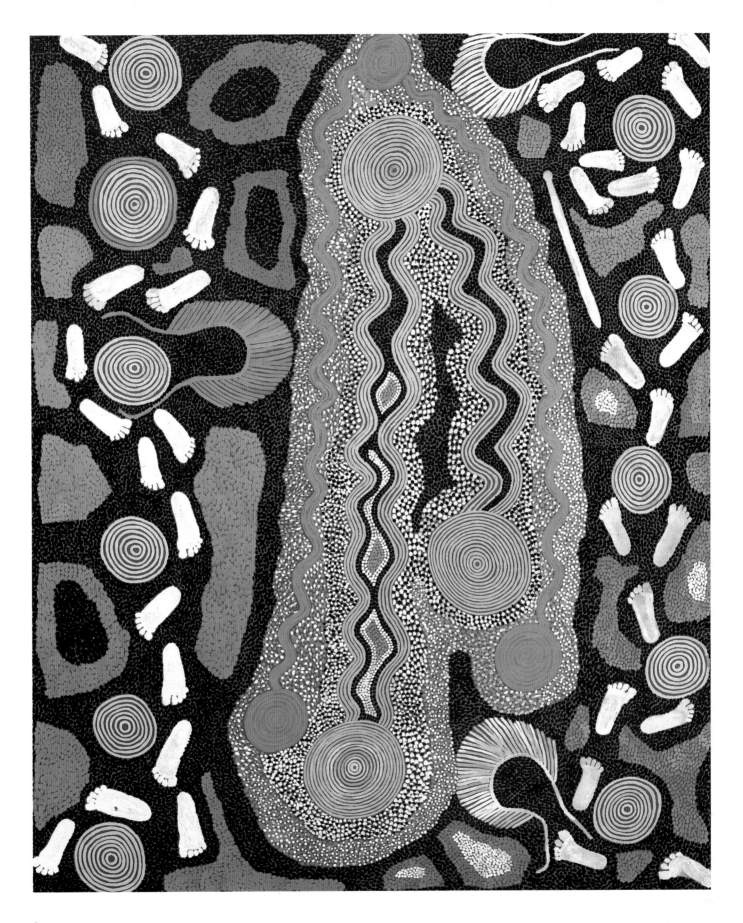

2
Anatjari Tjakamarra
Big Snake Dreaming 1975
Acrylic on canvas 152 x 122cm (60 x 48in)
Private collection

Anatjari Tjampitjinpa (born c.1927)

Also known as *Anatjari No.1*

Anatjari Tjampitjinpa was born of the Pintupi tribe. He walked into Papunya in the early 1960s, and joined the founding group of painters at the beginning of the Papunya Tula movement. His work was included in the Asia Society's exhibition *Dreamings: Art of Aboriginal Australia*, which toured the USA in 1988-9. Anatjari taught his younger brother Dini Campbell to paint. Dini's work is also featured in this book, as is that of Anatjari's son, George Yapa.

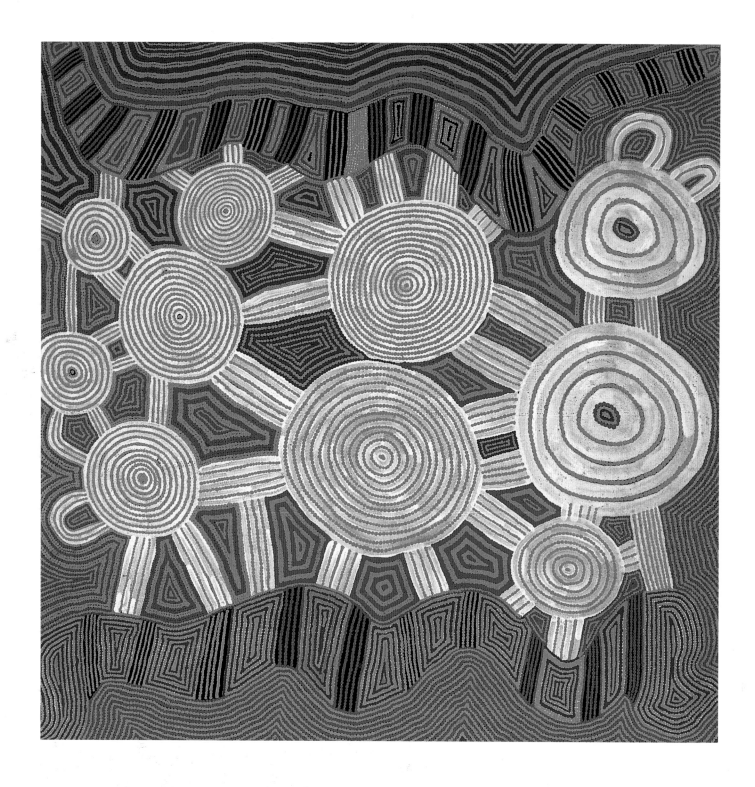

3
Anatjari Tjampitjinpa
Snake Dreaming 1988
Acrylic on canvas 120 x 120cm (47 ¼ x 47 ¼in)
Private collection

Barney Daniels was born at Haasts Bluff and describes his tribe as Luritja/Pintupi. He started painting in the mid-1980s and the Dreamings he paints include Rainbow Snake, Blue Tongue Lizard, Bush Fire, Centipede, Witchetty Grub and Bush Tucker. Barney Daniels has a very distinctive style of painting, and he was one of the first artists to adopt the style of stippled brushwork backgrounds. Collections that own his work include Longbeach Museum, California.

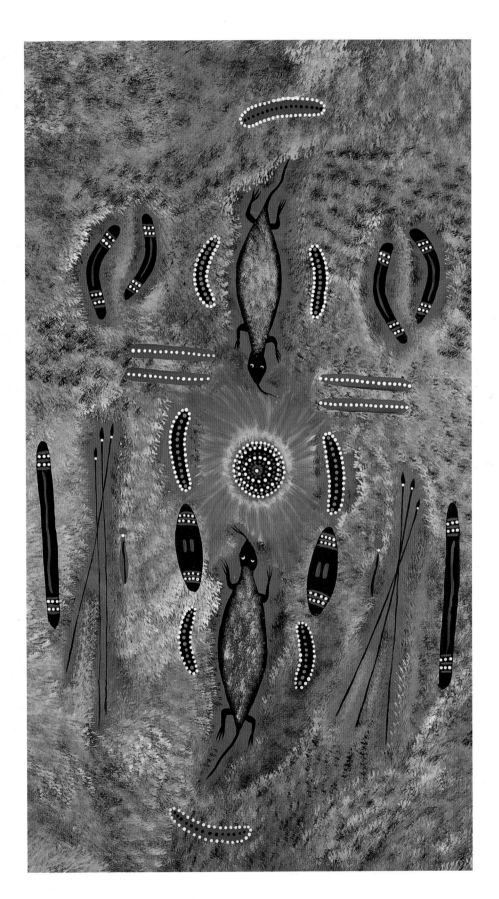

4
Barney Daniels Tjungurrayi
Lizard Dreaming 1993
Acrylic on canvas 134 x 76cm
(52¾ x 30in)
Private collection

Billy Stockman Tjapaltjarri
(born *c*.1927)

Billy Stockman was born at Ilpitirri, north-west of Papunya, and his tribal affiliation is Anmatyerre/Western Arrente. He was a founding member of the original painting group at Papunya, and in the 1970s he was one of the Papunya Town Councillors, and Chairman of the Papunya Tula Artists Company. Billy Stockman is a prolific painter, depicting Dreamings of Budgerigar, Spider, Yam and Wild Potato. He has travelled extensively outside Australia. Collections that own his work include the National Gallery of Australia and the National Museum of Australia.

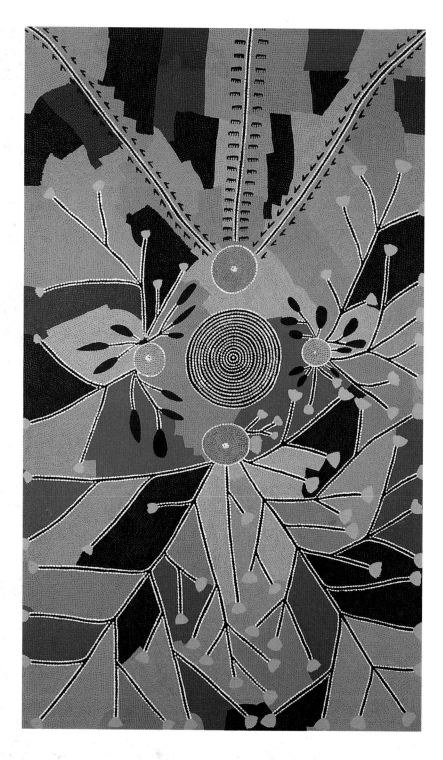

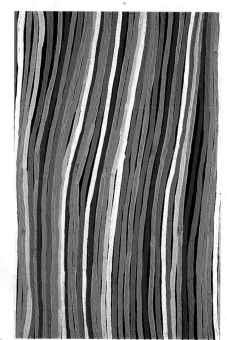

5
Billy Stockman Tjapaltjarri
Sacred Dreaming 1993
Acrylic on canvas 91 x 61cm
(35¾ x 24in)
Private collection

6
Billy Stockman Tjapaltjarri
Kangaroo Dreaming 1988
Acrylic on canvas 298 x 178cm
(117¼ x 70in)
Private collection

7
Billy Stockman Tjapaltjarri
Snake Dreaming 1989
Acrylic on canvas 191 x 127cm (75¼ x 50in)
Private collection

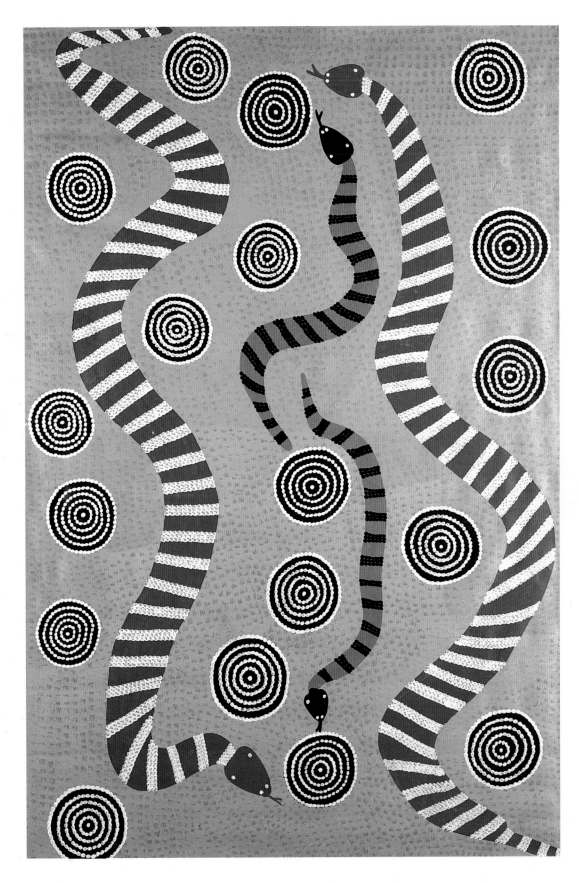

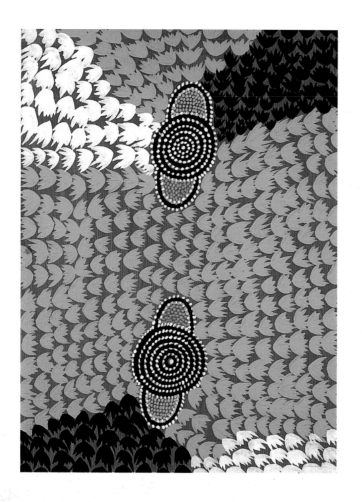

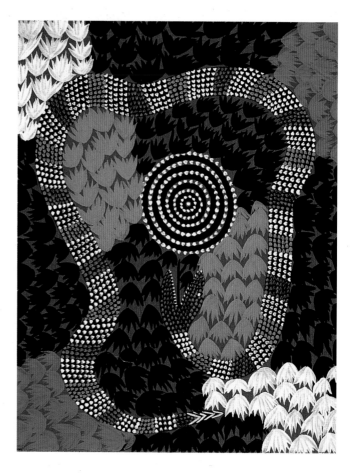

8
Billy Stockman Tjapaltjarri
Man's Dreaming 1979
Acrylic on canvas 76 x 56cm (30 x 22in)
Private collection

9
Billy Stockman Tjapaltjarri
Untitled 1975
Acrylic on canvas 51 x 31cm (20 x 12¼in)
Private collection

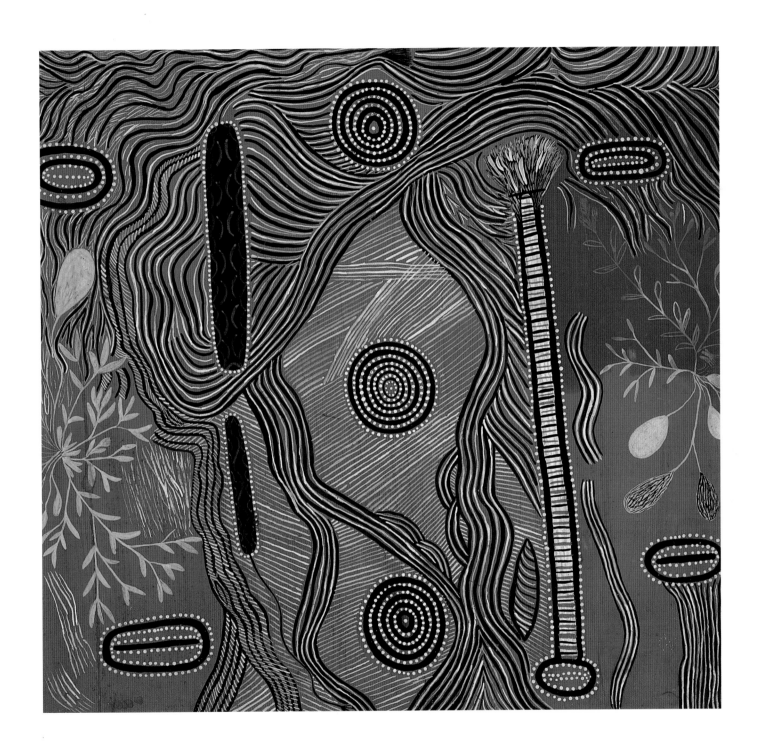

10
Billy Stockman Tjapaltjarri
Bush Potato Dreaming 1971
Paint on board 65 x 65cm (25½ x 25½in)
Private collection

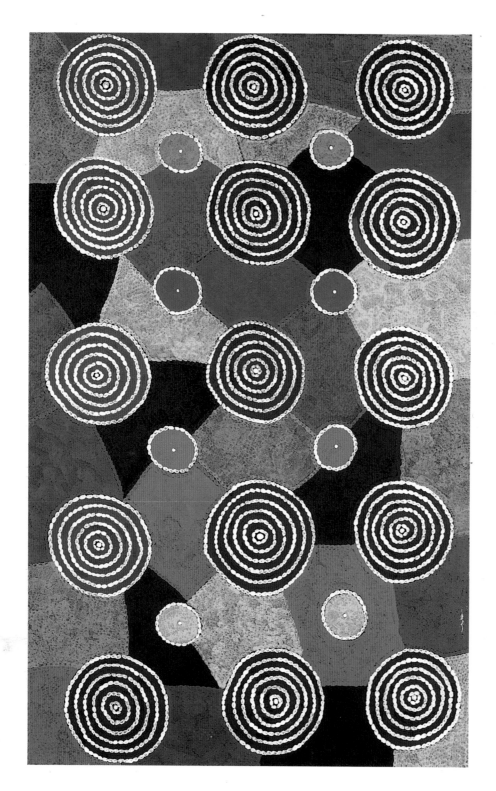

11
Billy Stockman Tjapaltjarri
Untitled 1992
Acrylic on canvas 140 x 90cm
(55 x 35½in)
Private collection

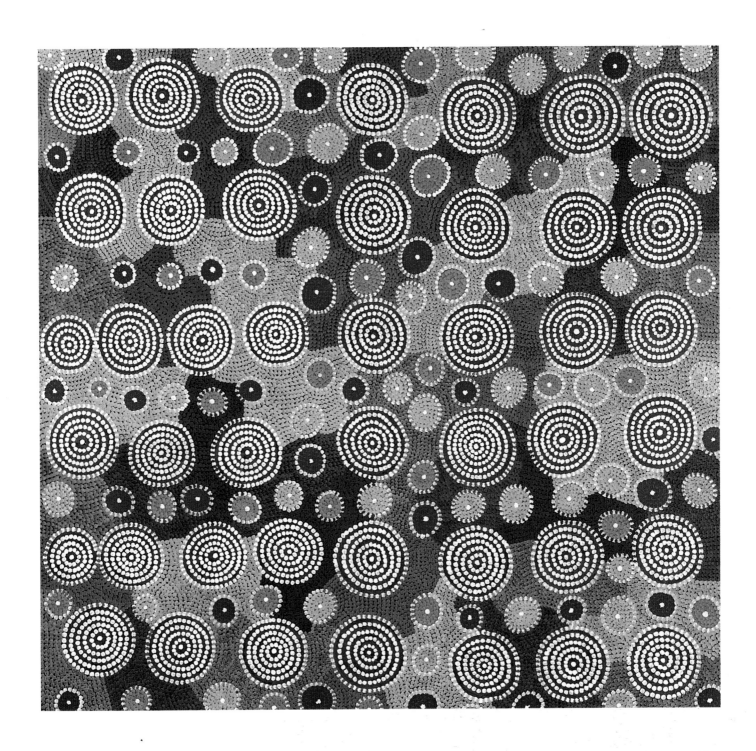

12
Billy Stockman Tjapaltjarri
Budgerigar Dreaming 1988
Acrylic on canvas 122 x 122cm
(48 x 48in)
Private collection

In Australia, budgerigars normally move in large flocks which give a great display of colour as they wheel to change direction or when they land at waterholes. The artist has shown this colour movement in his painting using combinations of blue, pink, yellow and green on a black background with red ochre, and white circles spread evenly over the surface producing a strong optical effect. Associated with seasonal cycles, the budgerigar becomes a metaphor for life itself.

Brogas Tjapangati
(born 1949)

Brogas Tjapangati was born of the Warlpiri tribe at Haasts Bluff. He began painting in 1982, but had been taught wood carving by Clifford Possum many years earlier, and he himself taught wood carving at the Papunya school. He has a delicate and easily recognisable style. The Dreamings he paints include Witchetty Grub, Water Snake, Parrot, Rock Wallaby and Women's Dreaming stories. His sister is the artist Pansy Napangati.

Carol Nampitjinpa
(date of birth unknown)

Carol Nampitjinpa is an occasional painter for Papunya Tula. No further biographical information was available for her.

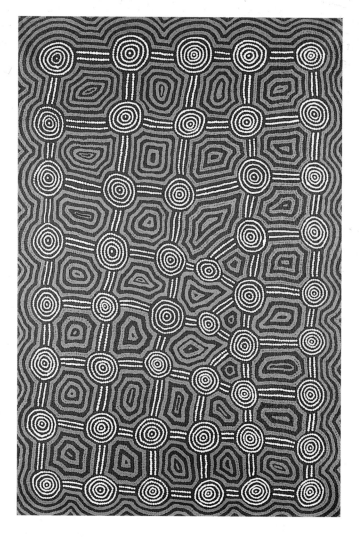

14
Carol Nampitjinpa
Tingari Cycle 1988
Acrylic on canvas 138 x 92cm (54¼ x 36¼in)
Private collection

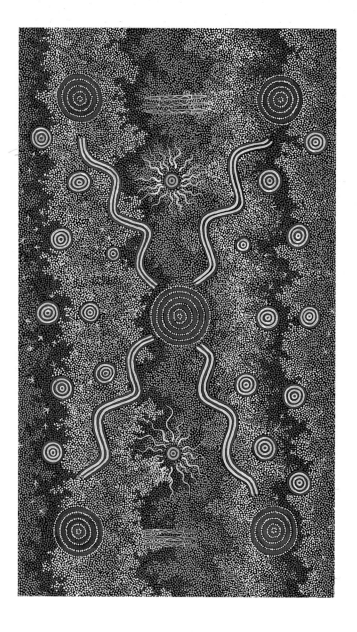

13
Brogas Tjapangati
Witchetty Grub Dreaming at Kunatjarrayi
1990
Acrylic on canvas 152 x 91cm (60 x 35¾in)
Private collection

Charlie Egalie was born at Pikilyi,
north-west of Mount Leibig, of the
Warlpiri/Luritja tribe. He was one of the
early painters at Papunya, starting in
around 1972, and the Dreamings he
paints include Woman, Sugar Ant,
Budgerigar, Wallaby, Bush Fire and Man.
He taught his daughter Natalie Corby to
paint. Collections that own his work
include the National Gallery of Australia
and the National Museum of Australia.

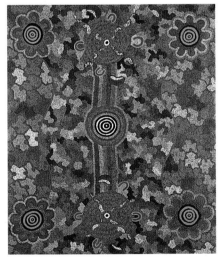

15
Charlie Egalie Tjapaltjarri
(assisted by Natalie Corby)
Witchetty Grub Dreaming 1989
Acrylic on canvas 143 x 126cm
(56¼ x 49½in)
Private collection

16
Charlie Egalie Tjapaltjarri
Budgerigar Ancestors 1974
Paint on board 61 x 46cm (24 x 18in)
Courtesy Art Gallery of Western Australia

Masses of tracks and simple circle arrangements
symbolise these important ancestors. The circles
are patches of grass whose seed the budgerigars
eat. The artist, by combining tracks and circles in
this way, endeavours to evoke the personality of
the budgerigars and so encourage their
proliferation.

Charlie Tarawa Tjungurrayi
(born *c*.1921)

Also known as *Wadama* or *Watuma*

Charlie Tarawa was born of the Pintupi tribe near the Kintore Ranges. He started painting in the early 1970s, and the Dreamings he paints include Emu, Wallaby, Water, Frog and Tingari stories from the Tjitururrnga area. Collections that own his work include the National Gallery of Australia, the National Gallery of Victoria and the Burke Museum, University of Washington, Seattle.

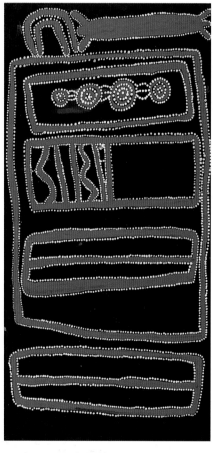

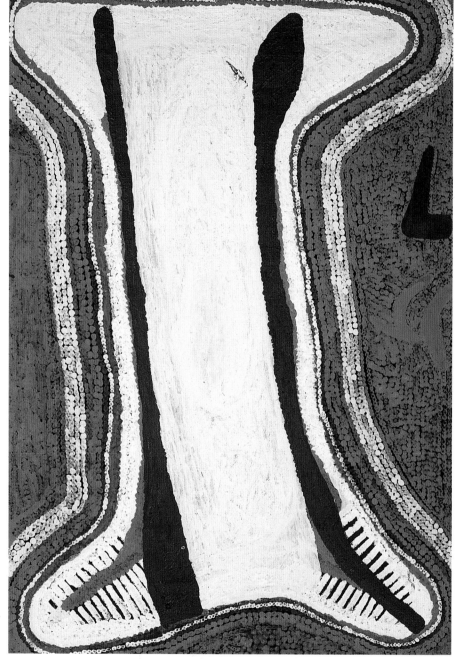

17
Charlie Tarawa Tjungurrayi
Mitukatjirri 1972
Paint on board 65 x 33cm
(25½ x 13in)
Courtesy National Gallery of Victoria

18
Charlie Tarawa Tjungurrayi
Ice Man Dreaming 1989
Acrylic on canvas 90 x 60cm
(35½ x 23½in)
Private collection

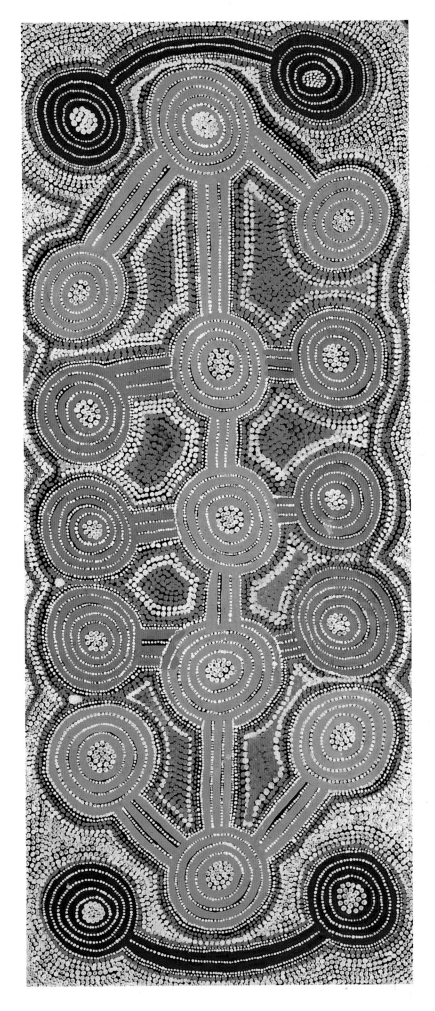

19
Charlie Tarawa Tjungurrayi
Tingari Cycle 1988
Acrylic on canvas 123 x 51cm
(48½ x 20in)
Private collection

This painting has as its central theme the Tingari creation myth. Although much of the detail of the Tingari stories is secret and sacred, paintings depicting these stories are often similar in structure, typically featuring linked patterns of circles and lines. As is often the case in Tingari Dreaming paintings, the specific story is not known to the viewer. This work is symmetrical with an implied directional structure. Perimeter colours of pink and yellow link the image together in a tightly structured composition. Red circles and linkage lines at either end of the composition unify and restrict the story.

20
Charlie Tarawa Tjungurrayi
Tingari Cycle 1984
Acrylic on canvas 89 x 59cm
(35 x 23¼in)
Private collection

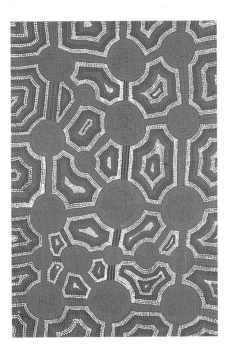

21
Charlie Tarawa Tjungurrayi
Centipede Dreaming 1978
Paint on board 52 x 32cm (20½ x 12½in)
Private collection

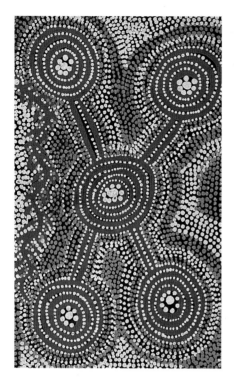

22
Charlie Tarawa Tjungurrayi
Untitled 1978
Acrylic on board 52 x 32cm
(20½ x 12½in)
Private collection

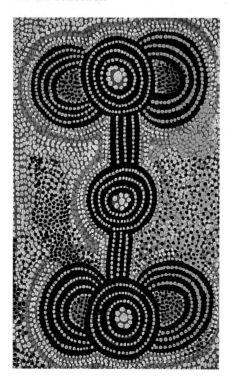

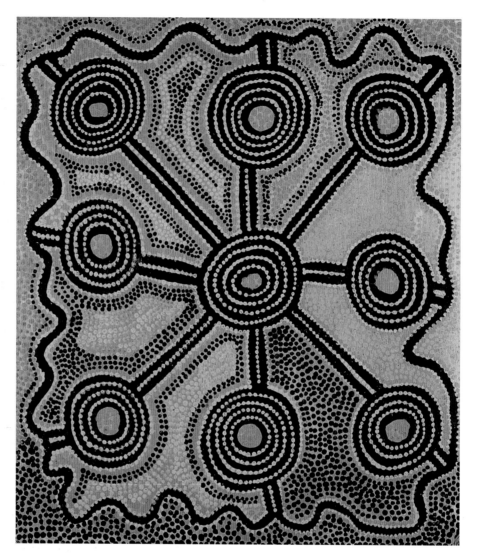

23
Charlie Tarawa Tjungurrayi
Warnampi Dreaming 1976
Paint on board 60 x 51cm (23 x 20in)
Private collection

In this painting the artist has chosen not
to be too specific in his depiction of the
subject matter. The perimeter is defined
by a long sinuous line which connects to
the circles and diagonal lines. Infilling
covers the entire surface, although some
areas are less complete than others. The
background is yellow ochre, with the
black linear structure painted over this,
and the orange and white pattern is the
final layer.

25
Charlie Tarawa Tjungurrayi
Bush Tucker Dreaming 1979
Paint on board 37 x 36cm (14½ x 14¼in)
Private collection

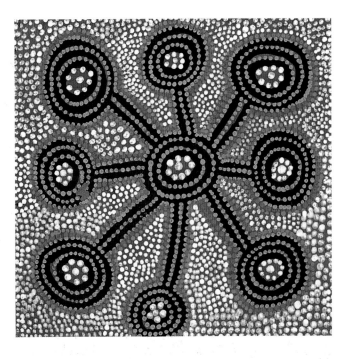

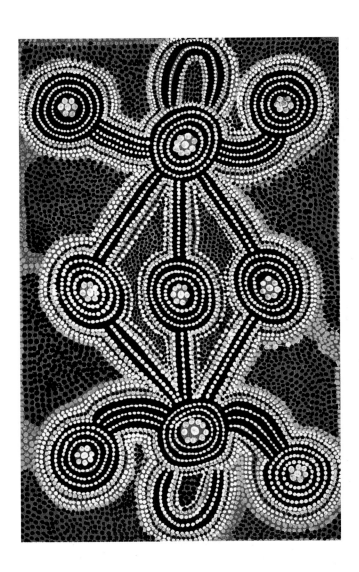

24
Charlie Tarawa Tjungurrayi
Ice Dreaming 1979
Paint on board 95 x 62cm (37½ x 24½ in)
Private collection

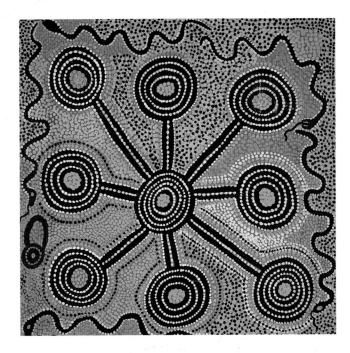

26
Charlie Tarawa Tjungurrayi
Warnampi Dreaming 1976
Paint on board 56 x 56cm (22 x 22in)
Private collection

Charlie Tjapangati
(born c.1949)

Charlie Tjapangati was born north-west of Jupiter Well of the Pintupi tribe. He started painting for Papunya Tula Artists in around 1978, and just a few years later in 1981 he travelled to America with Billy Stockman for the exhibition *Mr Sandman Bring Me a Dream*. He normally paints Dreamings of the Tingari Cycle. Collections that own his work include the National Gallery of Australia.

27
Charlie Tjapangati
Snake Dreaming 1982
Acrylic on canvas 122 x 92cm
(48 x 36¼in)
Private collection

Clifford Possum is probably the best-known and most widely collected of the Papunya Tula artists. He was born at Napperby of the Anmatyerre tribe, and joined his brother Tim Leura as one of the original group of painters at Papunya in the early 1970s. He was already an accomplished wood carver, and had taught his skill to children at Papunya.

Clifford Possum is a prolific painter, and his work has been included in the major touring exhibitions of Aboriginal art that have visited the USA and Europe since the start of the Papunya Tula painting movement. He paints a wide selection of Dreamings including Possum, Goanna, Man's Love Story, Water, Fire, Snake, Fish and Kangaroo. He was Chairman of

the Papunya Tula Artists Company during the late 1970s and early 1980s. Collections that own his work include the National Gallery of Australia, the National Gallery of Victoria and the Pacific Asia Museum, Los Angeles.

A comprehensive study of his work, *The Art of Clifford Possum,* by Vivien Johnson, was published in 1994 (see Bibliography).

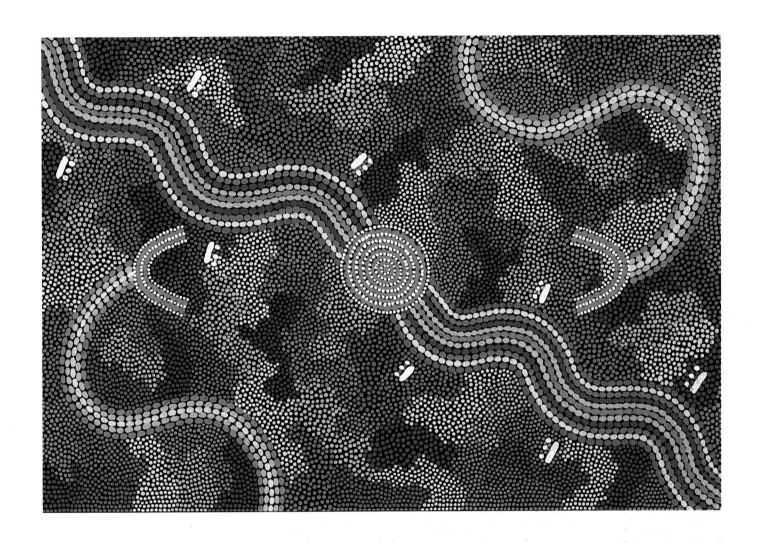

28
Clifford Possum Tjapaltjarri
Dingo Dreaming 1990
Acrylic on canvas 62 x 93cm (24½ x 36½in)
Private collection

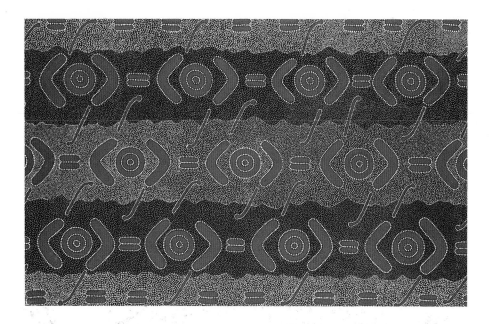

29
Clifford Possum Tjapaltjarri
Men's Dreaming 1983
Acrylic on canvas 77 x 122cm
(30¼ x 48in)
Private collection

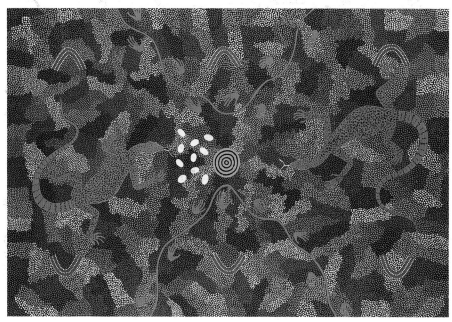

30
Clifford Possum Tjapaltjarri
Goanna Dreaming 1988
Acrylic on canvas 120 x 182cm
(47¼ x 71¾in)
Private collection

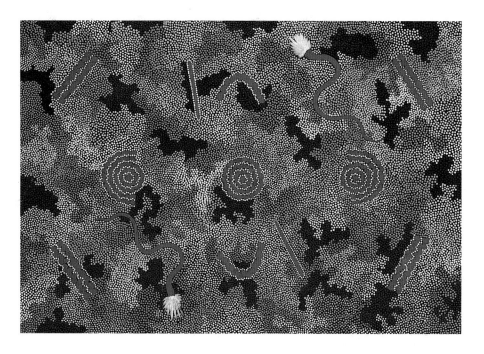

31
Clifford Possum Tjapaltjarri
Men's Dreaming 1990
Acrylic on canvas 93 x 134cm
(36½ x 52¾in)
Private collection

32
Clifford Possum Tjapaltjarri
Water Dreaming 1982
Acrylic on canvas 60 x 120cm
(23½ x 47¼in)
Private collection

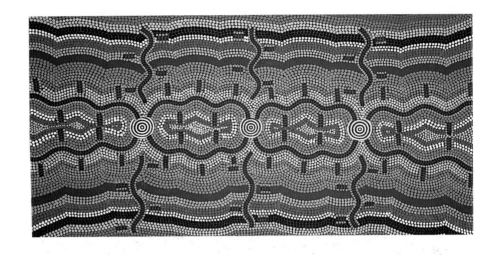

33
Clifford Possum Tjapaltjarri
Narripi (Worm) Dreaming 1987
Acrylic on canvas 90 x 120cm
(35½ x 47¼in)
Private collection

34
Clifford Possum Tjapaltjarri
Sacred Ceremony 1992
Acrylic on canvas 60 x 82cm
(23½ x 32¼in)
Private collection

35
Clifford Possum Tjapaltjarri
Yingalingi (Honey Ant) Dreaming 1983
Acrylic on canvas 244 x 366cm
(96 x 144in)
Courtesy National Gallery of Australia

36
Clifford Possum Tjapaltjarri
Men's Dreaming 1985
Acrylic on canvas 61 x 121cm
(24 x 47¾in)
Private collection

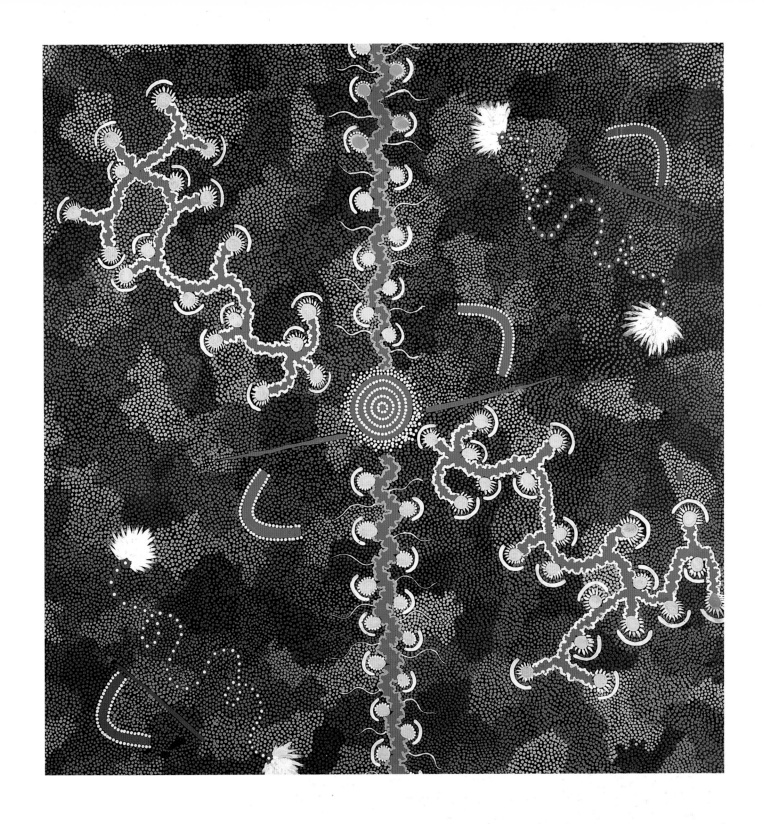

37
Clifford Possum Tjapaltjarri
Men's Dreaming 1990
Acrylic on canvas 132 x 127cm (52 x 50in)
Private collection

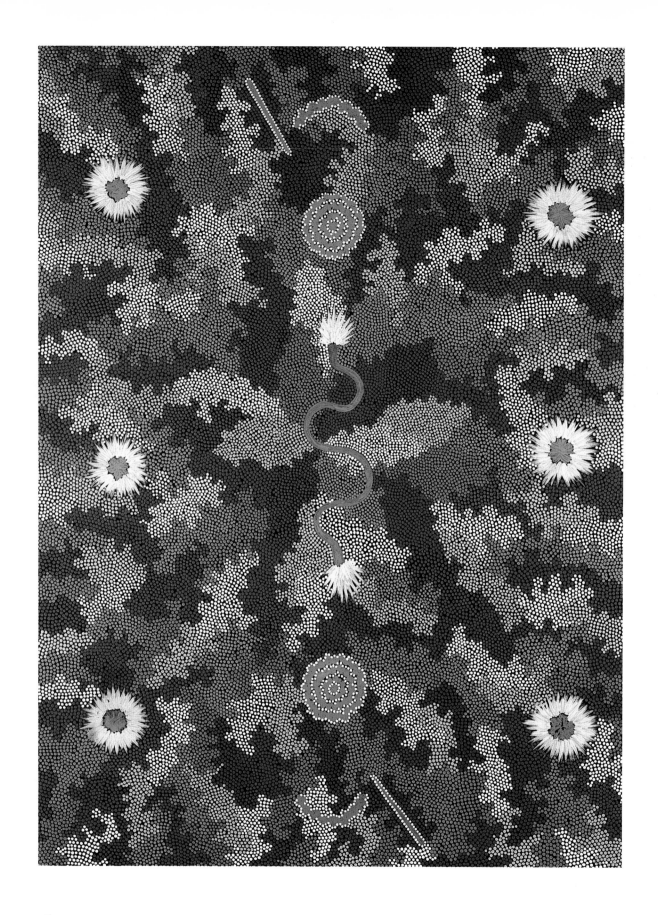

38
Clifford Possum Tjapaltjarri
Men's Dreaming 1988
Acrylic on canvas 166 x 123cm
(65¼ x 48½in)
Private collection

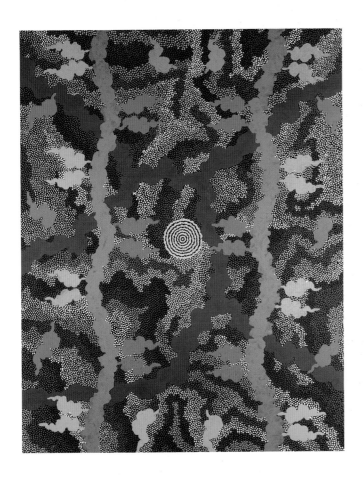

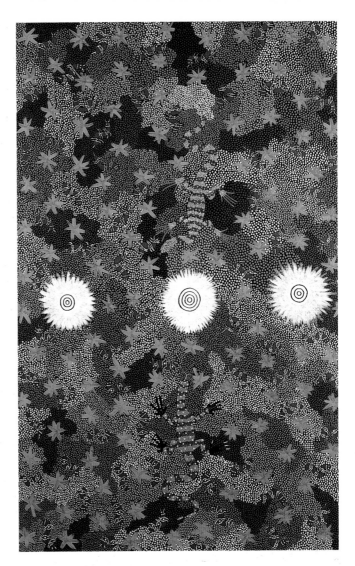

39
Clifford Possum Tjapaltjarri
Corkwood Dreaming 1992
Acrylic on canvas 164 x 128cm
(64½ x 50½in)
Private collection

40
Clifford Possum Tjapaltjarri
Goanna Dreaming 1988
Acrylic on canvas 193 x 122cm
(76 x 48in)
Private collection

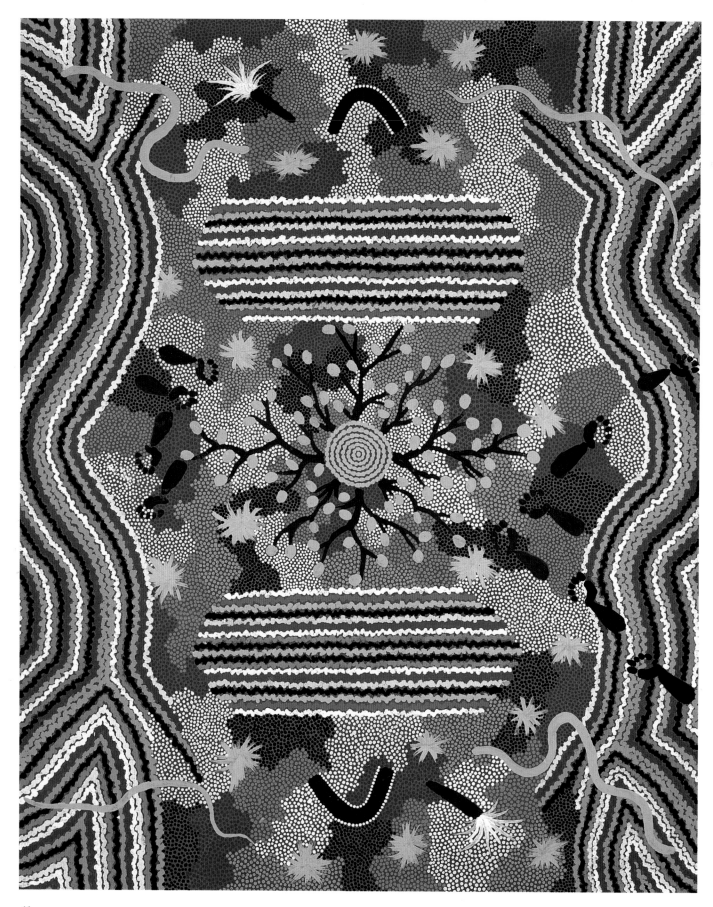

41
Clifford Possum Tjapaltjarri
Bush Plum Dreaming 1991
Acrylic on canvas 168 x 134cm (66¼ x 52¾in)
Private collection

Daisy Leura was born at Umbungurru Creek of the Anmatyerre tribe. She was married to Tim Leura, and her first canvases were done in the early 1980s with his help. She went on to become one of the first women to paint for Papunya Tula Artists in her own right, painting previously having been considered the exclusive domain of men. Collections that own her work include the National Gallery of Australia.

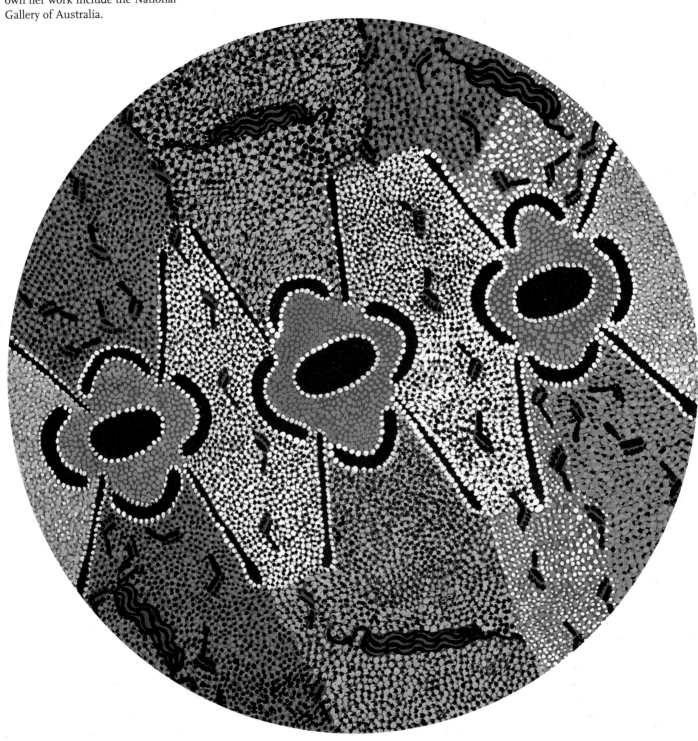

42
Daisy Leura Nakamarra
Woman's Dreaming 1982
Acrylic on canvas 50cm (19¾in) diameter
Private collection

David Corby Tjapaltjarri
(c. 1945-80)

David Corby was born of the Warlpiri tribe near Tjunti, north-west of Vaughan Springs. He joined his older brother Charlie Egalie as one of the original group of painters at Papunya in the early 1970s. He was one of the only artists of this period to sign his paintings on the front. The Dreamings he painted include Budgerigar, Wallaby, Emu and Witchetty Grub.

43
David Corby Tjapaltjarri
Emu Dreaming 1972
Paint on board 29 x 49cm
(11½ x 19¼in)
Private collection

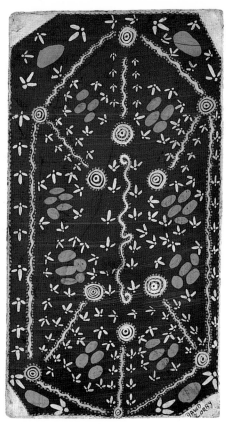

44
David Corby Tjapaltjarri
Untitled 1975
Paint on board 45 x 33cm (17¾ x 13in)
Courtesy Museum and Art Gallery of the Northern Territory

Dick Cowboy Tjapanangka
(date of birth unknown)

Dick Cowboy Tjapanangka is an occasional painter for Papunya Tula. No further biographical information was available for him.

45
Dick Cowboy Tjapanangka
Tingari Cycle 1989
Acrylic on canvas 112 x 83cm
(44 x 32¾in)
Private collection

Dick Lechleitner was born at Coniston of
the Anmatyerre tribe. Clifford Possum and
his brother Tim Leura were among his
childhood friends, and long before the
painting movement began at Papunya, he
and Clifford Possum would paint and sell
boomerangs. He first painted in
watercolours, and took up painting in
acrylics on canvas in the early 1980s. He
served for nine years on the Aboriginal
Congress. His paintings usually depict
Sugar Ant, Water and Women Dreamings.

46
Dick Lechleitner Tjapanangka
Water Dreaming 1989
Acrylic on canvas 123 x 73cm
(48½ x 28¾in)
Private collection

Dick Pantimas Tjupurrula
(c. 1940-83)

Dick Pantimas was born of the Luritja tribe at Tippa, north of Sandy Blight Junction. He began painting at Papunya in the late 1970s, having watched the older artists for many years, and he was considered one of the most promising of the second-generation artists until his untimely death in 1983. In 1990 a Water Dreaming motif from one of his paintings was used for a mosaic in the new Alice Springs airport. Collections that own his work include the National Gallery of Victoria.

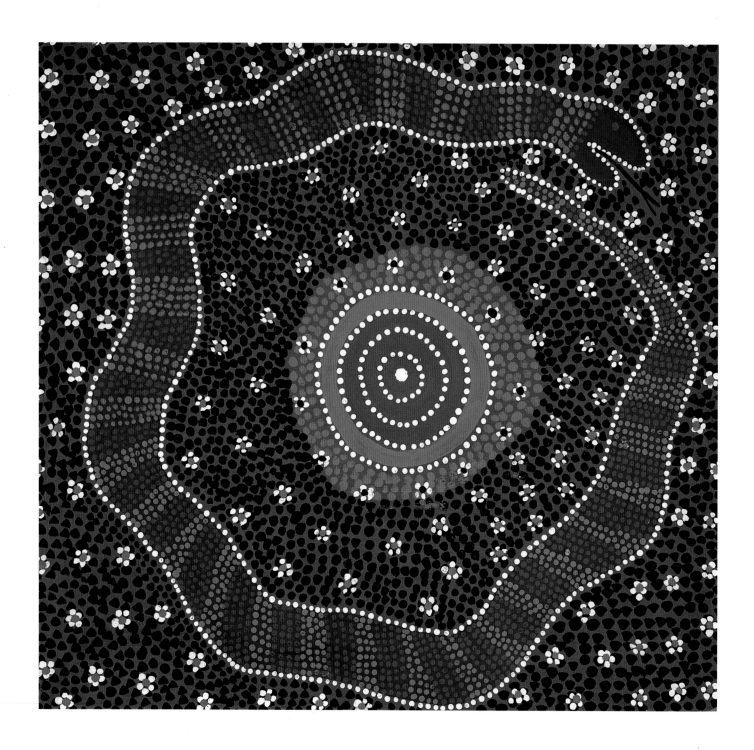

47
Dick Pantimas Tjupurrula
Warnampi Tingari 1980
Acrylic on canvas 53 x 51cm (20¾ x 20in)
Private collection

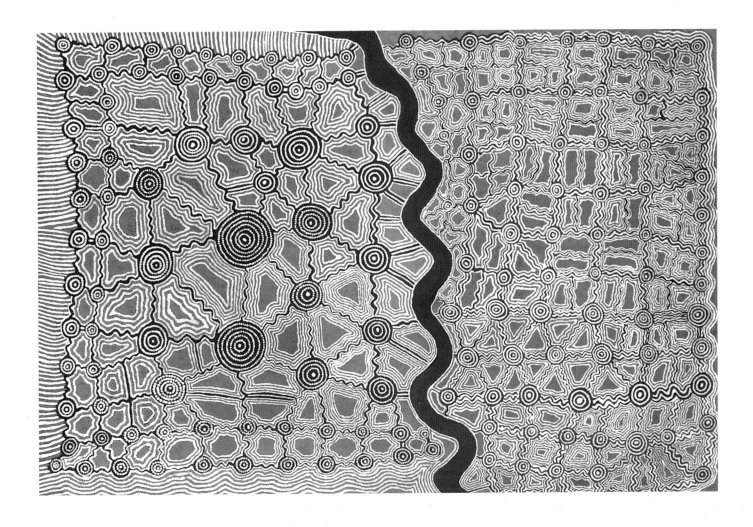

Dini Campbell was born of the Pintupi
tribe west of Kiwirrkura, and he arrived at
the Catholic mission settlement at Balgo in
the late 1950s. His older brother, Anatjari
Tjampitjinpa, was one of the original
painters at Papunya. Dini was one of the
team that assisted Uta Uta Tjangala with
the massive work portraying events at the
site of Yumari, which was included in the
Asia Society's exhibition *Dreamings: Art of
Aboriginal Australia*, which toured the USA
in 1988-9. He paints Tingari stories, and
his work is influenced by the linked
dotting style of Balgo painters. Collections
that own his work include the National
Gallery of Victoria.

48
Dini Campbell Tjampitjinpa
Tingari Dreaming 1986
Acrylic on canvas 121 x 183cm
(47¾ x 72in)
Courtesy National Gallery of Victoria

This picture shows a secret-sacred
episode from the epic Tingari Cycle.
Pilkati, a poisonous snake, is depicted at
Nyinmi soakage, a swampy place past
Kintore in the Gibson Desert. The
concentric circles are trees, and the
parallel etching in the upper section
represents sandhills.

Dinny Nolan Tjampitjinpa
(born *c*.1922)

Dinny Nolan was born of the Warlpiri tribe near Mount Allan, close to Yuendumu. He is a cousin of both Clifford Possum and Billy Stockman, and an older brother of Kaapa Tjampitjinpa. The Dreamings he paints include Water, Willy-willy, Goanna, Bush Fire, Emu, Bush Turkey and Pelican. The National Gallery of Victoria used one of his designs for a stained glass window. Collections that own his work include the National Gallery of Australia and the National Gallery of Victoria.

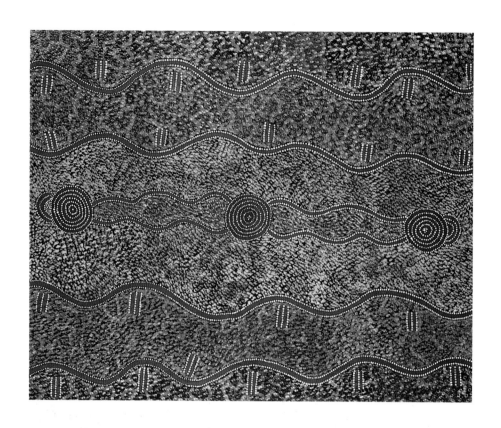

49
Dinny Nolan Tjampitjinpa
Water Dreaming 1988
Acrylic on canvas 122 x 152cm
(48 x 60in)
Private collection

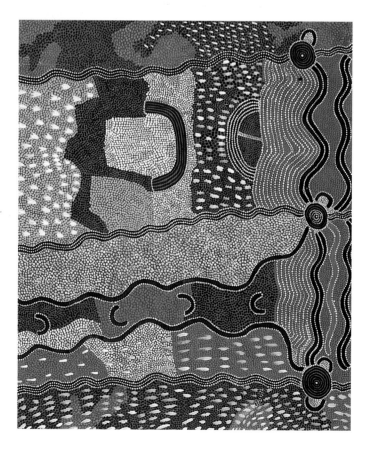

50
Dinny Nolan Tjampitjinpa
Walkupa 1975
Acrylic on canvas 203 x 172cm
(80 x 67¾in)
Courtesy National Gallery of Victoria

Don Ellis Tjapanangka was born of the Luritja tribe. He nearly always painted using a stick, and this is a rare example of a painting by him using a brush.

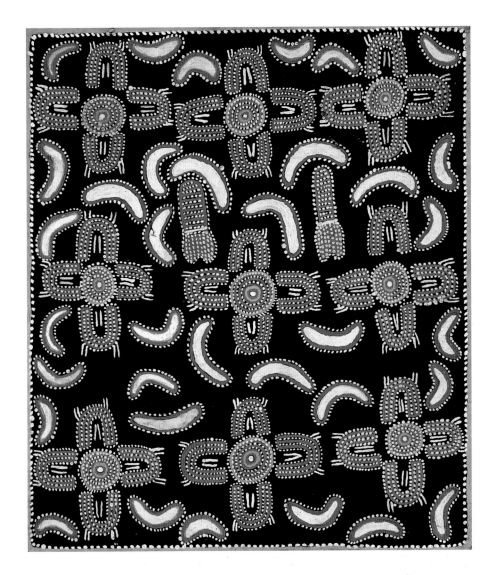

51
Don Ellis Tjapanangka
Boy's Story 1971
Paint on board 52 x 45cm (20½ x 17¾in)
Private collection

Eddie Ediminja Tjapangati
(born 1916)

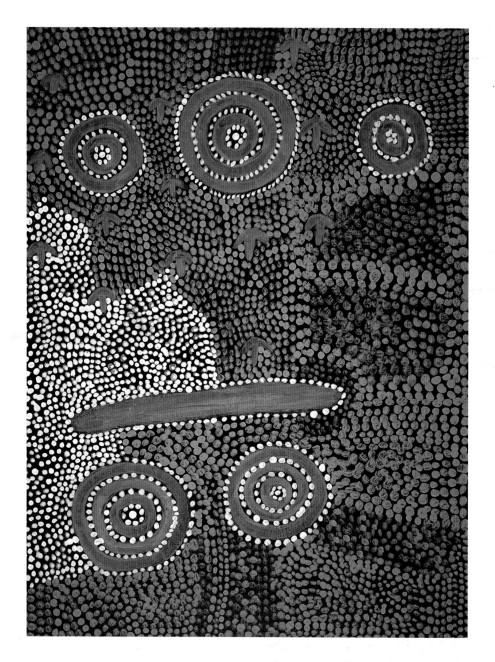

Eddie Ediminja was born at Ulpunyali, west of Watakarra, of the Pitjantjatjara tribe. He started painting in the mid-1970s, and depicts the Two Women Dreaming and the Three Men Lying behind Windbreaks Dreaming. His two sons now help him with his painting.

52
Eddie Ediminja Tjapangati
Emu Murudi (Other Side Sandy Blight, Kanala) 1977
Paint on board 70 x 46cm (27½ x 18in)
Courtesy South Australia Museum

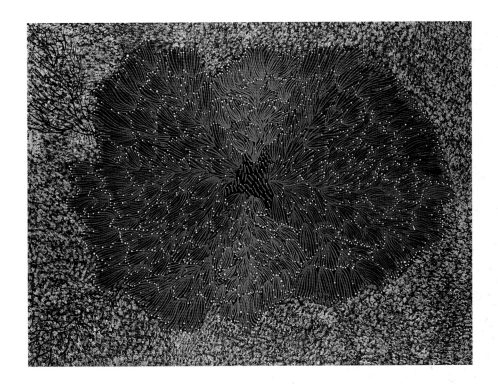

Eunice Napangati was born at Yuendumu of the Warlpiri/Luritja tribe. She started painting with Kaapa Tjampitjinpa in the early 1980s and has since become a leading artist in her own right. She has recently completed a major commission for the new Alice Springs airport which opened in 1991. Her sister Patsy Napangati's work is also featured in this book.

53
Eunice Napangati
Bush Banana Dreaming 1992
Acrylic on canvas 91 x 120cm
(35¾ x 47¼in)
Private collection

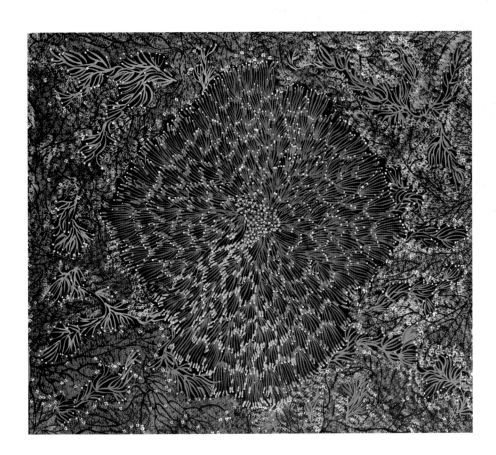

54
Eunice Napangati
Bush Tucker Dreaming 1992
Acrylic on canvas 112 x 128cm
(44 x 50½in)
Private collection

Fabrianne Petersen Nampitjinpa
(born 1965)

Fabrianne Petersen was born of the Luritja tribe at Papunya. She is one of the few young women painters living at Kintore. The Dreamings she paints include Bush Potato, Witchetty Grub, Honey Ant and Country.

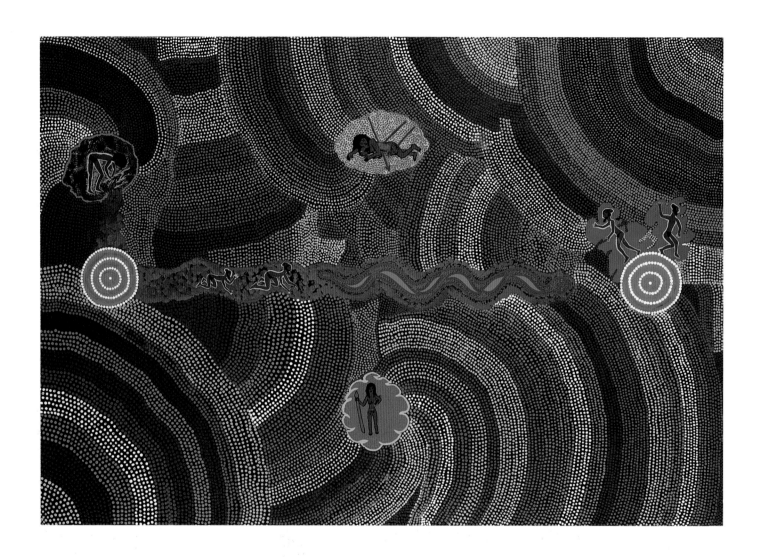

55
Fabrianne Petersen Nampitjinpa
Men's Hunting Dreaming 1991
Acrylic on canvas 84 x 121cm (33 x 47¾in)
Private collection

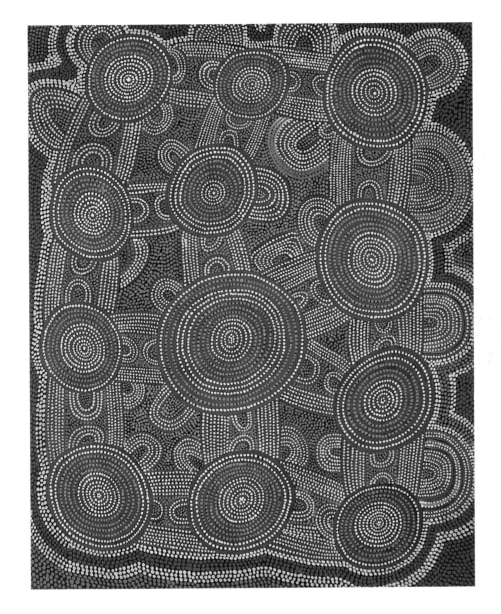

Freddy West was born of the Pintupi tribe at Kiwirrkura, west of Kintore. He began painting in the early 1970s, and after a break of some years he started again in the early 1980s. Collections that own his work include the National Museum of Australia.

In the Dreamtime, Tingari men journeyed across the Western Desert stopping in certain places to enact the rituals which now form an important part of present-day ceremonial cycles. In this painting a group of elders are sitting in a circle recounting the events which occurred at Mayilinna in the legendary Dreamtime. They then show sacred objects to, and perform ritual ceremonies for the novices who accompany them. The elders are represented by the band of circles in the middle. The novices are the rows of circles on either side, and the bars connecting the circles are ceremonial poles erected during the ceremony.

56
Freddy West Tjakamarra
Tingari Men Dreaming at Mayilinna
1974
Paint on board 80 x 61cm (31½ x 24in)
Courtesy Art Gallery of Western Australia

Gabriella Possum Nungurrayi
(born 1967)

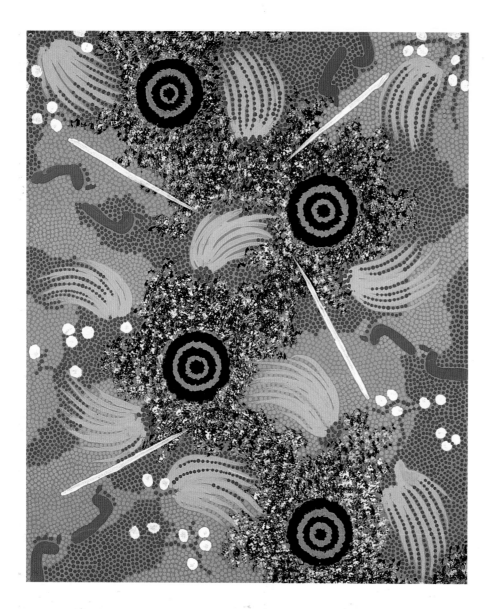

Gabriella Possum was born of the Anmatyerre tribe at Mount Allan. She is the eldest daughter of Clifford Possum, and was taught to paint by her father when she was very young. When she was only sixteen she won the Alice Springs Art Prize. The Dreamings she paints include Bush Coconut, Black Seed, Exploding Seed Pod and Women's stories.

57
Gabriella Possum Nungurrayi
Untitled 1990
Acrylic on canvas 61 x 51cm (24 x 20in)
Private collection

George Bush was born at Mayilnpa near
Alice Springs. He describes his tribe as
Luritja/Anmatyerre. He was one of the
original group of artists at Papunya in the
early 1970s. The Dreamings he paints
include Water Snake, Spider and Bush
Tucker.

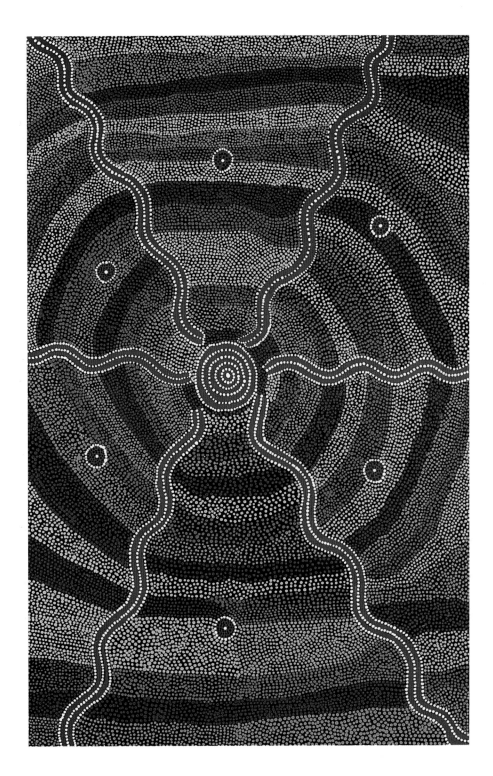

58
George Bush Tjangala
Untitled 1983
Acrylic on canvas 122 x 76cm
(48 x 30in)
Private collection

George Jampu Tjapaltjarri
(born c.1950)

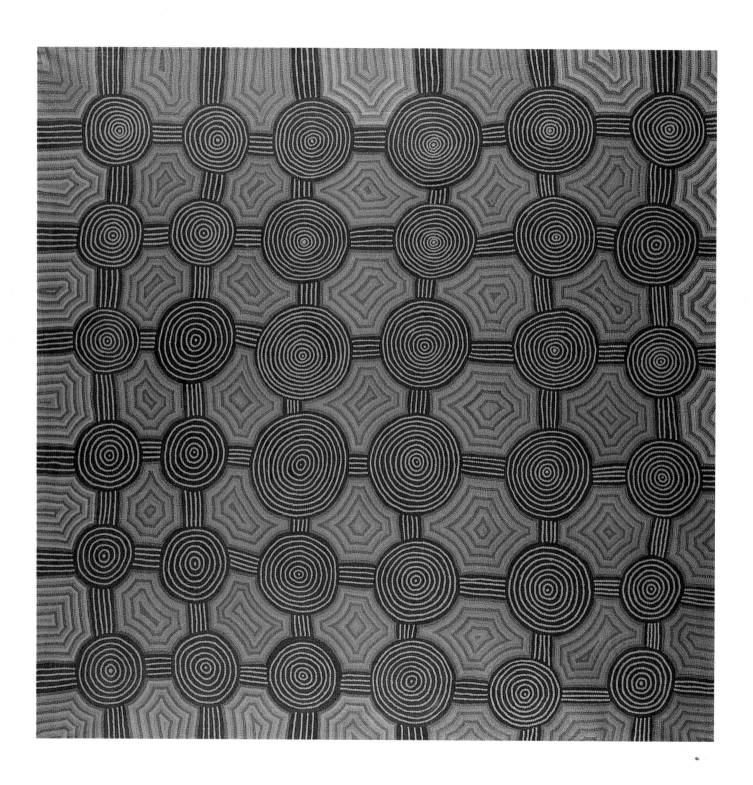

George Jampu was born of the Pintupi
tribe at Wala Wala near Kiwirrkura. He
began painting for Papunya Tula Artists
in 1983, and his paintings depict Tingari
stories.

59
George Jampu Tjapaltjarri
Tingari Cycle 1988
Acrylic on canvas 181 x 181cm
(71¼ x 71¼in)
Private collection

George Tjapaltjarri
(date of birth unknown)
Also known as *Dr George*

George Tjapaltjarri was born south-west of Jupiter Well of the Pintupi tribe. He came out of the desert with his family in 1964. He is an Aboriginal doctor, hence the name 'Dr George'. Collections that own his work include the National Gallery of Victoria.

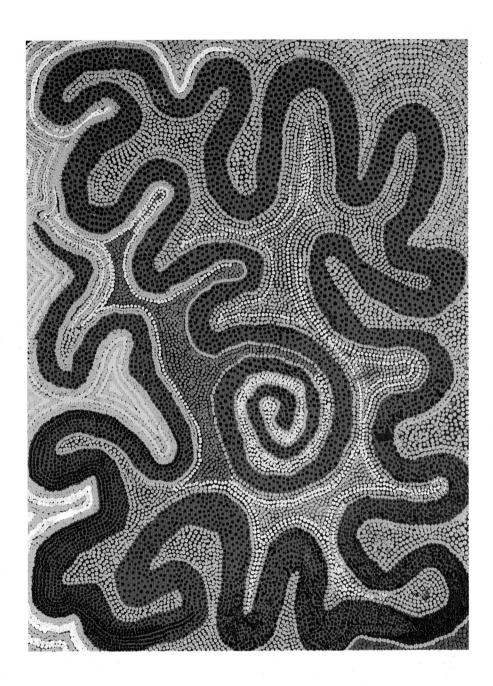

60
George Tjapaltjarri
Snake Dreaming at Wanpurratintja 1988
Acrylic on canvas 122 x 91cm (48 x 35¾in)
Courtesy National Gallery of Victoria

George Tjapanangka
(born *c.*1938)

Also known as *Yuendumu George*

George Tjapanangka was born of the
Pintupi tribe, in the area of Yurrituppa.
He began painting for Papunya Tula
Artists in the late 1980s.

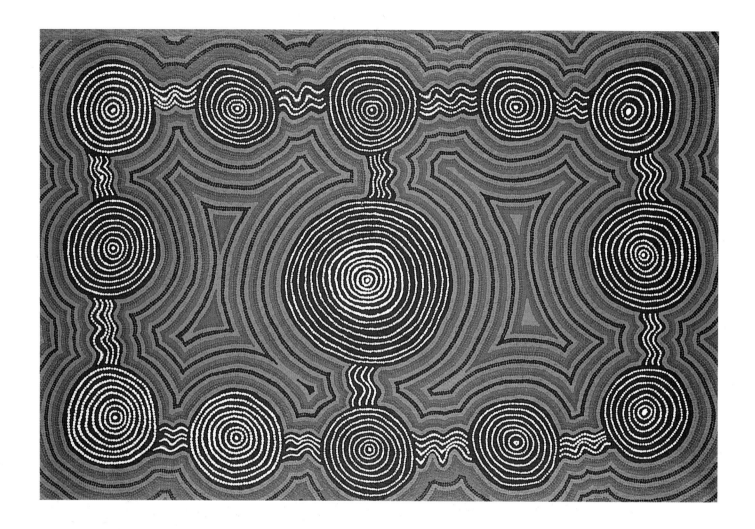

61
George Tjapanangka
Tingari Cycle 1988
Acrylic on canvas 90 x 135cm
(35½ x 53¼in)
Private collection

George Tjungurrayi
(born c.1947)
Also known as *George Hairbrush Tjungurrayi*

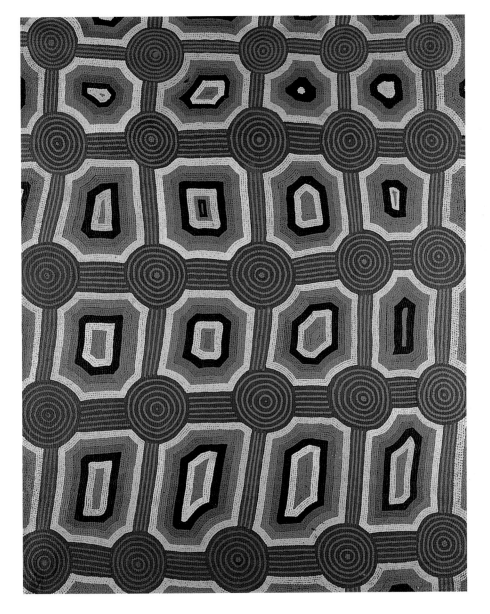

George Tjungurrayi was born of the Pintupi tribe, across the Western Australian border. He is a younger brother of Willy Tjungurrayi, and began painting at Papunya in 1976. He paints the Tingari stories for his region.

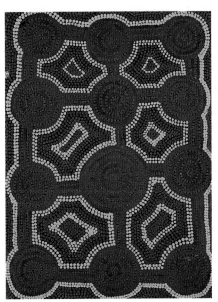

62
George Tjungurrayi
Tingari Cycle 1988
Acrylic on canvas 150 x 120cm
(59 x 47¼in)
Private collection

63
George Tjungurrayi
Tingari Cycle 1984
Acrylic on canvas 40 x 30cm
(15¾ x 11¾in)
Private collection

George Yapa Tjangala
(born c.1950)

Also known as *George Yapa Yapa Tjangala*

George Yapa was born of the Pintupi tribe near Jupiter Well and Kiwirrkura. He is the son of Anatjari Tjampitjinpa. His first experience of painting was in the mid-1970s, working on paintings by Uta Uta Tjangala and Charlie Tarawa, and he started painting in his own right in 1980. The Dreamings he paints include Eagle Hawk and Tingari stories from the area around Kirrpinga and Wala Wala.

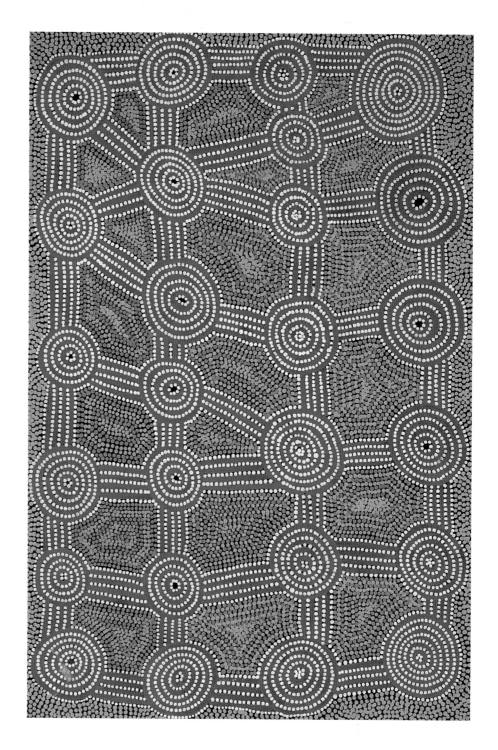

64
George Yapa Tjangala
Tingari Cycle 1983
Acrylic on canvas 91 x 61cm (35¾ x 24in)
Private collection

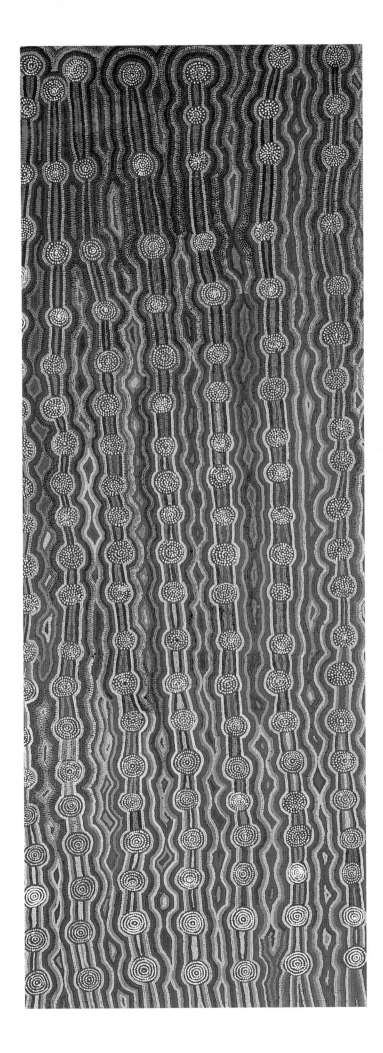

Ginger Tjakamarra
(born c. 1945)

Ginger Tjakamarra was born of the Pintupi tribe. He began painting for Papunya Tula Artists in the early 1980s, and his wife, Wingie Napaltjarri, whose work is also featured in this book, often assists in his paintings. Collections that own his work include the National Gallery of Victoria.

65
Ginger Tjakamarra
(assisted by Wingie Napaltjarri)
Tingari Cycle 1989
Acrylic on canvas 312 x 132cm (122¾ x 52in)
Private collection

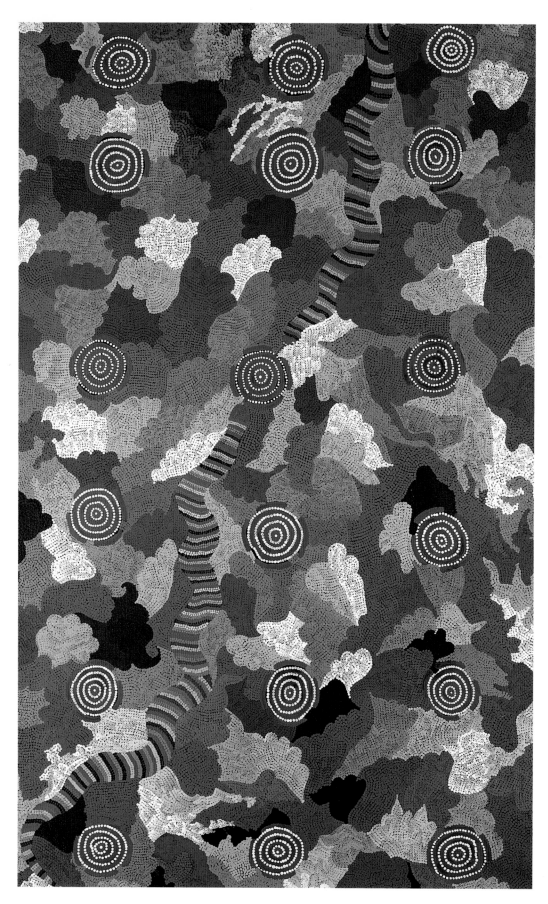

66
Ginger Tjakamarra
(assisted by Wingie Napaltjarri)
Rainbow Serpent Dreaming 1989
Acrylic on canvas 212 x 130cm (83½ x 51¼in)
Private collection

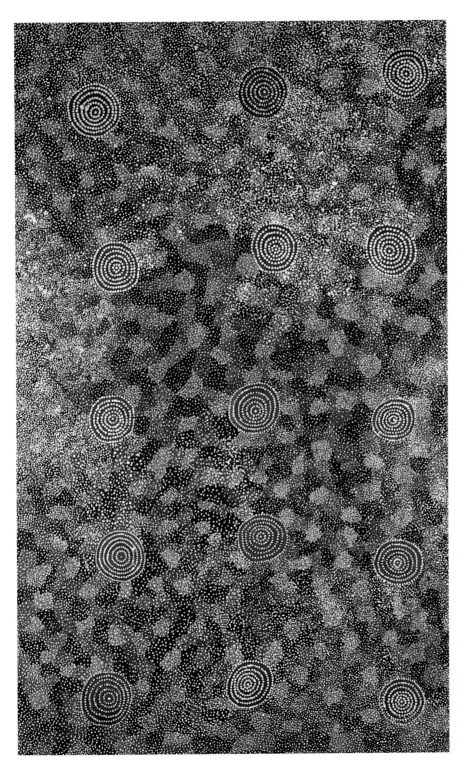

Gladys Napanangka was born near Haasts Bluff of the Luritja tribe. Her first husband was Old Walter Tjampitjinpa, who was one of the original painting group at Papunya. After his death she married another member of the original painting group, Johnny Warangkula. She paints Dreamings of Witchetty Grub and other Bush Tucker stories. She is one of the senior women in the Papunya community.

67
Gladys Napanangka
Milky Way Dreaming 1989
Acrylic on canvas 210 x 130cm
(82¾ x 51¼in)
Private collection

68 (overleaf)
Gladys Napanangka
Bush Tucker Dreaming 1991
Acrylic on canvas 125 x 85cm (49¼ x 33½in)
Private collection

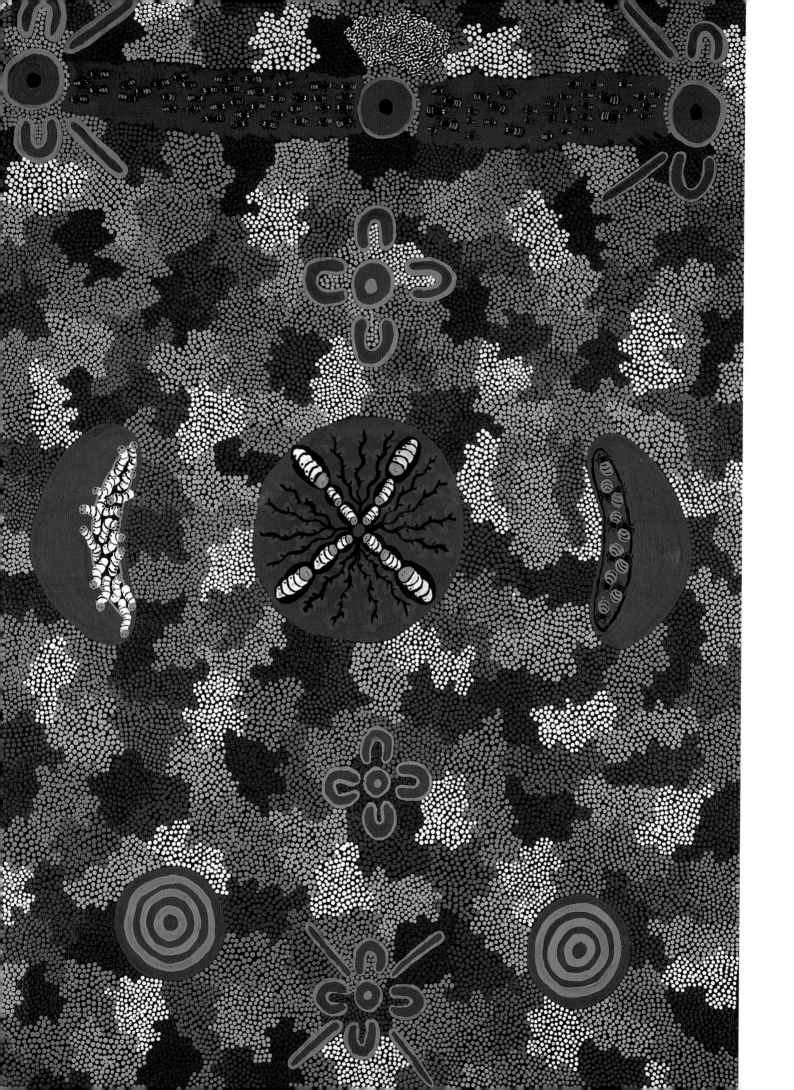

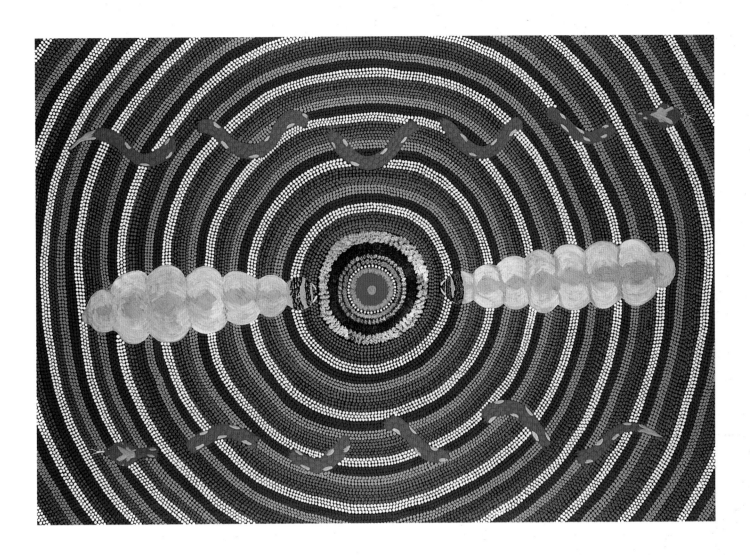

Goodwin Tjapaltjarri was born of the Pintupi tribe at Haasts Bluff. He started painting in the early 1980s, with instruction on technique and on the Dreamings he was allowed to depict from Charlie Egalie and Turkey Tolson. He paints Dreamings of Dingo and Rock Wallaby from the area around Nyuuman.

69
Goodwin Tjapaltjarri
Witchetty Grub and Snake Dreaming
1989
Acrylic on canvas 128 x 185cm
(50½ x 72¾ in)
Private collection

Harper Morris Tjungurrayi
(born *c.*1930)

Harper Morris has been painting since the early 1970s. He is of the Alyawarre tribe and is a brother of the well known artist from Utopia, Emily Kame Kngwarreye. He often paints the Emu Dreamings associated with the Anangra waterhole near Utopia. Collections that own his work include the National Gallery of Victoria.

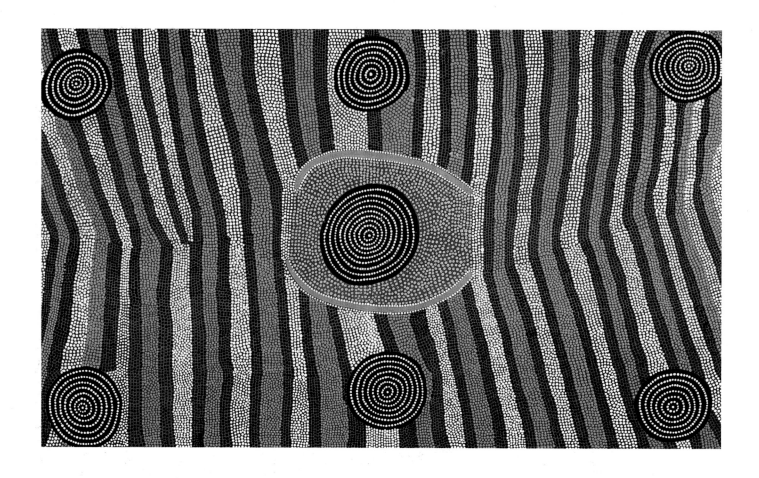

70
Harper Morris Tjungurrayi
Untitled 1987
Acrylic on canvas 90 x 150cm (35½ x 59in)
Courtesy Art Gallery of South Australia

Jack Kunti Kunti Tjampitjinpa
(c.1930-90)

Jack Kunti Kunti was born west of Kintore of the Pintupi tribe. He began painting for Papunya Tula Artists in the early 1980s. Collections that own his work include the National Gallery of Australia.

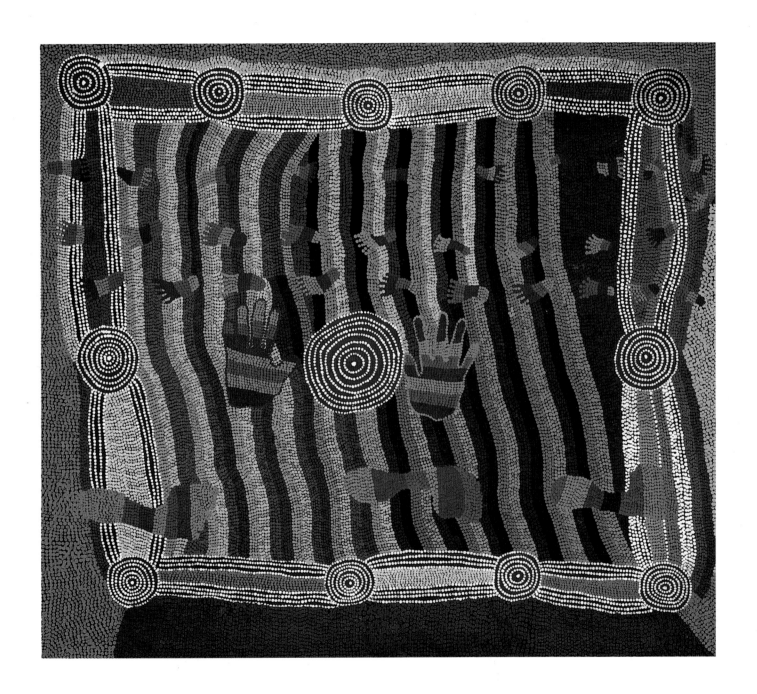

71
Jack Kunti Kunti Tjampitjinpa
Dreaming at the Site Lupuinga 1985
Acrylic on canvas 118 x 131cm
(46½ x 51½in)
Courtesy Museum and Art Gallery of the Northern Territory

John John Bennett Tjapangati

(date of birth unknown)

John John Bennett was born of the Pintupi tribe near Mukulurru, north of the Docker River, which, according to Aboriginal mythology, is the southernmost place visited by Tingari people. He began painting for Papunya Tula in the early 1980s. Collections that own his work include Holmes à Court.

72
John John Bennett Tjapangati
Tingari Cycle 1988
Acrylic on canvas 151 x 122cm (59½ x 48in)
Private collection

John Roger Tjakamarra
(date of birth unknown)

John Roger Tjakamarra is an occasional
painter for Papunya Tula. No further
biographical information was available for
him.

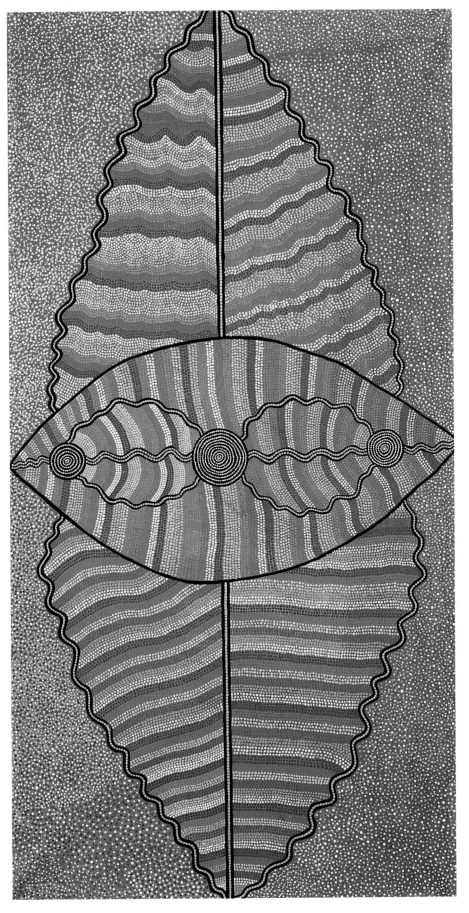

73
John Roger Tjakamarra
Sacred Cave Dreaming 1989
Acrylic on canvas 240 x 124cm
(94½ x 48¾in)
Private collection

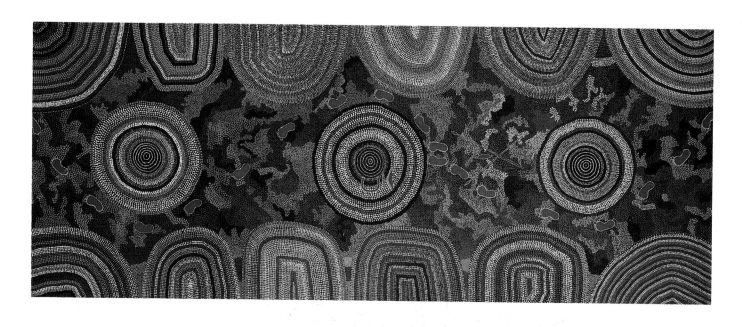

74
John Roger Tjakamarra
Jakamarra's Hunting 1991
Acrylic on canvas 124 x 320cm (48¾ x 126in)
Private collection

John Tjakamarra was born north of Kiwirrkura of the Pintupi tribe. He was one of the original painting group at Papunya, and he depicts Dreamings of Tingari stories. Collections that own his work include the Burke Museum, University of Washington, Seattle.

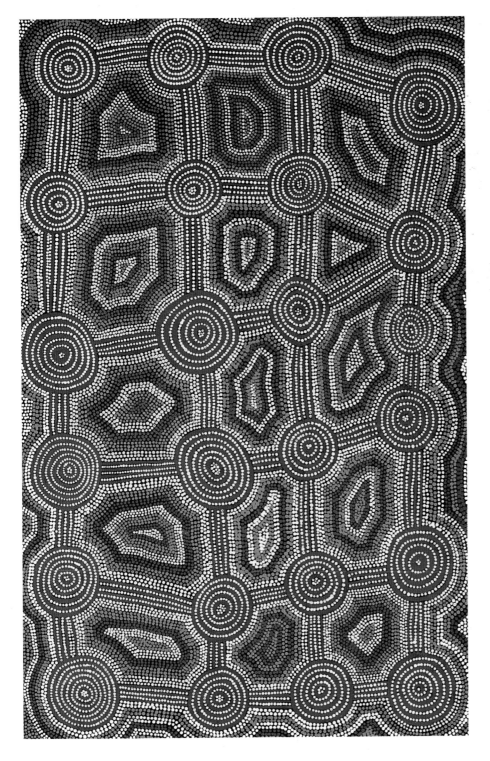

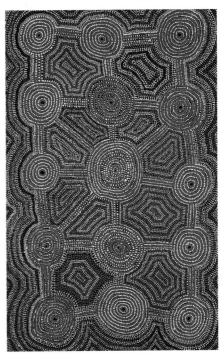

75
John Tjakamarra
Tingari Cycle 1983
Acrylic on canvas 121 x 77cm (47¾ x 30¼in)
Private collection

76
John Tjakamarra
Tingari Cycle 1983
Acrylic on canvas 122 x 79cm (48 x 31in)
Private collection

Johnny Scobie Tjapanangka
(born c.1935)

Johnny Scobie was born of the Pintupi tribe in the Kintore Ranges. He began to paint in the late 1970s, and most frequently paints the Wedgetail Eagle Dreaming. He is married to the artist Narpula Scobie, whose work is also featured in this book.

77
Johnny Scobie Tjapanangka
Untitled 1988
Acrylic on canvas 244 x 182cm
(96 x 71¾in)
Private collection

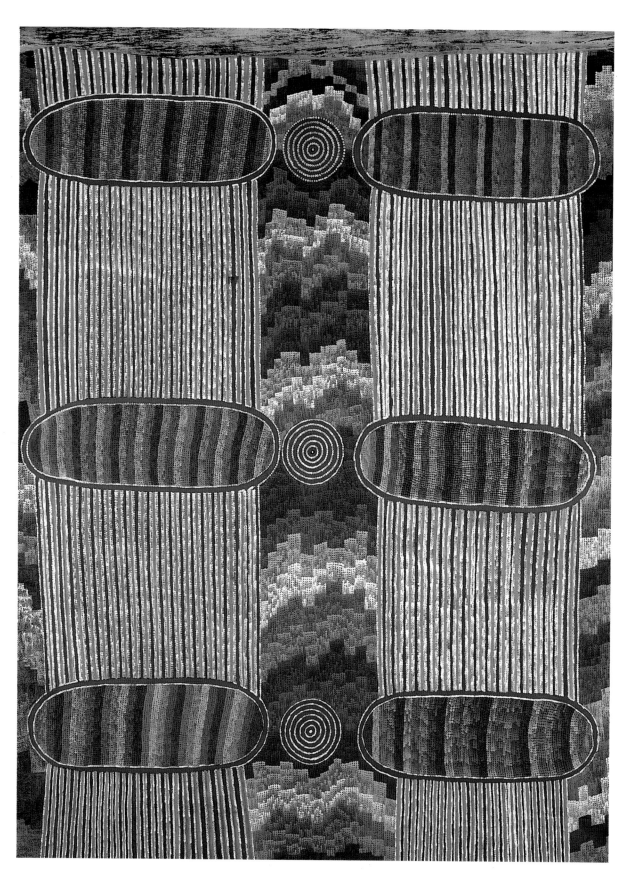

78
Johnny Warangkula Tjupurrula
Secret Man's Dreaming 1988
Acrylic on canvas 143 x 127cm
(56¼ x 50in)
Private collection

Johnny Warangkula was born of the Luritja tribe at Minjilpirri, north-west of Illpili, and his brother was the painter Dick Pantimas Tjupurrula. He was one of the original group of painting men at Papunya in 1971. He quickly developed his own distinctive style of painting, and the complexity of his technique of dotting and overdotting makes him one of the most important of all the desert painters. He remained a major force in the painting movement throughout the 1980s. He is married to the painter Gladys Napanangka. The Dreamings he paints include Water, Yam, Fire and Egret. Collections that own his work include the National Gallery of Australia and the National Gallery of Victoria.

Johnny Warangkula Tjupurrula
Bush Potato Dreaming 1975
Acrylic on board 40 x 50cm (15¾ x 19¾in)
Private collection

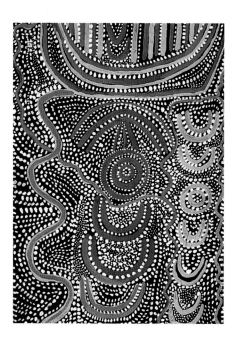

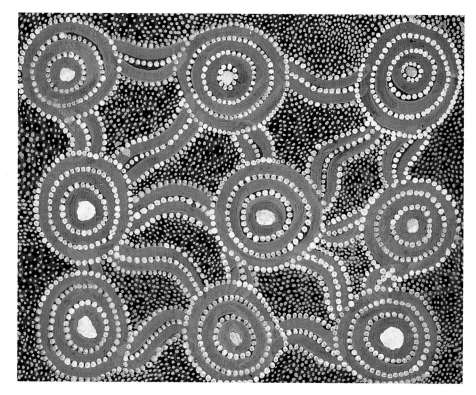

79
Johnny Warangkula Tjupurrula
Three Men Dreaming 1971
Paint on board 42 x 30cm
(16½ x 11¾in)
Private collection

81
Johnny Warangkula Tjupurrula
Kangaroo and Egret Dreaming 1975
Paint on board 34 x 45cm
(13½ x 17¾in)
Private collection

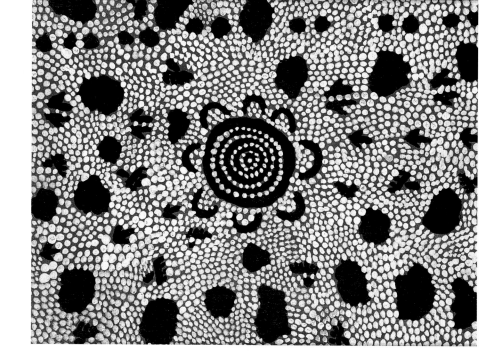

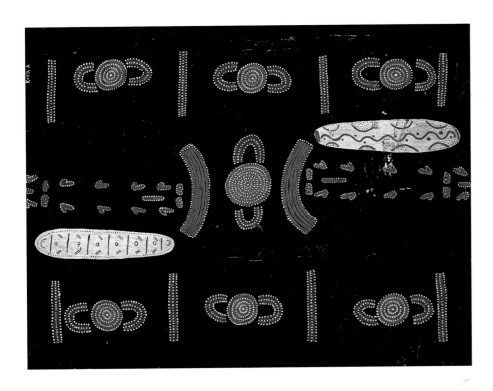

82
Kaapa Tjampitjinpa
Untitled 1971
Paint on board 91.5 x 122cm
(36 x 48in)
Private collection

Kaapa Tjampitjinpa was born at Napperby of the Anmatyerre/Arrente tribe. He played a leading role within the original group of painters at Papunya, who chose him to paint the now famous mural on the school wall at Papunya because of his mastery of brushwork. He shared the first prize in the 1971 Caltex Golden Jubilee Art Award, the first award publicly to recognise the work of Papunya Tula artists. Plate 83 (below) was also included in this exhibition. He was the first Chairman of the Papunya Tula Artists Company. The Dreamings he most frequently painted include Black Goanna, Yam, Witchetty Grub, Shield, Owl, Pelican, Emu and Snake. Collections that own his work include the National Gallery of Australia and the National Museum of Australia.

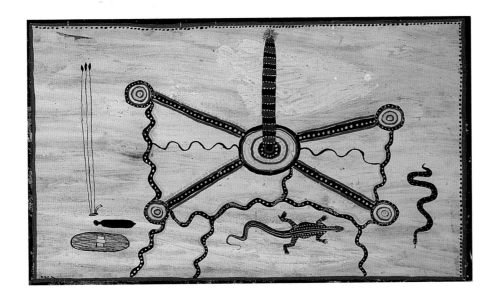

83
Kaapa Tjampitjinpa
Goanna Corroboree at Mirkantji 1971
Paint on board 32 x 55cm (12½ x 21¾in)
Private collection

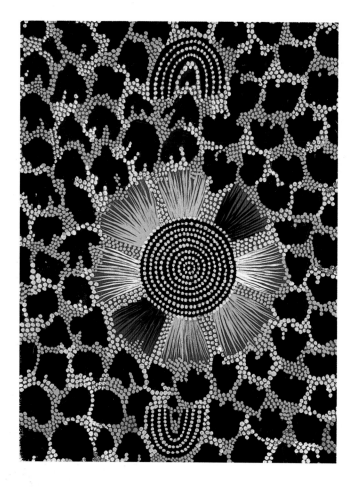

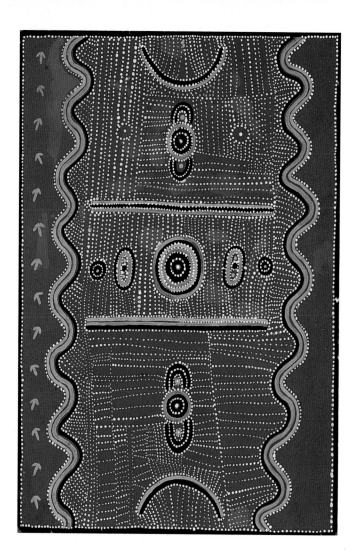

84
Kaapa Tjampitjinpa
Blue Tongue Lizard at Warlukurlangu 1978
Paint on board 61 x 46cm (24 x 18in)
Private collection

This dynamic work shows the Dreaming
site of Warlukurlangu, where the Blue
Tongue Lizard started fire by blowing.
The fire emanates from the centre of the
painting; the black areas are burnt grasses
and the 'U' shapes represent male spirit
figures. Fire is associated with the cycle of
renewal; some fires are caused by
lightning and followed by rain, thus
forming part of the cycle of
replenishment and renewal. The artist
uses pinks, yellows and white on a red
ochre ground in an unusually strong and
expressive composition.

85
Kaapa Tjampitjinpa
Emu Dreaming 1971
Paint on board 61 x 45cm (24 x 17¾in)
Private collection

86
Kaapa Tjampitjinpa
Goanna Dreaming 1973
Paint on paper 60 x 40cm (23½ x 15¾in)
Private collection

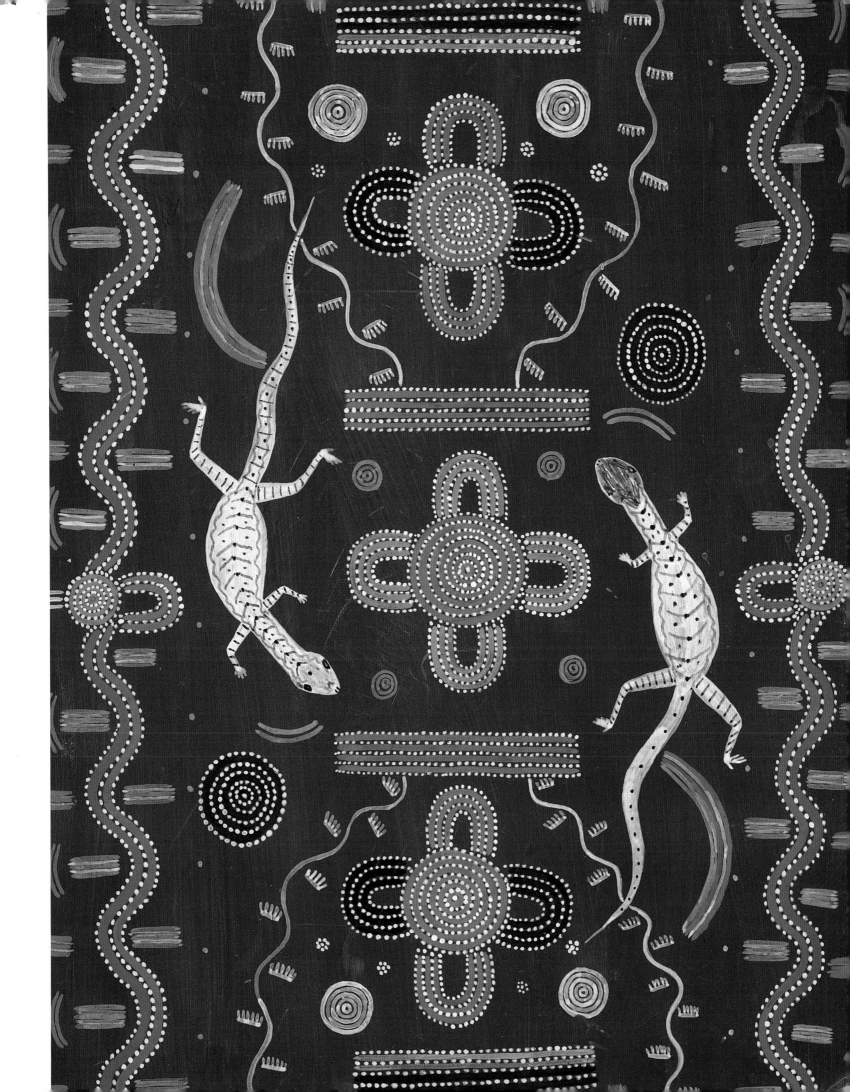

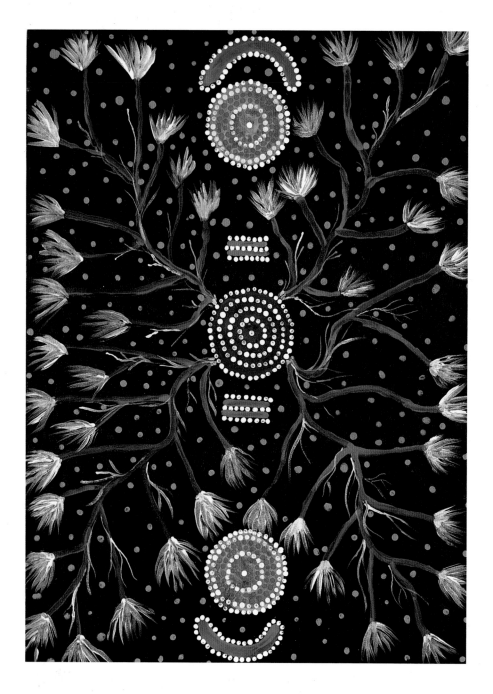

87
Kaapa Tjampitjinpa
Bush Potato Dreaming 1979
Acrylic on canvas 65 x 46cm (25½ x 18in)
Private collection

88
Kaapa Tjampitjinpa
Mount Wedge Rain Dreaming 1984
Acrylic on canvas 152 x 91cm
(60 x 35¾in)
Private collection

This painting is concerned with water
rituals and relates specifically to a rain-
making site near Mount Wedge, south-
west of Napperby Station. In it the artist
is expressing the benefits that result from
rain in the desert climate. The artist has
chosen an image which is strongly
centered with intersecting diagonal lines;
straight and curving lines represent other
significant rain-making sites. The use of
the colour blue refers to water.

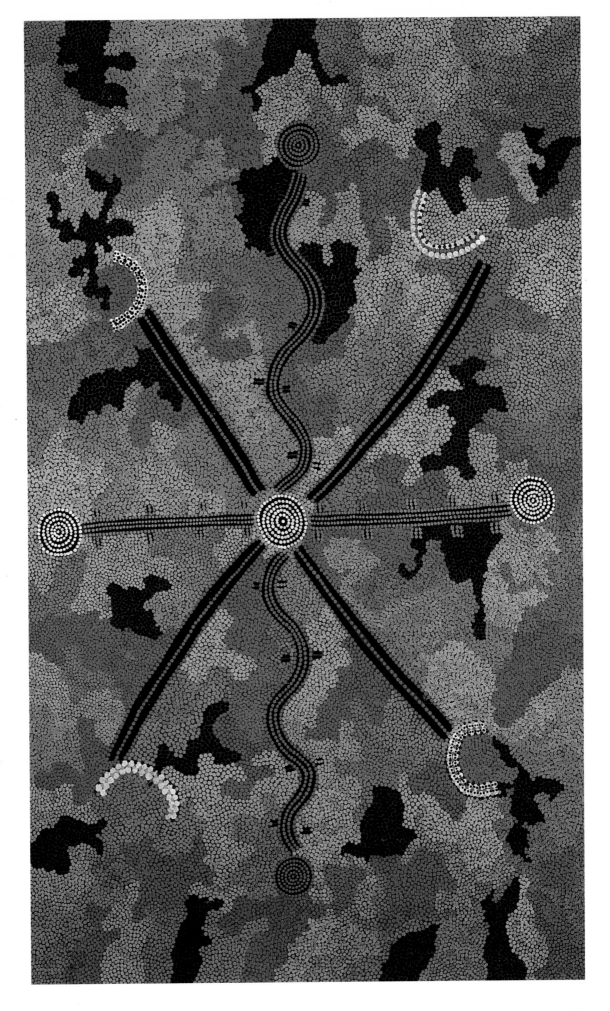

Keith Kaapa Tjangala
(born 1962)

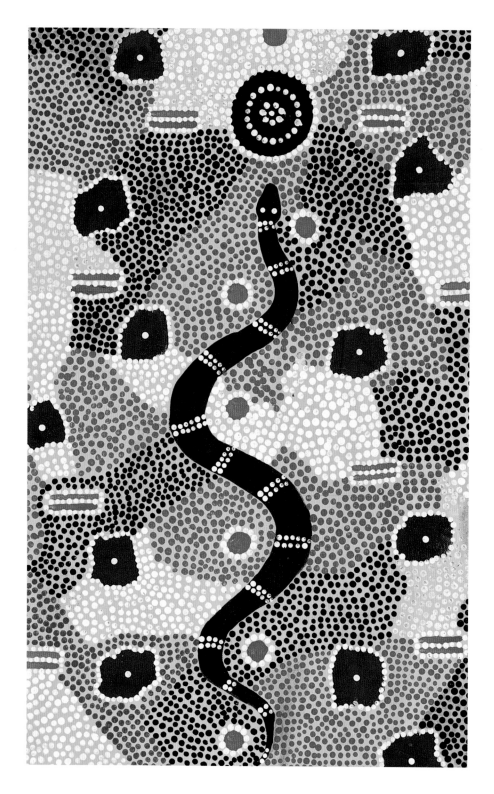

Keith Kaapa was born of the Warlpiri tribe. The Dreaming he most frequently depicts in his paintings is the Witchetty Grub Dreaming.

89
Keith Kaapa Tjangala
Snake Dreaming 1989
Acrylic on canvas 90 x 37cm
(35½ x 14½in)
Private collection

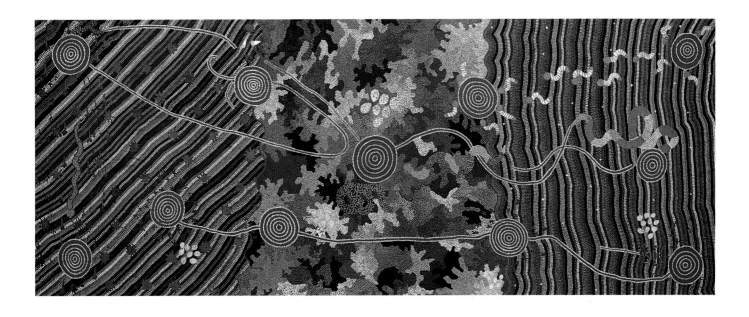

Kenny Tjakamarra was born of the
Anmatyerre tribe north of Haasts Bluff.
He paints Snake and Two Women
Dreamings, and also the Perentie
Dreaming story, which runs from Kintore
through Haasts Bluff.

90
Kenny Tjakamarra
Untitled 1988
Acrylic on canvas 119 x 394cm
(46¾ x 155in)
Private collection

Linda Syddick Jungkata Napaltjarri
(born 1941)

Also known as *Linda Sims Napaltjarri*

Linda Syddick was born at Jigalong of a Pintupi mother and a Pitjantjatjara father. In 1943 her father was killed in a spearing, and she was raised by her uncle Shorty Lungkarda, who taught her to paint. Linda Syddick is a deeply religious woman and her paintings reflect both her extensive knowledge of the Dreaming and her Christian beliefs, a rare combination amongst the artists of the Western Desert. She paints Tingari Dreamings, and is also well known for her interpretation of the modern film character 'ET'.

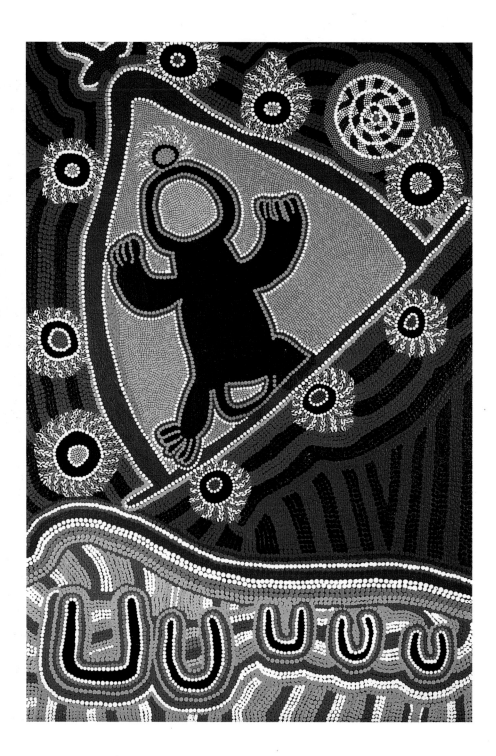

91
Linda Syddick Jungkata Napaltjarri
ET Returning Home 1994
Acrylic on canvas 91 x 60cm
(35¾ x 23½in)
Courtesy Museum and Art Gallery of the Northern Territory

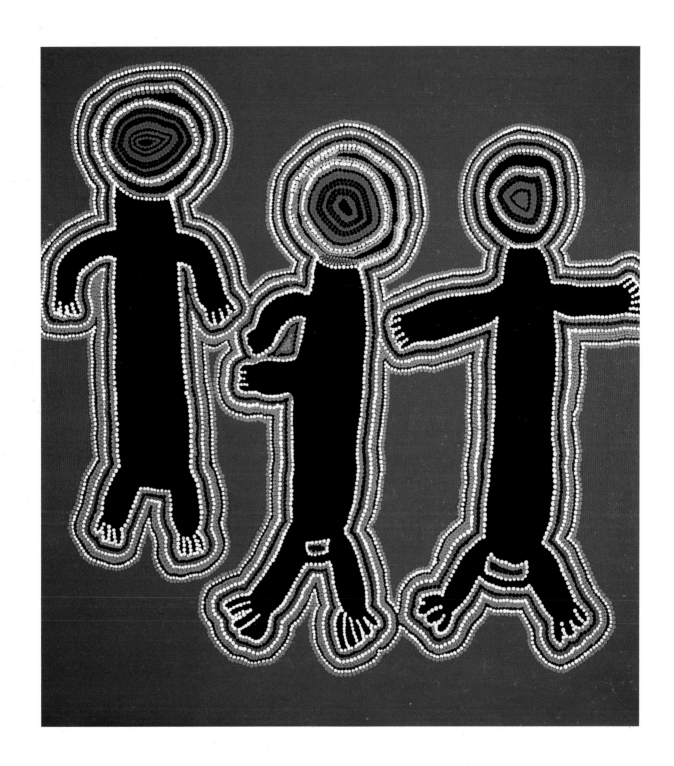

92
Linda Syddick Jungkata Napaltjarri
ET and Friends 1992
Acrylic on canvas 81 x 75cm
(32 x 29½in)
Courtesy Museum and Art Gallery of
the Northern Territory

Long Jack Phillipus Tjakamarra
(born c.1932)

Long Jack Phillipus was born at Kalimpinpa, north-east of Kintore. His tribal affiliation is Warlpiri/Luritja. He has been part of the painting movement since its beginning in the early 1970s and has painted intermittently since then, winning several awards for his work in the early 1980s. The Dreamings he paints include Hare, Wallaby, Kingfisher, Snake and Dingo. Collections that own his work include the National Gallery of Victoria.

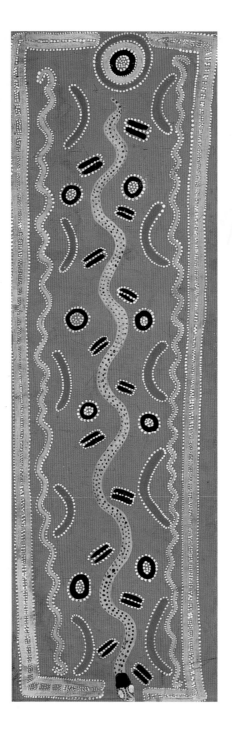 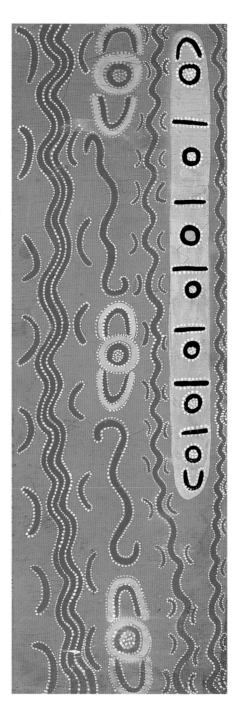

This is a rare example of a painting carried out on both sides of a board.

93
Long Jack Phillipus Tjakamarra
Snake Dreaming 1971
Paint on board 92 x 31cm
(36¼ x 12¼in)
Private collection

94
Long Jack Phillipus Tjakamarra
Snake Dreaming 1971
Paint on board 92 x 31cm
(36¼ x 12¼in)
Private collection

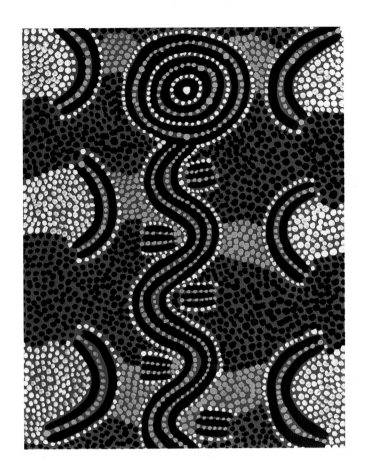

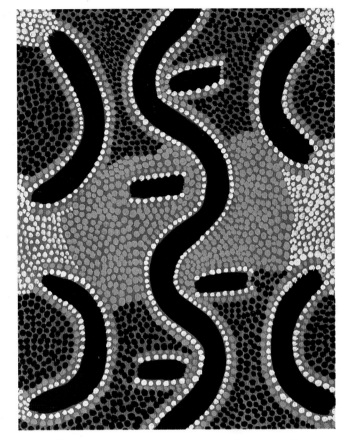

95
Long Jack Phillipus Tjakamarra
Talurarra 1976
Acrylic on canvas 61 x 46cm (24 x 18in)
Private collection

Talurarra is a large waterhole site located
in the Western Desert region to the west
of Alice Springs. A large carpet snake
travelled to this site from the East. As it
travelled its trail forged a water tract and
it provoked the clouds to form and the
rain to fall. The story of this mythological
being is re-enacted in rainfall ceremonies,
and also in the legends telling how the
features of the land were formed.

96
Long Jack Phillipus Tjakamarra
The Serpent at Talurarra 1976
Acrylic on canvas 61 x 51cm (24 x 20in)
Private collection

The story for this painting is the same as
that of the previous painting, *Talurarra*.

Lynette Corby Nungurrayi

(date of birth unknown)

Lynette Corby Nungurrayi is an occasional painter for Papunya Tula. No further biographical information was available for her.

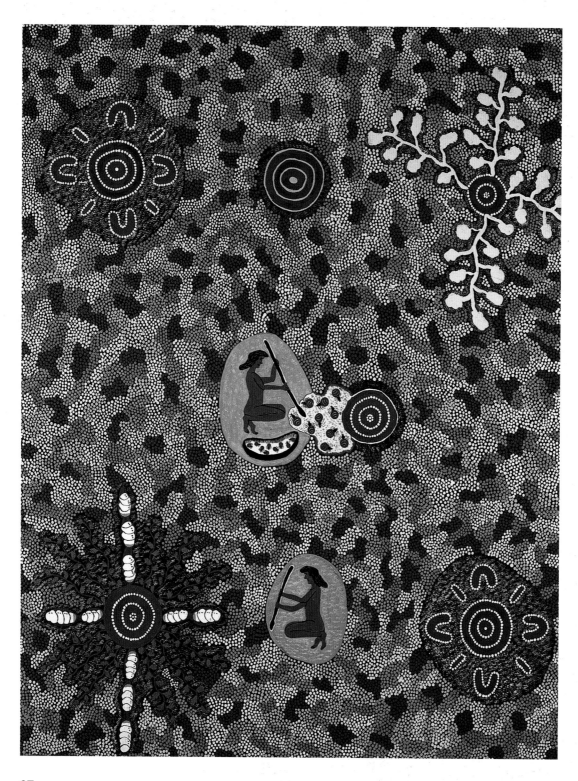

97
Lynette Corby Nungurrayi
Witchetty Grub Dreaming 1991
Acrylic on canvas 122 x 93cm (48 x 36½in)
Private collection

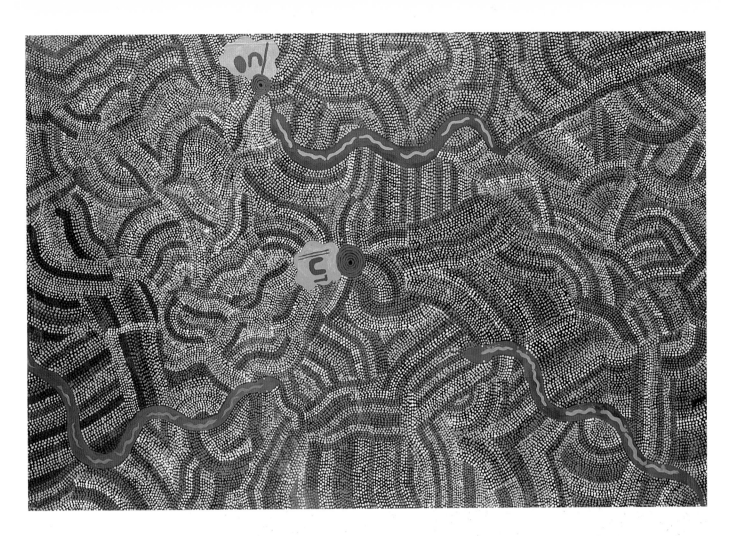

98
Lynette Corby Nungurrayi
Snake Dreaming 1990
Acrylic on canvas 127 x 189cm (50 x 74½in)
Private collection

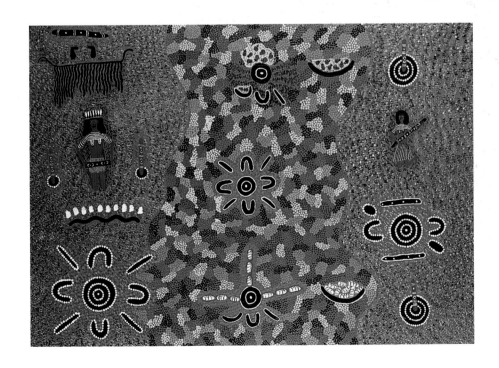

99
Lynette Corby Nungurrayi
Woman's Dreaming 1991
Acrylic on canvas 89 x 125cm
(35 x 49¼in)
Private collection

Maringka Nangala

(date of birth unknown)

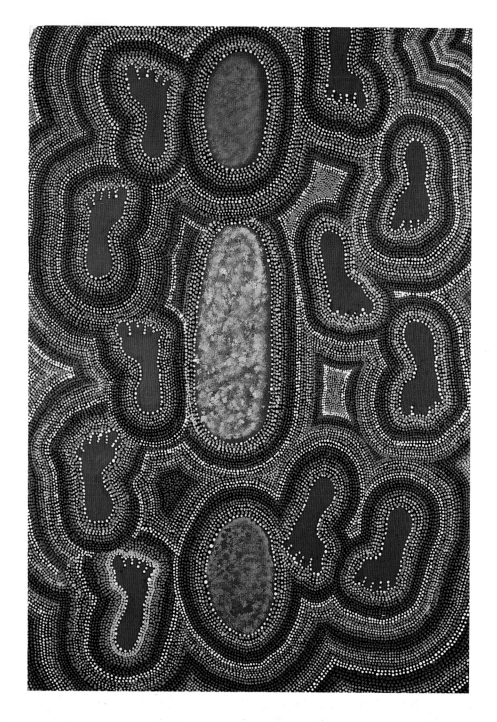

Maringka Nangala is an occasional painter for Papunya Tula. No further biographical information was available for her.

100
Maringka Nangala
Men's Dreaming 1991
Acrylic on canvas 126 x 87cm
(49½ x 34¼in)
Private collection

Mary Dixon Nungurrayi
(born 1960)

Mary Dixon was born of the Warlpiri tribe near Town Bore Creek. She is the wife of the artist Colin Dixon, who occasionally assists on her paintings. Mary started painting in the mid-1980s, and she depicts Dreamings of Witchetty Grub, and a Milky Way Dreaming concerning the origins of Venus, Orion and the Pleieades.

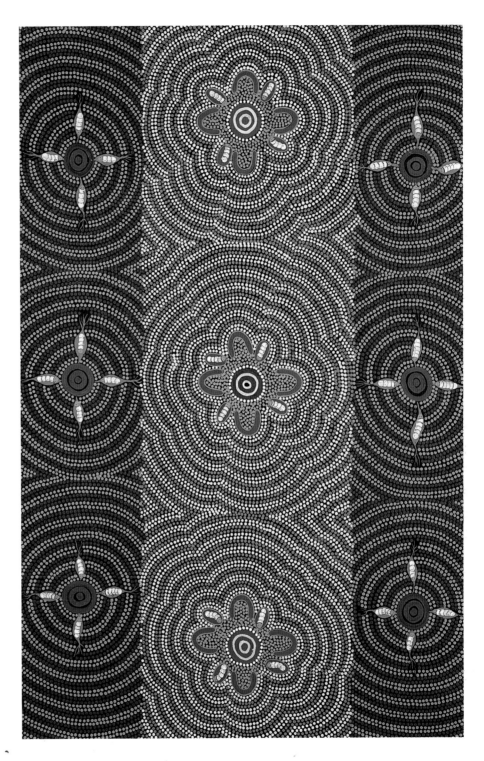

101
Mary Dixon Nungurrayi
(assisted by Colin Dixon Tjapanangka)
Witchetty Grub Dreaming 1988
Acrylic on canvas 130 x 85cm (51¼ x 33½in)
Private collection

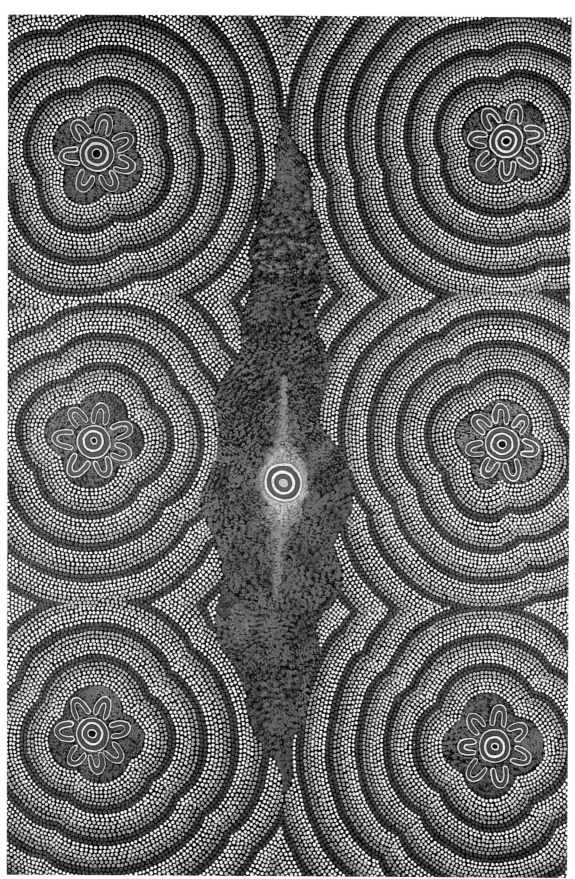

102

Mary Dixon Nungurrayi
(assisted by Colin Dixon Tjapanangka)
Milky Way Dreaming 1989
Acrylic on canvas 180 x 120cm (70¾ x 47¼in)
Private collection

Maxie Tjampitjinpa was born of the Warlpiri tribe at Haasts Bluff. He started painting in 1980 with Mick Wallankarri as his tutor, and paints Dreamings of Bush Fire, Flying Ant and Women. He has developed a very particular style of background work, which many have copied but few have mastered. In 1984 Maxie Tjampitjinpa won the Northern Territory Art Award. Collections that own his work include the National Gallery of Australia and the National Gallery of Victoria.

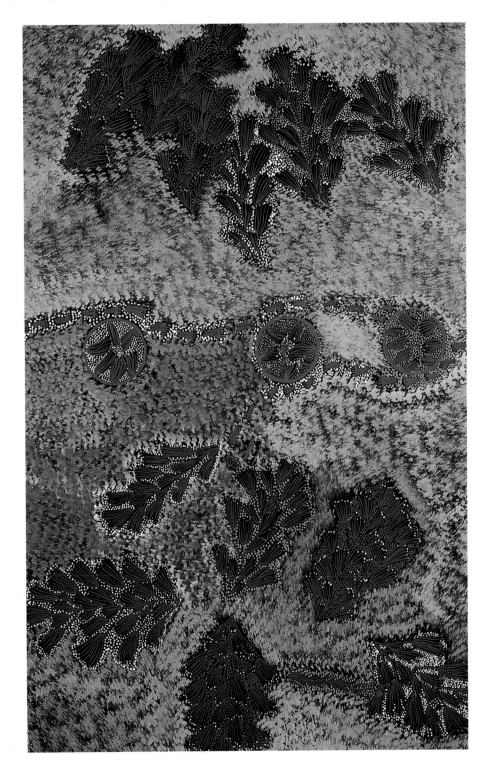

103
Maxie Tjampitjinpa
Bush Fire Dreaming 1995
Acrylic on canvas 90 x 61cm
(35½ x 24in)
Private collection

104
Maxie Tjampitjinpa
Bush Tucker Dreaming 1991
Acrylic on canvas 130 x 84cm
(51¼ x 33in)
Private collection

Michael Nelson Tjakamarra
(born *c.* 1949)

Michael Nelson was born of the Warlpiri tribe at Pikilyi, west of Yuendumu. He started painting at Papunya in 1983, and is now one of the best-known Aboriginal artists. He is a prolific artist, and paints in a very individual and distinctive style, usually depicting Dreamings of Possum, Snake, Two Kangaroos, Yam and Flying Ant. In 1984 he won the National Aboriginal Art Award, and in 1987 one of his very large paintings was installed in the foyer of the Sydney Opera House. At the Royal opening of the new National Parliament in 1988 he was presented to Her Majesty the Queen as the designer of the 200-metre-square mosaic in front of the new Parliament building. In 1989 he participated in the BMW Art Car Project hand painting one of the cars, and in the same year he had his first one-man exhibition. In 1993 he received the Australia Medal for services to Aboriginal art, and an Artist's Fellowship from the Visual Arts Board, Australia Council. Collections that own his work include the National Gallery of Australia.

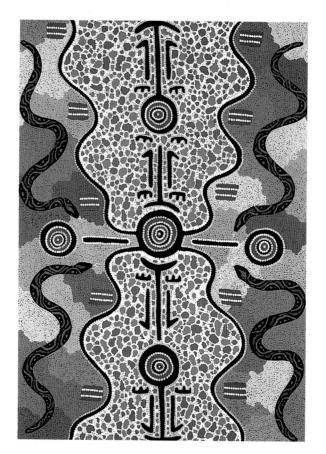

105
Michael Nelson Tjakamarra
Kangaroo and Snake Dreaming 1991
Acrylic on canvas 127 x 91cm (50 x 35¾in)
Private collection

107 (opposite)
Michael Nelson Tjakamarra
Snake and Kangaroo Dreaming 1991
Acrylic on canvas 120 x 90cm (47¼ x 35½in)
Private collection

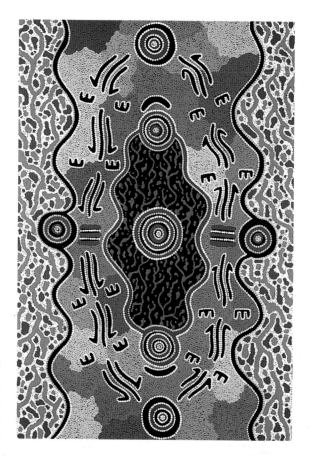

106
Michael Nelson Tjakamarra
Kangaroo Dreaming 1991
Acrylic on canvas 127 x 91cm (50 x 35¾in)
Private collection

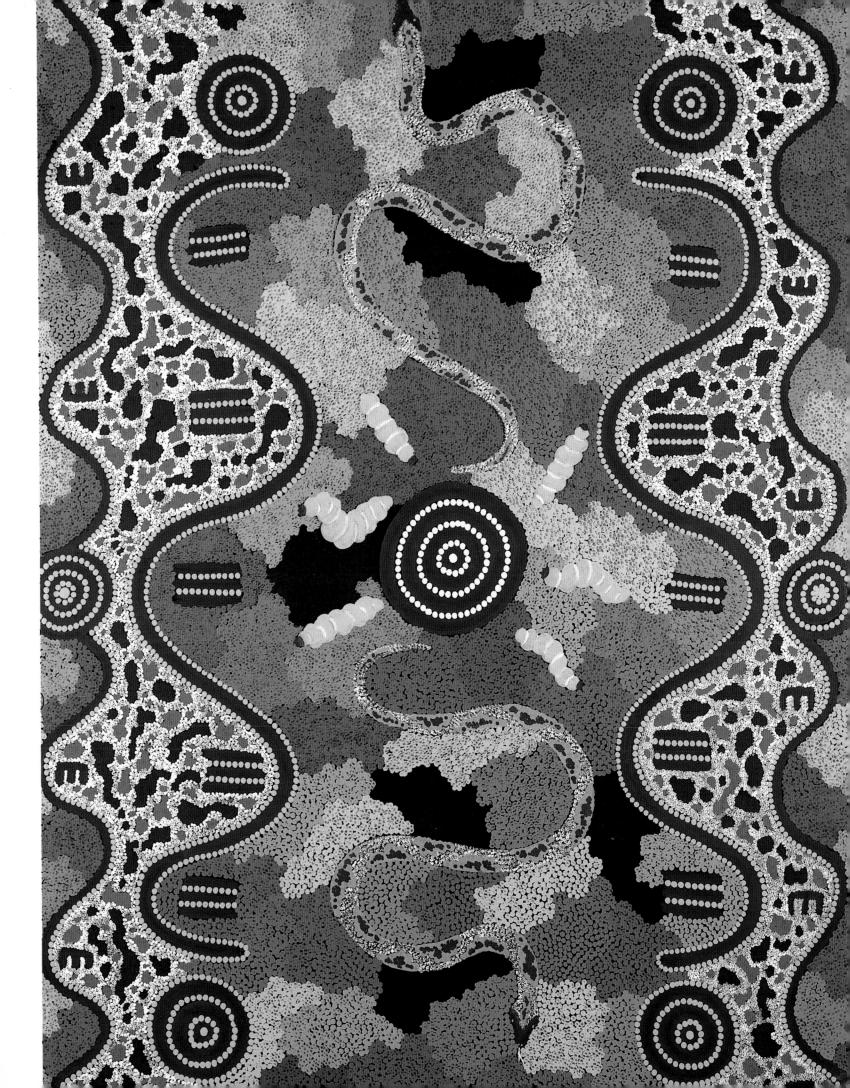

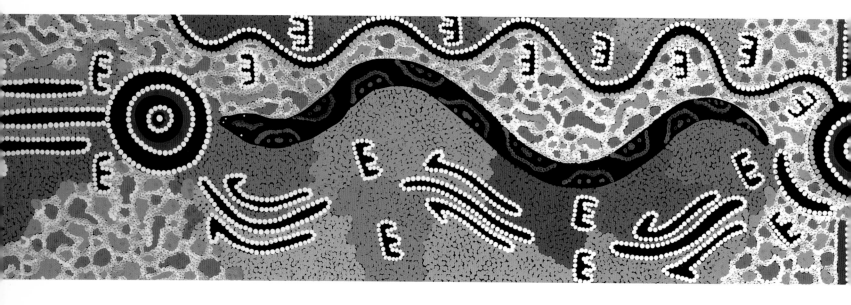

108
Michael Nelson Tjakamarra
Snake and Kangaroo Dreaming 1991
Acrylic on canvas 32 x 209cm (12½ x 82¼in)
Private collection

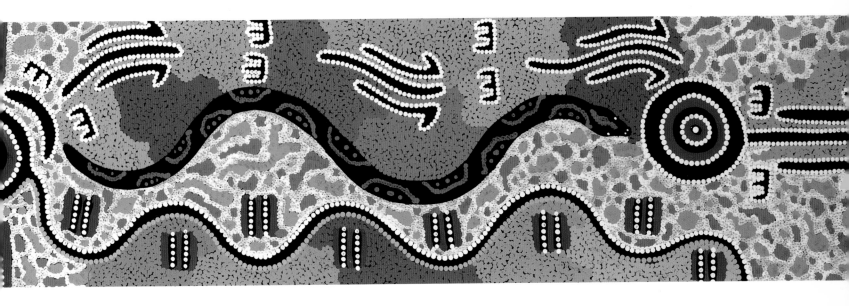

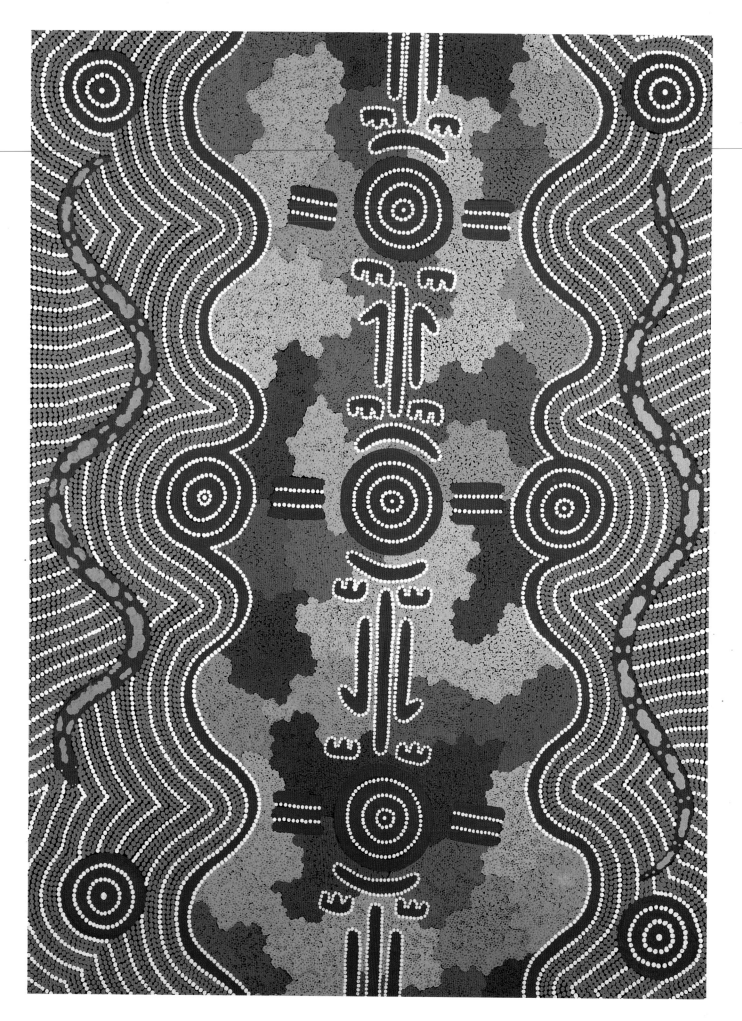

109 (opposite)
Michael Nelson Tjakamarra
Kangaroo Dreaming with Rainbow Serpent
1992
Acrylic on canvas 146 x 100cm (57½ x 39¼in)
Private collection

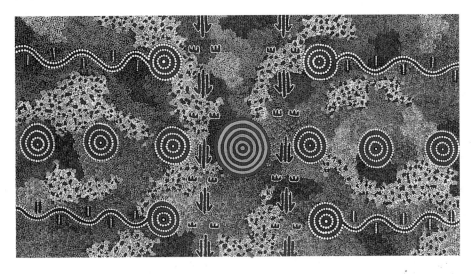

110
Michael Nelson Tjakamarra
Kangaroo Dreaming 1986
Acrylic on canvas 89 x 168cm (35 x 66¼in)
Private collection

111
Michael Nelson Tjakamarra
Yam and Kangaroo Dreaming 1987
Acrylic on canvas 152 x 122cm (60 x 48in)
Private collection

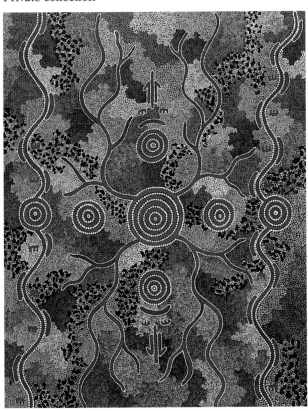

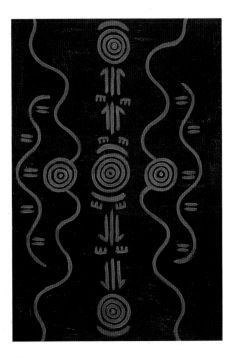

112
Michael Nelson Tjakamarra
Kangaroo and Water Dreaming 1989
Acrylic on canvas 90 x 60cm
(35½ x 23½in)
Private collection

This incomplete picture demonstrates how
the artists start their paintings.

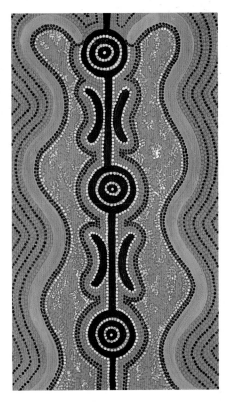

113
Michael Nelson Tjakamarra
Snake Dreaming 1983
Paint on board 69 x 39cm (27¼ x 15¼in)
Private collection

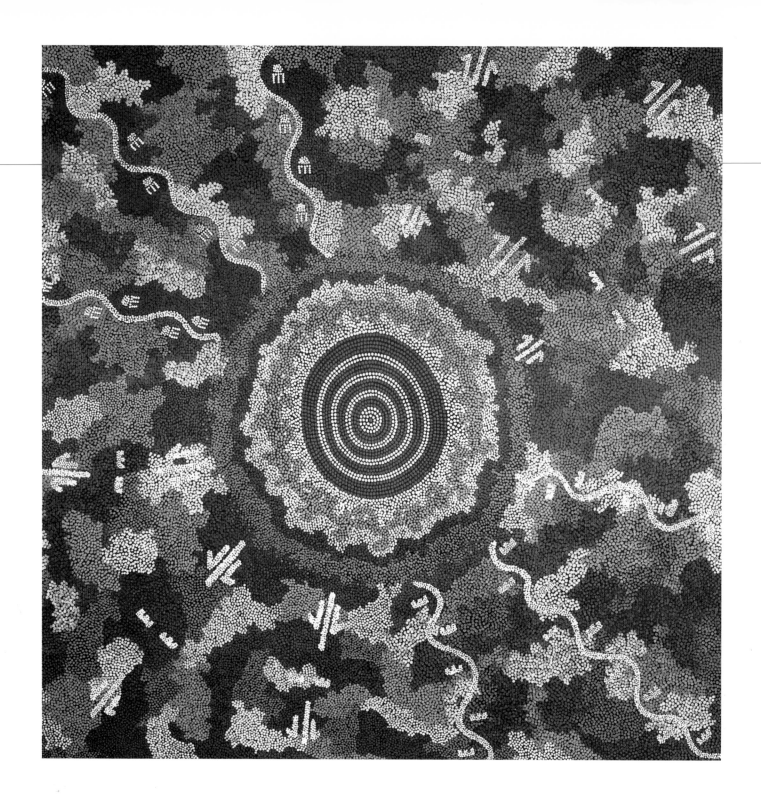

114
Michael Nelson Tjakamarra
Possum and Wallaby Dreaming 1985
Acrylic on canvas 140 x 140cm (55 x 55in)
Courtesy Parliament House Art Collection,
Canberra

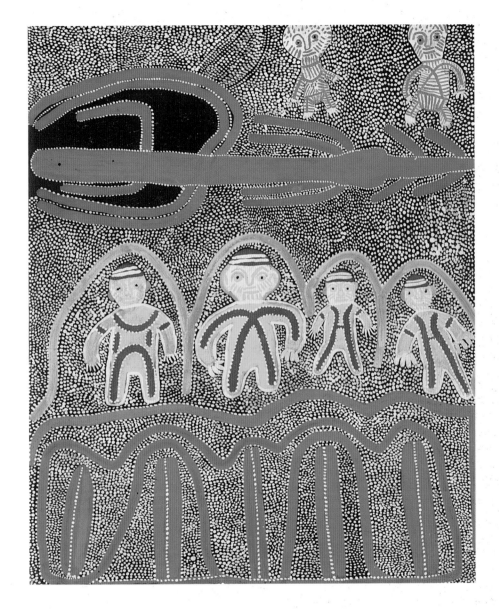

Mick Namarari was born of the Pintupi tribe at Marnpi, south-west of Mount Rennie. He was serving on the Papunya Council when the art teacher Geoffrey Bardon arrived at Papunya, and Mick Namarari soon expressed his interest in painting to Bardon. During the early 1970s, Bardon made a film about the artist entitled *Mick and the Moon*. Mick Namarari was a prolific painter in the 1980s and the Dreamings he painted include Kangaroo, Dingo, Water and Wild Bandicoot. Collections that own his work include the National Gallery of Australia and the National Gallery of Victoria.

115
Mick Namarari Tjapaltjarri
Medicine Story 1972
Acrylic on canvas 76 x 61cm
(30 x 24in)
Courtesy National Gallery of Victoria

This was the first canvas painted at Papunya. At the time, in the Pintupi camp, some of the young boys were succumbing to petrol-sniffing, and the artist felt anger at this threat to his culture. The four corroboree men in the centre are dancing for good medicine,

chanting to 'keep more kids alive'. Above the dancing men is a large plant spreading across the desert; above it are two kids alive. In the lower section, the roots of good bush tucker are pushing upwards through the soil.

116
Mick Namarari Tjapaltjarri
Untitled 1984
Acrylic on canvas 89 x 60cm (35 x 23½in)
Private collection

117
Mick Namarari Tjapaltjarri
Untitled 1984
Acrylic on canvas 89 x 60cm (35 x 23½in)
Private collection

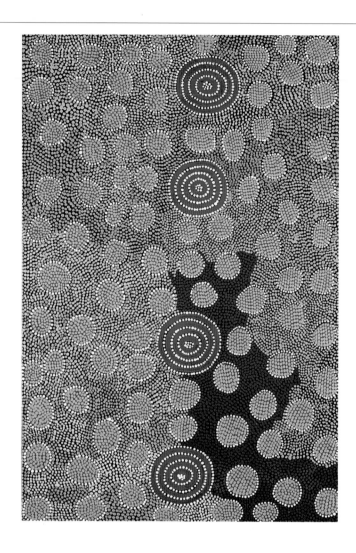

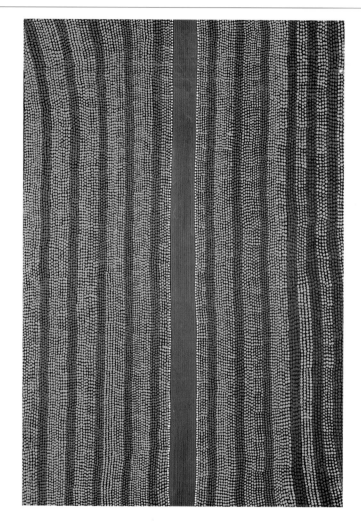

118
Mick Namarari Tjapaltjarri
Tingari Cycle 1984
Acrylic on canvas 69 x 55cm (27¼ x 21¾in)
Private collection

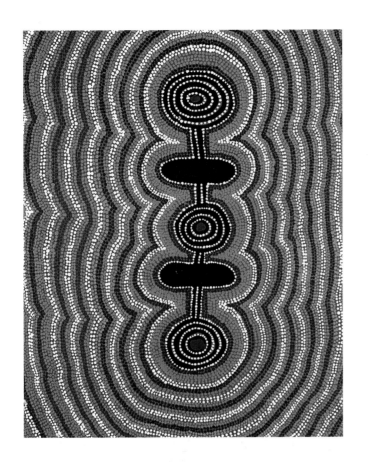

119
Mick Namarari Tjapaltjarri
Tingari Cycle 1984
Acrylic on canvas 61 x 51cm (24½ x 20in)
Private collection

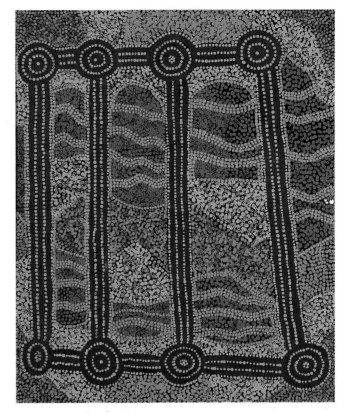

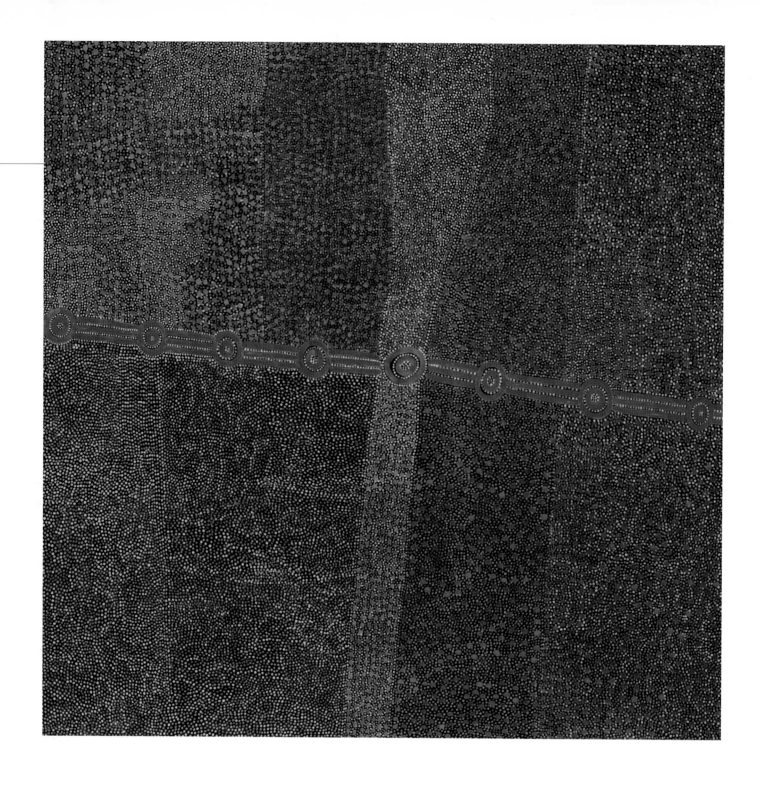

120
Mick Namarari Tjapaltjarri
My Country 1989
Acrylic on canvas 160 x 160cm (63 x 63in)
Private collection

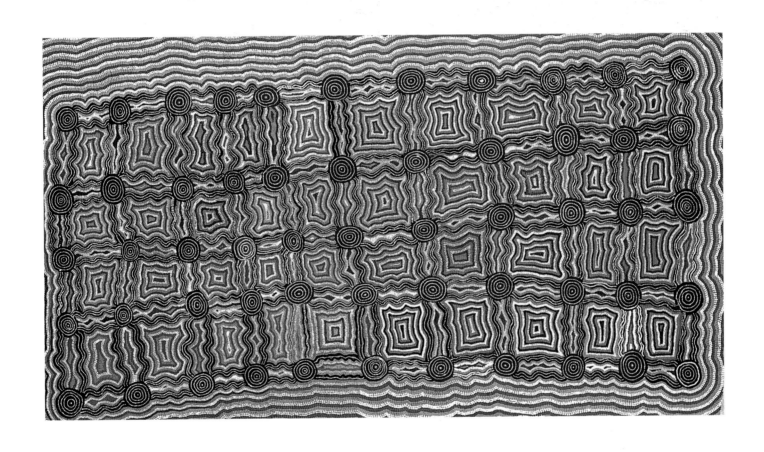

121
Mick Namarari Tjapaltjarri
Tingari Circle 1988
Acrylic on canvas 133 x 239cm (52¼ x 94in)
Private collection

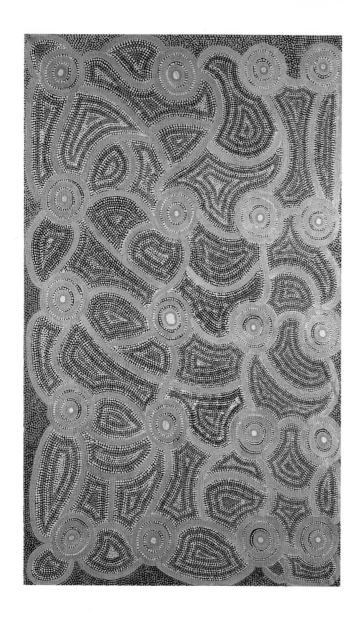

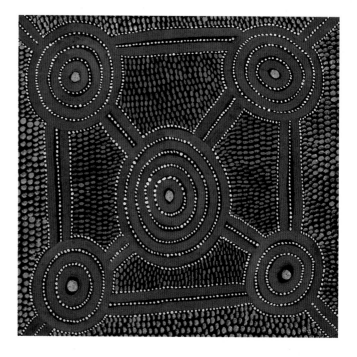

122
Mick Namarari Tjapaltjarri
Wild Bandicoot Dreaming 1988
Acrylic on canvas 150 x 90cm (59 x 35½in)
Private collection

123
Mick Namarari Tjapaltjarri
Nyunmarnu 1978
Paint on board 34 x 35cm (13½ x 13¾in)
Private collection

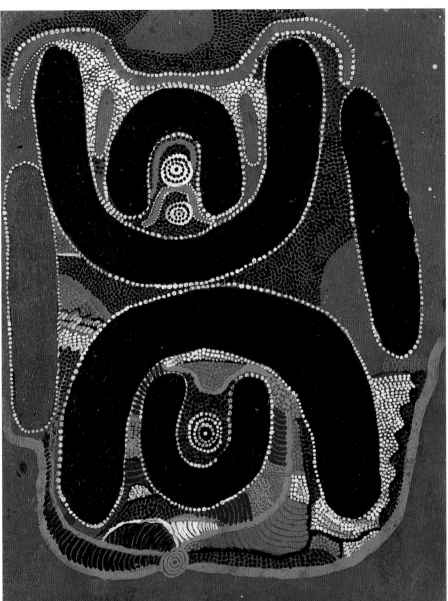

Mick Wallankarri Tjakamarra (born *c.*1900)

Also known as *Old Mick Tjakamarra*

Old Mick was born at Watikipinrri, west of Central Mount Wedge. He claims to be of the Aranda/Luritja tribe, but it is said that he was one of the last of the Kukatja tribe. Because of his senior ceremonial status, and his great knowledge of designs and stories, Old Mick became one of the most important of the early Papunya Tula artists. His work has been highly influential on other artists such as Maxie Tjampitjinpa and Don Tjungurrayi. The Dreamings he paints include Sugar Ant, Yam, Snake, Water and Women. His work was the first among the Western Desert painters to be collected by the National Gallery of Australia. Other collections that own his work include the Pacific Asia Museum, Los Angeles and the National Gallery of Victoria.

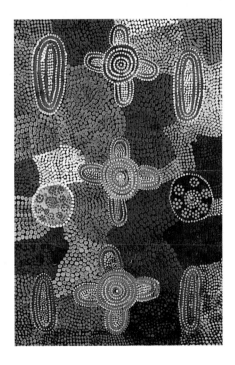

124
Mick Wallankarri Tjakamarra
Old Man's Dreaming on Death or Destiny 1971
Paint on board 62 x 46cm
(24½ x 18in)
Courtesy National Gallery of Victoria

The theme of this painting is an old man facing death. Traditionally, when old men or women of a tribe became frail and were unable to keep up with the rest of the group, they would be left behind with food, shelter and water. They very rarely used the food and water, but would lie down, practise a form of self-hypnosis and die. The large half-circles represent an old man lying on the ground; the smaller black arcs are the same old man sitting by a camp fire. At the bottom of the painting is a windbreak; the striated upper section represents bush food. The black *tjurunga* symbolises the spirit of the old man, alive and strong, and the red-ochre *tjurunga* the eternal symbol of the old man's totemic ancestor.

125
Mick Wallankarri Tjakamarra
Untitled 1976
Acrylic on canvas 124 x 82cm
(48¾ x 32¼in)
Private collection

Millie Napaltjarri
(date of birth unknown)

Millie Napaltjarri is an occasional painter for Papunya Tula. No further biographical information was available for her.

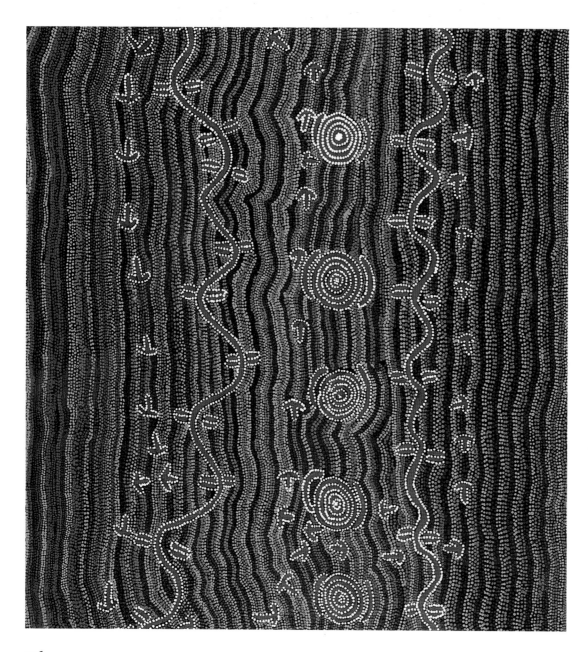

126
Millie Napaltjarri
Emu Dreaming 1991
Acrylic on canvas 121 x 91cm (47¾ x 35¾in)
Private collection

Narpula Scobie was born at Haasts Bluff of the Pintupi tribe, and is a younger sister of the artist Turkey Tolson. She is now married to Johnny Scobie, whose work is also featured in this book. Narpula Scobie started painting in the early 1980s and is now the only senior Pintupi woman still painting for Papunya Tula Artists. She paints the Bush Tucker Dreaming and other women's stories.

Narpula Scobie Napurrula
(born *c*.1958)

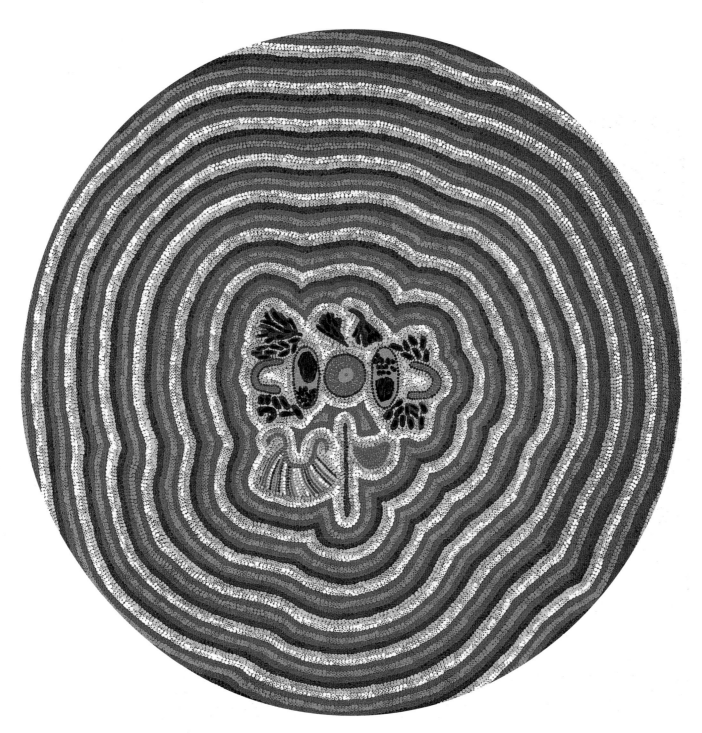

127
Narpula Scobie Napurrula
Woman's Dreaming Site 1990
Acrylic on canvas 89cm (35in) diameter
Courtesy Art Gallery of South Australia

Noel Thompson Tjapaltjarri

(date of birth unknown)

Noel Thompson Tjapaltjarri is an occasional painter for Papunya Tula. No further biographical information was available for him.

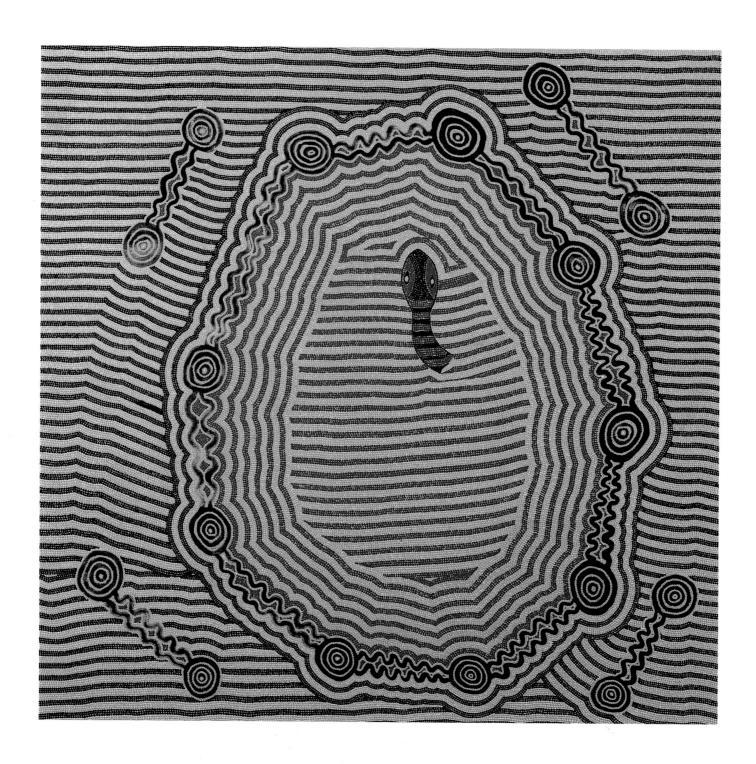

128
Noel Thompson Tjapaltjarri
Rainbow Serpent at Lake Macdonald 1991
Acrylic on canvas 129 x 128cm (50¾ x 50½in)
Private collection

Nosepeg Tjupurrula
(c. 1920-93)
Also known as *Nosepeg Tjunkata Tjupurrula*

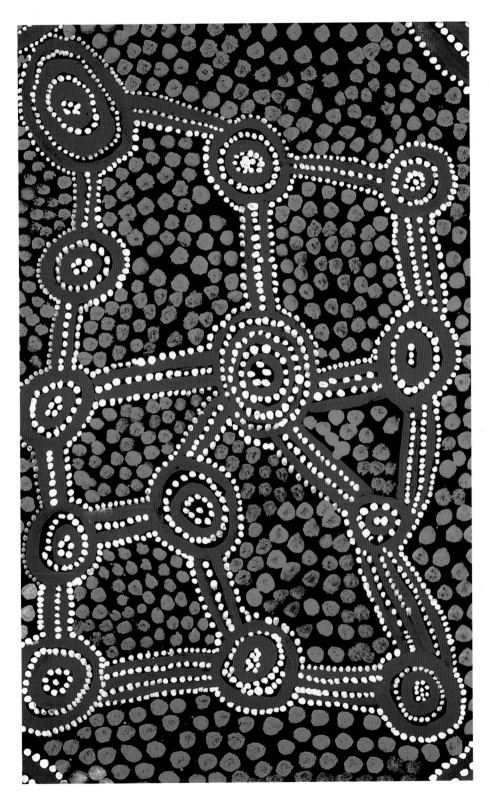

Nosepeg Tjupurrula was born in the Pintupi/Wenampa country near Lake Mackay. He was one of the early group of painters at Papunya, and the Dreamings he painted include Bush Tobacco and Grass Seed stories. His role in the community, however, always took precedence over his painting, and as a leading figure in the Aboriginal community he appeared in many films and documentaries.

129
Nosepeg Tjupurrula
Lungkarta Dreaming 1978
Paint on board 94 x 34cm (37 x 13½in)
Private collection

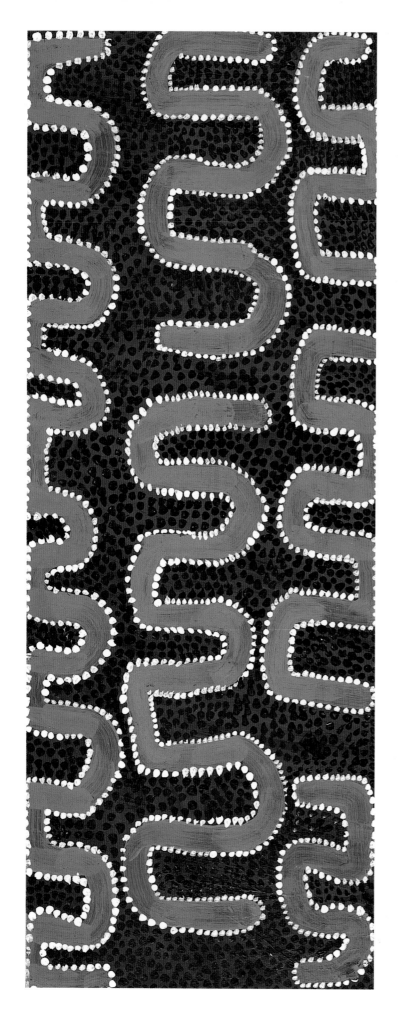

130
Nosepeg Tjupurrula
Tingari Cycle 1989
Acrylic on canvas 91 x 59cm (35¾ x 23¼in)
Private collection

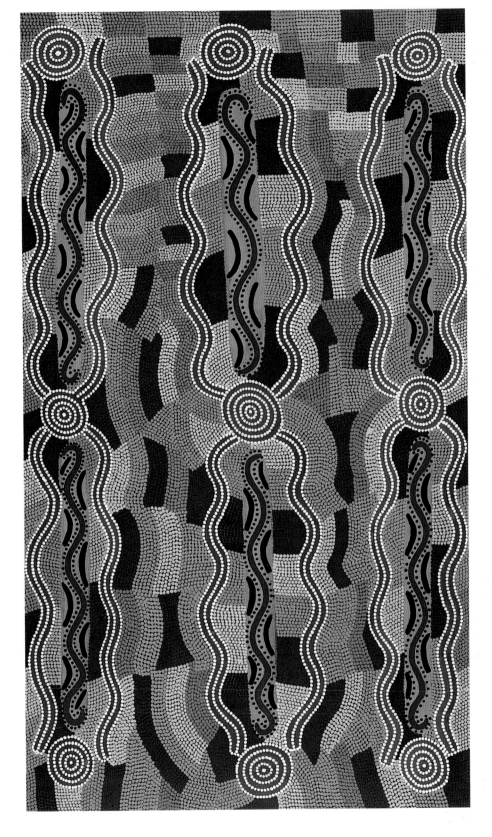

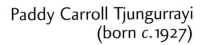
Paddy Carroll was born of the Warlpiri tribe at Yarrungkanyi, north-west of Yuendumu. His father was shot in the Coniston massacre in 1928. Paddy Carroll began painting in 1977 at Papunya. He has extensive ceremonial knowledge, and paints Dreamings of Witchetty Grub, Water, Wallaby, Bush Potato, Possum, Goanna, Woman, Man, Sweet Potato, Bush Grapes, Bush Berries, Carpet Snake and Budgerigar. He painted the concentric circles in the design of the bicentennial Australian $10 note issued in 1988. Collections that own his work include the National Gallery of Australia.

131
Paddy Carroll Tjungurrayi
Water Dreaming 1987
Acrylic on canvas 152 x 92cm (60 x 36¼in)
Private collection

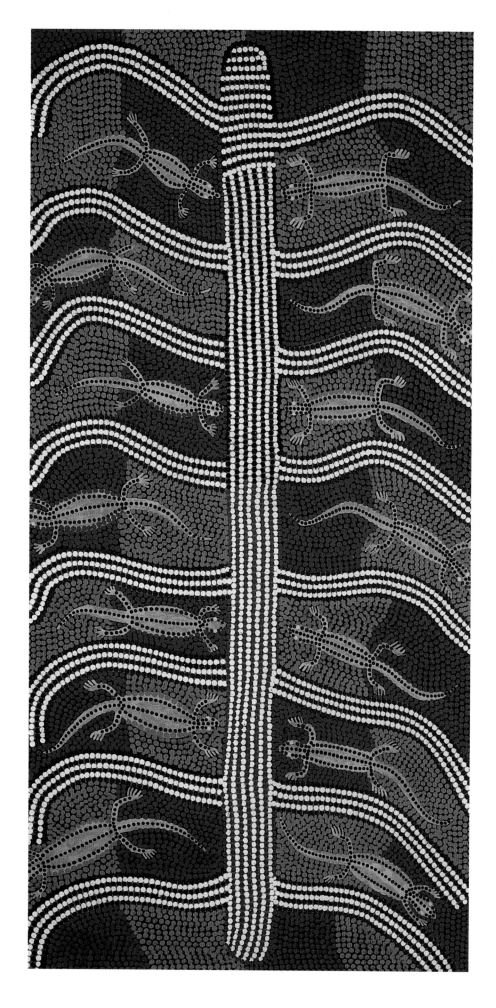

132
Paddy Carroll Tjungurrayi
Goanna Dreaming 1984
Acrylic on canvas 121 x 61cm
(47¾ x 24in)
Private collection

This painting shows a strong, structured composition with a dominant centered totemic pole and radiating branches. The goanna forms are repeated within the structure and are unusual in that they are representational. They are shown both entering and leaving the Dreaming. The artist is experimenting with structure and repetition and has chosen to use an ochre-based colour system. The intricate forms show the artist's knowledge of his subject.

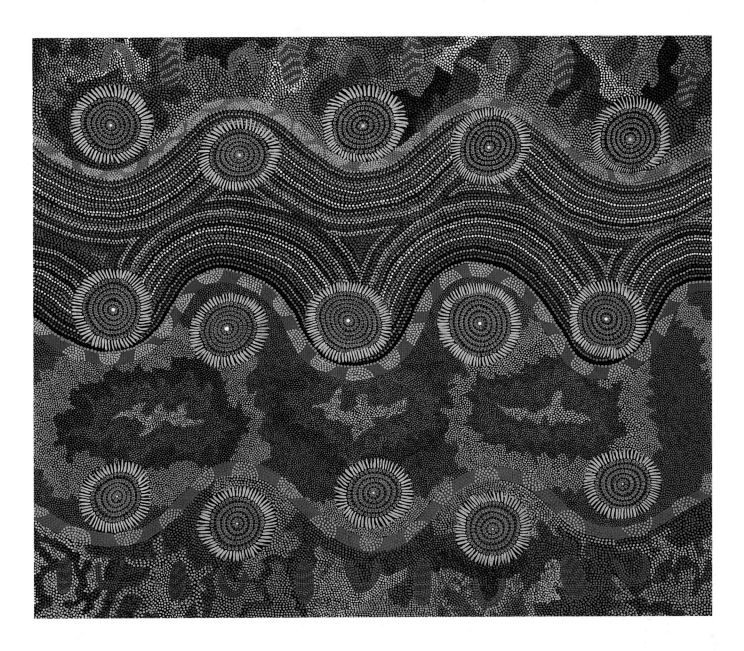

Pansy Napangati was born at Haasts Bluff. Her tribal affiliation is Luritja/Warlpiri. She started painting in the early 1970s, and was the first of the women artists to paint in her own right at Papunya, without first being an apprentice to one of the male painters. The Dreamings she paints include Bush Banana, Water Snake, Kangaroo, Cockatoo, Bush Mangoes and Willy Wagtail from her father's side, and Seven Sisters, Hail, Desert Raisin and Two Women from her mother's side. During the late 1980s she emerged as Papunya Tula's foremost woman artist. She has had solo exhibitions in Sydney and Melbourne, and in 1989 won the Aboriginal Art Award. Collections that own her work include the National Gallery of Victoria.

133
Pansy Napangati
Women's Food Supply at Pikilyi
1989
Acrylic on canvas 106 x 123cm
(41¾ x 48½in)
Private collection

Petra Nampitjinpa
(born 1966)

Also known as *Petra Turner Nampitjinpa*

Petra Nampitjinpa was born at Papunya.
She started painting in the early 1980s,
and occasionally assists on her sister
Sonder Turner Nampitjinpa's work. The
Dreamings she paints include Bush Fire
and Two Women Dancing.

134
Petra Nampitjinpa
Bush Fire Dreaming 1988
Acrylic on canvas 152 x 137cm
(60 x 54in)
Private collection

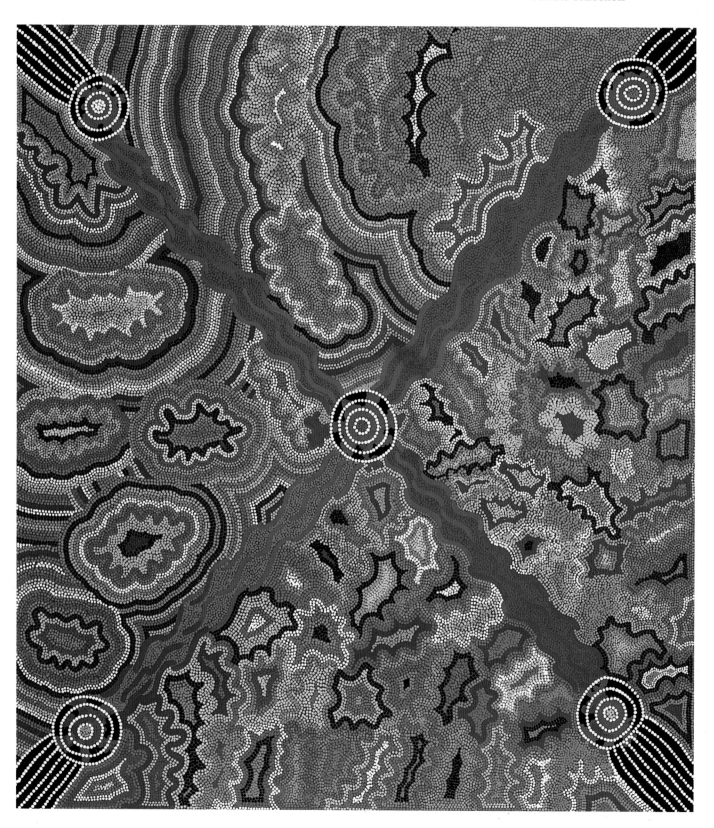

Pinta Pinta was born of the Pintupi tribe at Yumari. He started painting in the early 1970s just after Geoffrey Bardon left Papunya. He paints only intermittently, and his work usually depicts Tingari stories. Collections that own his work include the National Gallery of Victoria.

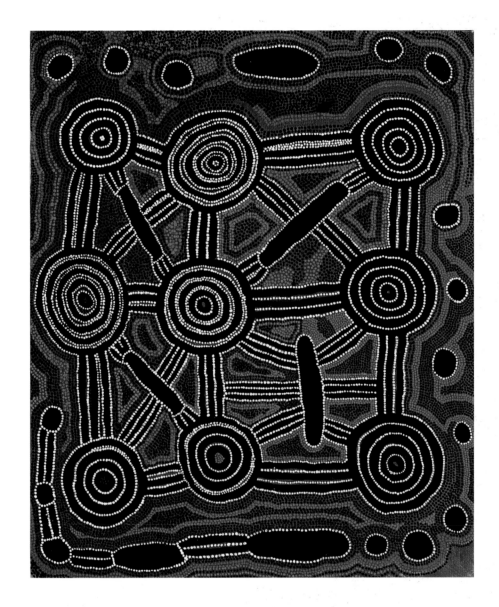

135
Pinta Pinta Tjapanangka
Tingari Dreaming at Yaru Yaru
1981
Acrylic on canvas 102 x 82cm
(40¼ x 32¼in)
Courtesy National Gallery of Victoria

The artist depicts the secret-sacred Tingari site of Yaru Yaru, west of Kintore. The elongated shapes represent the designs painted on the legs of ceremonial participants. The concentric circles indicate important sites joined by lines of travel.

Riley Major Tjangala
(born c.1948)

Riley Major was born at Putjarra, south of Mount Leibig, of the Pintupi tribe. He was taught to paint by his elder brother, the artist George Tjangala, in the early 1980s. He usually paints a Snake Dreaming associated with the Kakarra site.

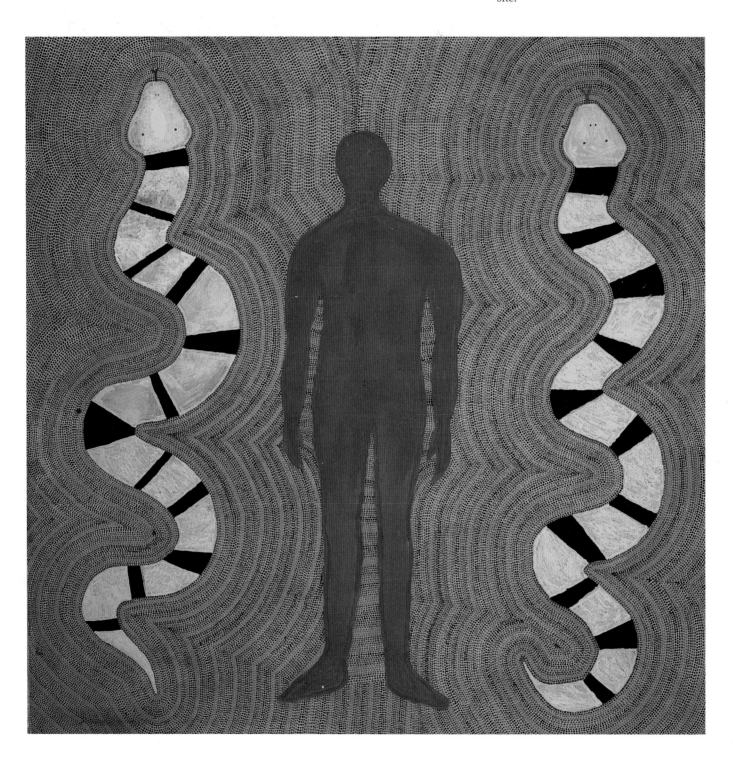

136
Riley Major Tjangala
Snake Dreaming 1988
Acrylic on canvas 180 x 180cm (70¾ x 70¾in)
Private collection

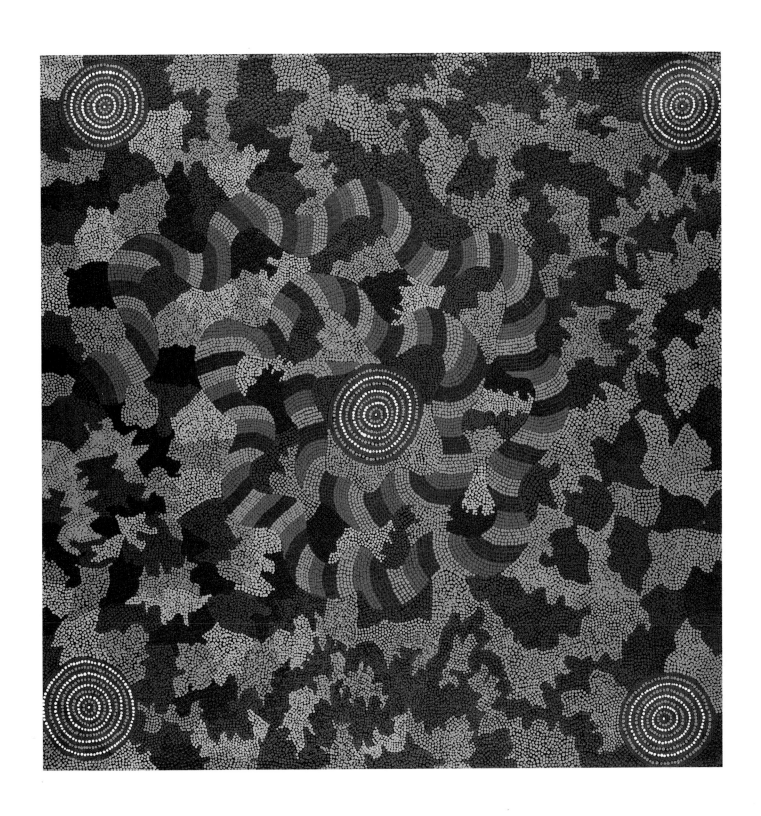

137
Riley Major Tjangala
Snake Dreaming 1989
Acrylic on canvas 120 x 120cm (47¼ x 47¼in)
Private collection

Ronnie Tjampitjinpa
(born c.1943)

Ronnie Tjampitjinpa was born near Muyinnga, west of the Kintore Ranges. He started painting in the early 1980s, and has gone on to become one of Papunya Tula's most important artists.

Collections that own his work include the National Gallery of Australia and the Musée des Arts Africains et Océaniens, Paris.

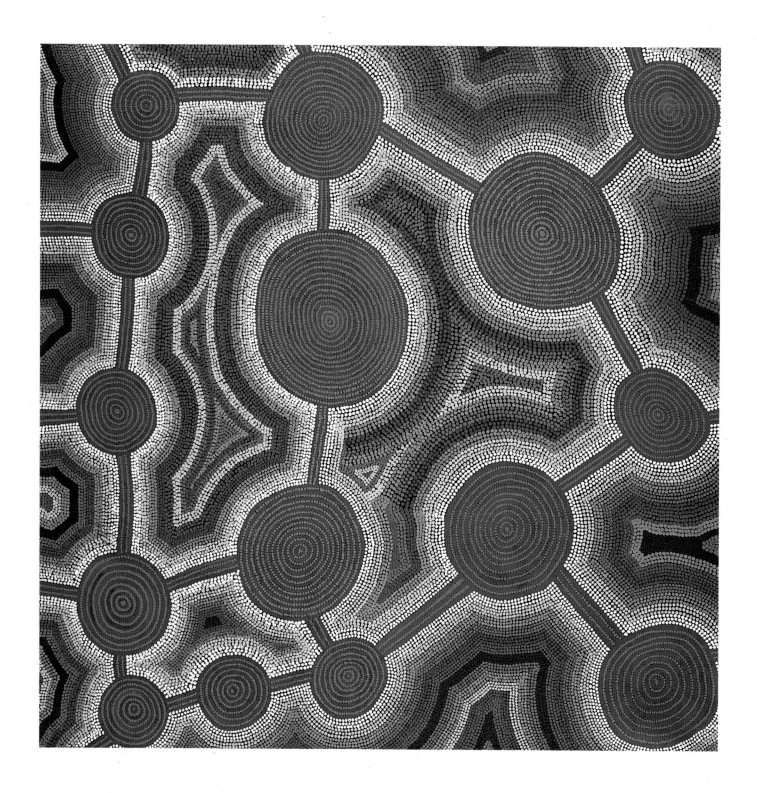

138
Ronnie Tjampitjinpa
Tingari Cycle 1986
Acrylic on canvas 106 x 106cm (41¾ x 41¾in)
Private collection

139
Ronnie Tjampitjinpa
Two Women Dreaming at
Kurakuratja 1994
Acrylic on canvas 200 x 120cm
(78¾ x 48in)
Private collection

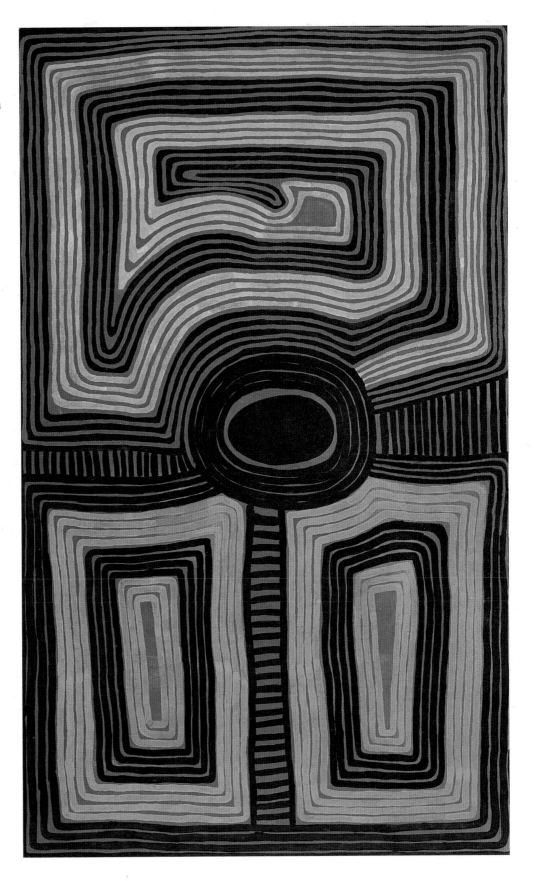

Sandra Nampitjinpa
(born 1954)

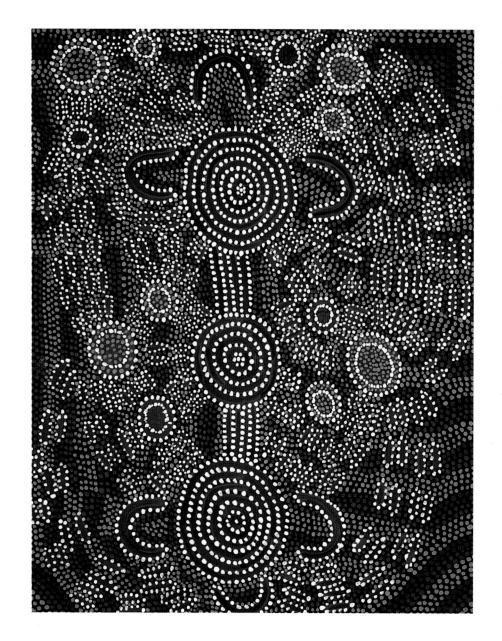

Sandra Nampitjinpa was born of the Warlpiri tribe at Yuendumu. She usually paints Dreamings of Two Women Dancing. She was taught to paint by her father in the early 1980s, and her work was among the first by a Papunya Tula woman to be purchased by the National Gallery of Australia.

140
Sandra Nampitjinpa
Flying Ant Dreaming 1981
Acrylic on canvas 71 x 56cm
(28 x 22in)
Courtesy Museum and Art Gallery of
the Northern Territory

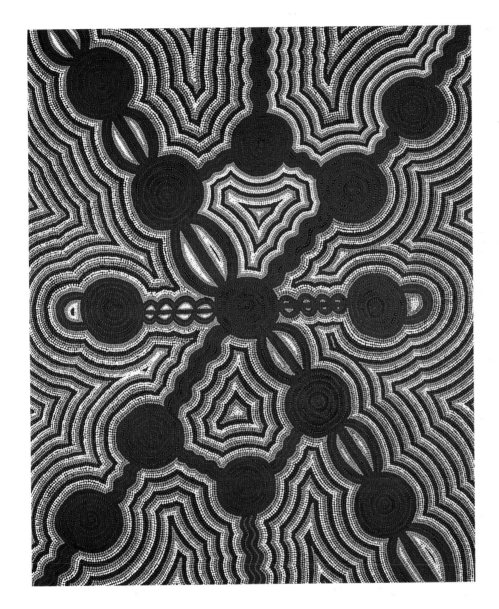

Shorty Jackson was born at Malka, south-east of Kiwirrkura, of the Pintupi tribe, and is the oldest son of Uta Uta Tjangala, whose work is also featured in this book. He is custodian of the site of Ngatjaanga where, according to Aboriginal mythology, the Snake Woman creator ancestor was said to have killed the Snake. (Shorty Jackson's father depicts these events in his paintings.) Shorty has been painting since the late 1980s.

In the Dreamtime, an old man travelled to the site of Yinnanarri, north-west of Kintore. During his travels he made camp at various rockhole sites along the way. This old man was rather promiscuous, and is said to have had liaisons with a number of women. The roundels represent the sites at which he made camp, with the central roundel depicting Yinnanarri. The 'U' shapes adjacent to two of these roundels show the old man sitting down. The straight lines with arcs at either side show the designs used during the ceremonies associated with the site.

141
Shorty Jackson Tjampitjinpa
Travelling to Yinnanarri 1987
Acrylic on canvas 151 x 121cm
(59½ x 47¾in)
Courtesy Art Gallery of Western Australia

Shorty Lungkarda Tjungurrayi
(*c.*1920-87)

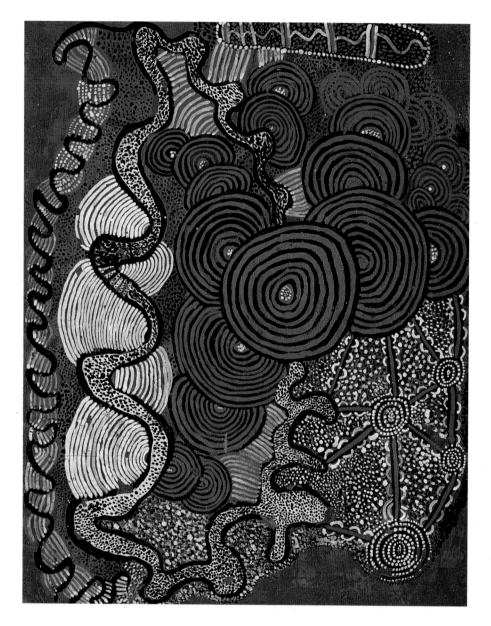

Shorty Lungkarda was one of the last men to join the original group of painters at Papunya. He was one of the senior men of the Pintupi tribe, and was renowned for his hunting and dancing skills as well as being an authority on ritual matters. The Dreamings he painted include Blue Tongue Lizard, Goanna, Bush Banana, Snake and Bandicoot, and his work is known for its boldness and intensity. Collections that own his work include the National Gallery of Victoria.

142
Shorty Lungkarda Tjungurrayi
Men in a Bush Fire 1972
Paint on board 65 x 50cm
(25½ x 19¾in)
Courtesy National Gallery of Victoria

Simon Tjakamarra was born of the Pintupi tribe at Kulkuta in the Pollock Hills. He began painting regularly for Papunya Tula Artists in the early 1980s, and quickly adopted the subtle and powerful, classic Pintupi style of painting, consisting typically of circles and connecting lines. He usually painted Tingari stories from around the area of Kulkuta. His older brother was Anatjari Tjakamarra, one of the original group of painting men at Papunya, whose work is also featured in this book.

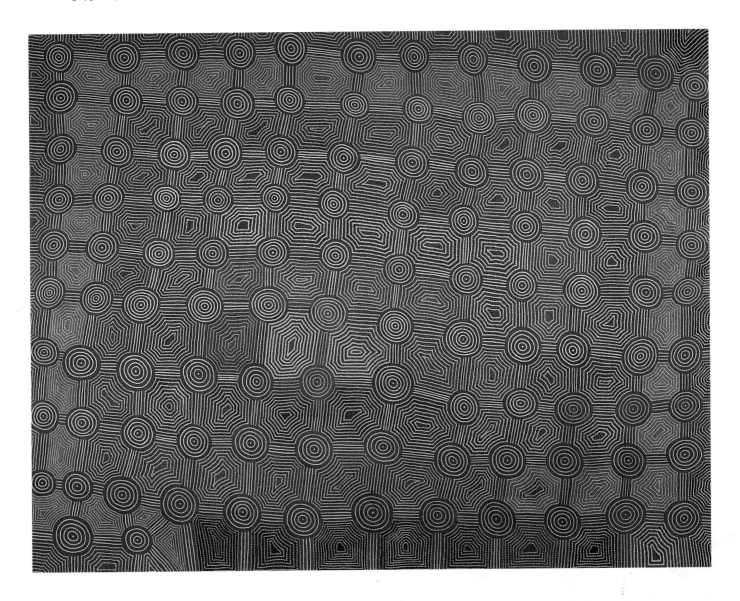

143
Simon Tjakamarra
Tingari Dreaming at Karrkurritinytja 1986
Acrylic on canvas 214 x 274cm
(84¼ x 107¾in)
Courtesy Art Gallery of Western Australia

This painting depicts a story associated with the site of Karrkurritinytja, near the Kintore Ranges. Since the story is associated with the secret-sacred ceremonies of the Tingari Men, no further information was revealed. According to Aboriginal mythology, the Tingari Men travelled over vast areas of the desert regions, creating the landscape, performing rituals and instructing the post-initiatory youths with whom they were travelling in the higher education undergone by all initiated Aboriginal men of the region.

Sonder Turner Nampitjinpa
(born 1956)

Also known as *Sonder Nampitjinpa*

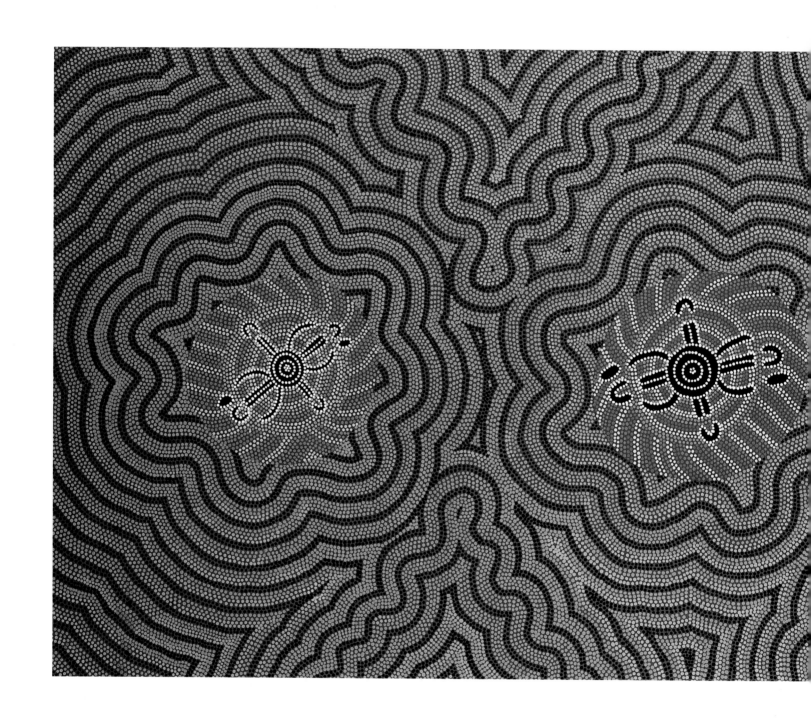

144
Sonder Turner Nampitjinpa
(assisted by Petra Turner Nampitjinpa)
Nangala's Dreaming 1989
Acrylic on canvas 127 x 261cm (50 x 102¾in)
Private collection

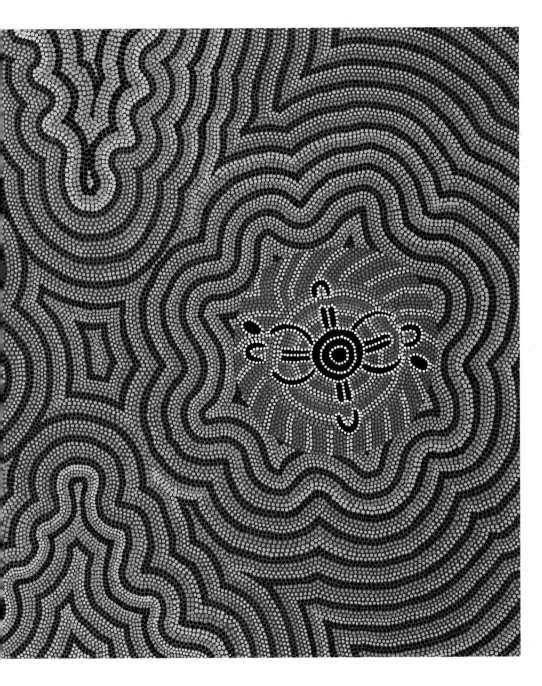

Sonder Turner was born of the Warlpiri tribe near Yuendumu. She started to paint in the early 1980s, and was one of the first women painters of the Western Desert to gain recognition for her work. Her sister is the artist Petra Turner Nampitjinpa who occasionally assists on her work. She usually paints the Two Women Dancing story for Mount Leibig. Collections that own her work include the National Gallery of Australia.

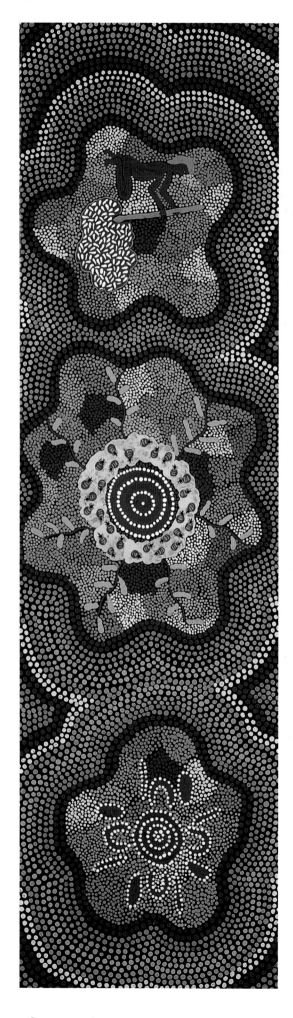

145
Sonder Turner Nampitjinpa
Bush Tucker Dreaming 1989
Acrylic on canvas 127 x 36cm (50 x 14¼in)
Private collection

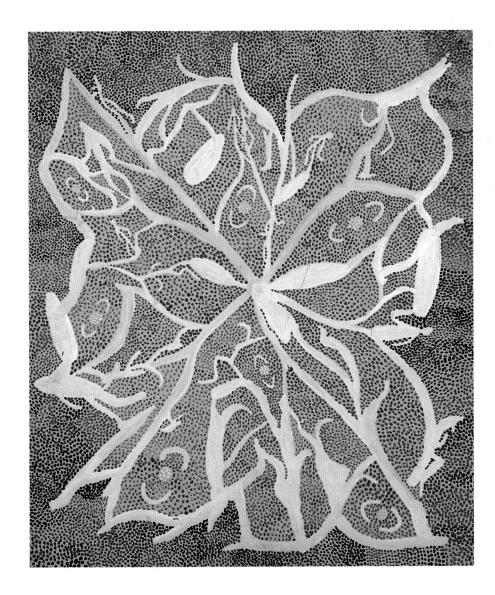

Tim Leura was born at Napperby of the Anmatyerre tribe. He was the first of the early painters to befriend Geoffrey Bardon at Papunya when the painting movement started, and was the obvious candidate to become leader of the original group of painters. He was not as prolific as his brother Clifford Possum, but his early work is now particularly sought after. In 1980, with the help of Clifford, he painted a major work, *Napperby Death Spirit Dreaming*, which was chosen as the centrepiece for the Asia Society's exhibition *Dreamings: Art of Aboriginal Australia*, which toured the USA in 1988-9. This painting, seven metres in length, is considered to be one of the greatest works of the Papunya school of painting. Other Dreamings he painted include Possum, Blue Tongue Lizard, Fire and Yam. It is said that his sadness at the loss of the traditional way of life was reflected in his paintings, which were often of a sombre nature. Collections that own his work include the National Gallery of Australia and the National Gallery of Victoria.

146
Tim Leura Tjapaltjarri
Yam Dreaming 1972
Paint on board 69 x 60cm
(27¼ x 23½in)
Private collection

This painting shows human and animal forms emerging from and enclosed within the area bounded by the root of the yam. The artist has used the same white ochre paint to depict both the figures and the root, thereby suggesting a common spirituality. The area of light-coloured stippling enclosed within the root represents grass; the darker area of stippling surrounding the roots depicts ground that has been scorched in the search for the yam. This is one of the most important paintings from the early days of Papunya Tula, and can be seen again as part of the artist's most famous painting, *Napperby Death Spirit Dreaming*, on page 146.

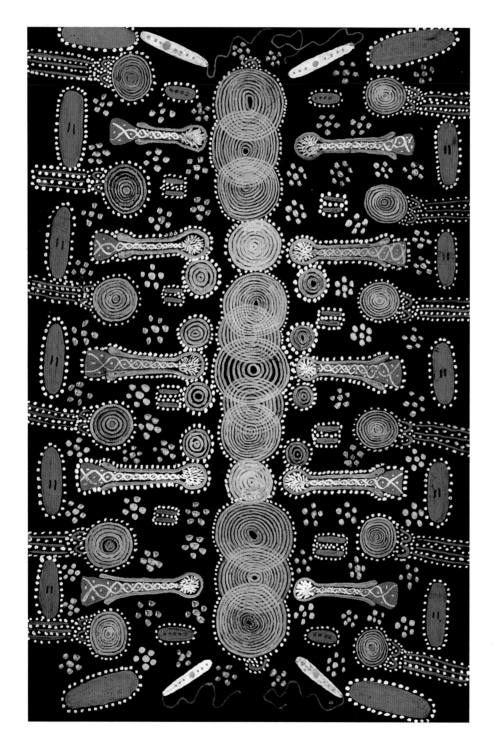

147
Tim Leura Tjapaltjarri
Men's Dreaming 1971
Paint on board 53 x 34 cm (20¾ x 13½in)
Private collection

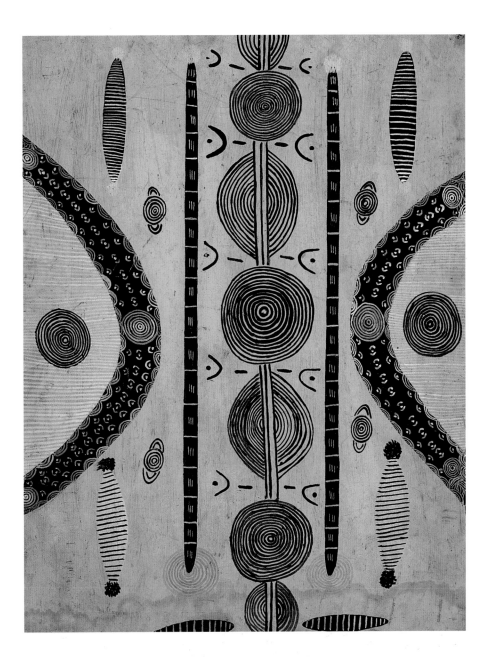

148
Tim Leura Tjapaltjarri
Honey Ant Dreaming 1972
Paint on board 60 x 40cm (23½ x 15¾in)
Private collection

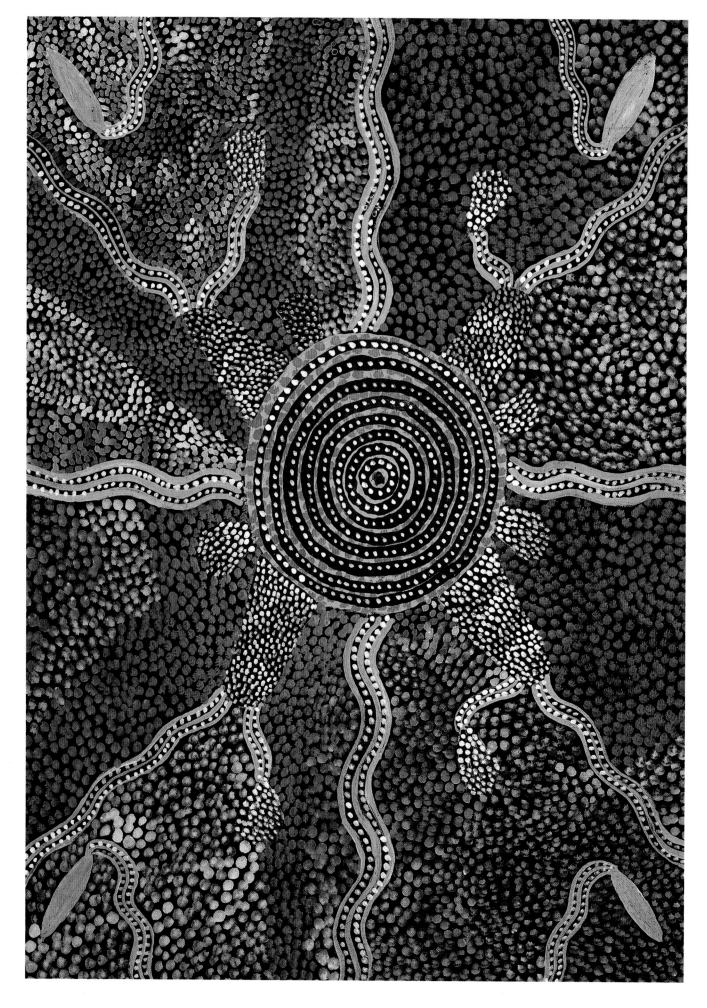

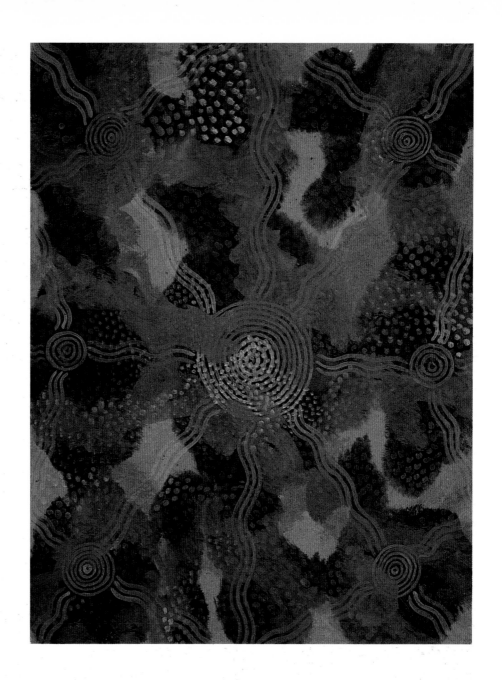

150
Tim Leura Tjapaltjarri
Bush Fire c.1976
Acrylic on board 60 x 40 cm
(23½ x 15¾in)
Private collection

149
Tim Leura Tjapaltjarri
Sweet Potato at Napperby 1976
Acrylic on board 76 x 40cm (30 x 15¾in)
Private collection

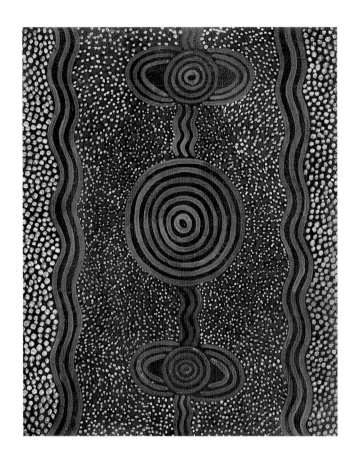

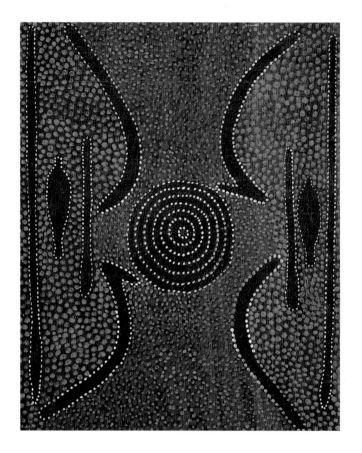

151
Tim Leura Tjapaltjarri
Untitled 1978
Paint on board 50 x 40 cm (19¾ x 15¾in)
Private collection

152
Tim Leura Tjapaltjarri
Untitled 1978
Paint on board 50 x 40 cm (19¾ x 15¾in)
Private collection

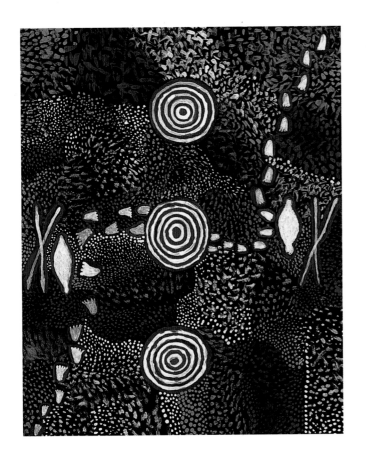

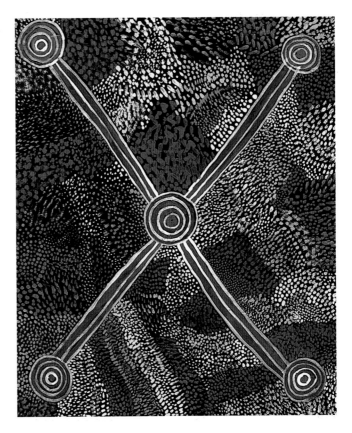

153
Tim Leura Tjapaltjarri
Untitled 1984
Acrylic on canvas 51 x 41cm (20 x 16¼in)
Private collection

154
Tim Leura Tjapaltjarri
Man's Dreaming 1984
Acrylic on canvas 61 x 51cm (24 x 20in)
Private collection

This unique painting was commissioned by Geoffrey Bardon in 1980 for a film on Western Desert artists and their changing lifestyles. The artist combines on one canvas all the major Dreamings which criss-cross traditional Anmatyerre country near Napperby station: Yam, Water, Sun and Moon Love Story, Old Man and Death Spirit Dreaming. The artist produces exact copies of three paintings previously done for Geoffrey Bardon: *Yam Dreaming* (shown on page 139), *Love Song of Sun and Moon* and

Death Spirit Dreaming.

These direct quotations of early works express his close relationship to Bardon, and comment on the history of the Papunya Tula movement. The work also documents the stylistic differences between Tim Leura and his brother Clifford Possum, who was responsible only for the large travelling line and the central row of circles. Tim Leura's dotting is sombre, smudged and atmospheric; Clifford Possum, a brilliant technician, applies paint evenly in crisp circles.

The painting evokes the Death Spirit being as he travels the familiar territory of his homeland, revealed as a stylised map of places where the Anmatyerre lived, hunted, ate, fought and rested. The depiction of the spirit being as a human skeleton, journeying along the central spiralling line, dramatises his eternal supernatural presence in the landscape. The painting is a compendium of the artist's spiritual life, a summary of his life as an artist and a hunter, and his most important Dreamings are shown as

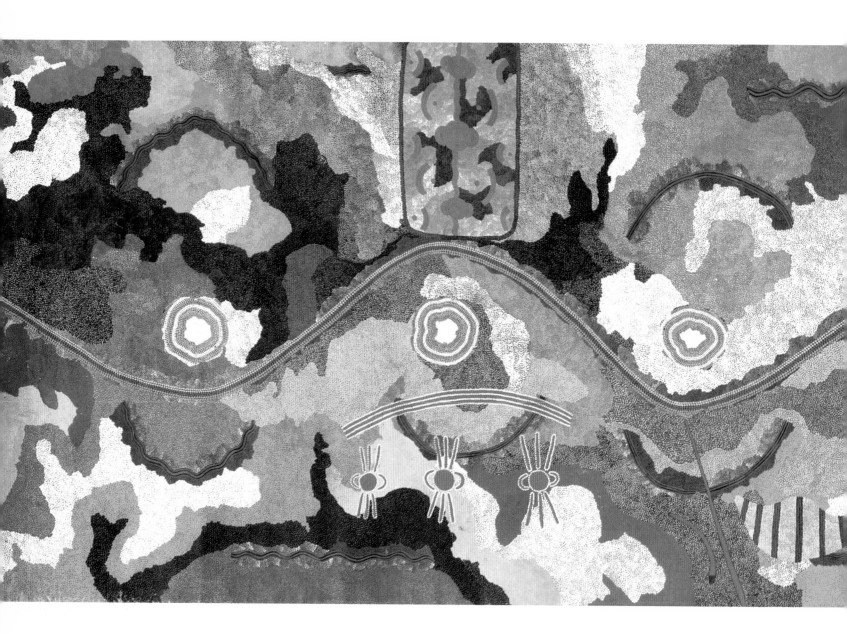

windows in the painting. The figure can also be read as an Aboriginal man whose death is dramatically prefigured in the painting. The background dotting reflects visual qualities of the landscape: leaves, smoke, and grass, sand and earth imprinted with tracks and footprints. The presence of nomadic hunters is implied by the depiction of spear, boomerangs, *woomera* and shield.

155
Tim Leura Tjapaltjarri
(assisted by Clifford Possum)
Napperby Death Spirit Dreaming 1980
Acrylic on canvas 213 x 701 cm (83¾ x 276in)
Courtesy National Gallery of Victoria

Timmy Payungka Tjapangati
(born *c.* 1942)

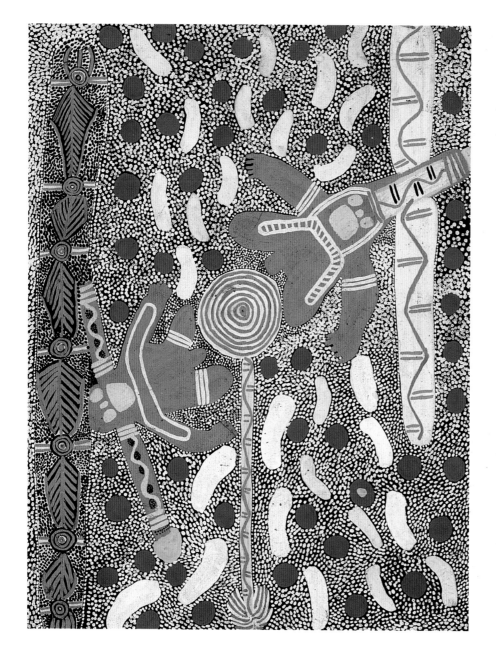

Timmy Payungka was born of the Pintupi tribe just west of Central Lake Mackay. He was one of the original group of painters at Papunya in 1971. The Dreamings he paints include Dancing Women, Dingo, Snake and Water Dreaming stories. Collections that own his work include the National Gallery of Victoria.

156
Timmy Payungka Tjapangati
Untitled 1972
Paint on board 62 x 46cm
(24½ x 18in)
Courtesy National Gallery of Victoria

Toby Brown was born of the Anmatyerre tribe. Most of his paintings date from the mid-1970s, and the Dreamings he painted include Kangaroo, Euro, Mulga Seed and Snake.

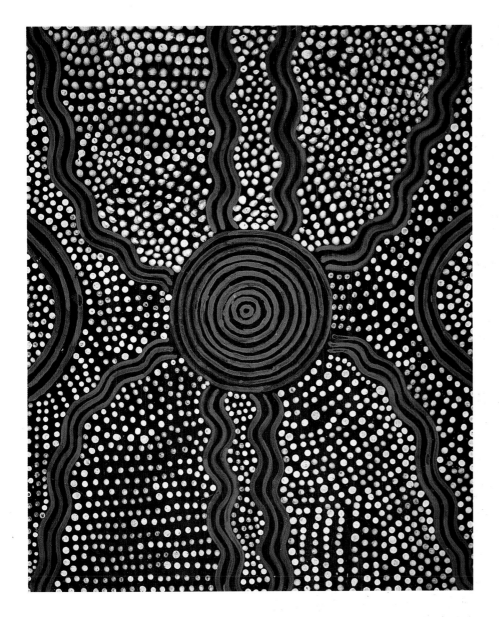

157
Toby Brown Tjampitjinpa
Untitled 1975
Paint on board 38 x 31cm (15 x 12¼in)
Courtesy South Australia Museum

Tommy Lowry Tjapaltjarri
(c. 1935-87)

Also known as *Tommy Larry Japaljarri*

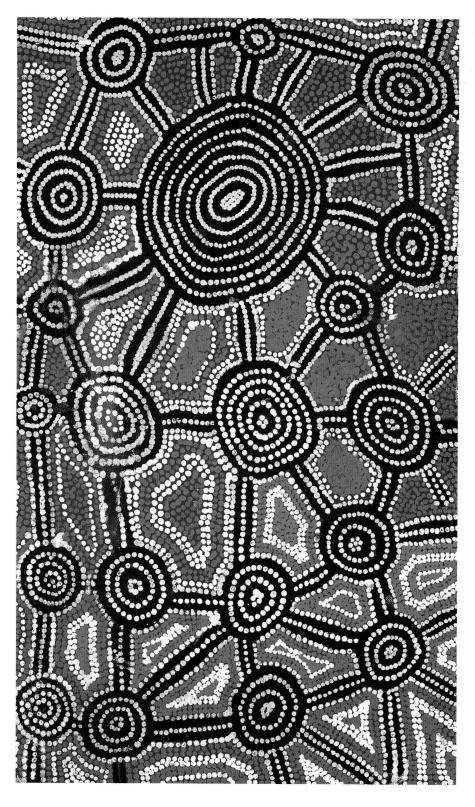

Tommy Lowry was born in the Clutterbuck Hills south-west of Kintore. His tribal affilation was Pintupi/Ngardajarra. He painted Dreamings of Tingari stories, specifically the Snake Men stories for his area.

158
Tommy Lowry Tjapaltjarri
Tingari Cycle 1984
Acrylic on canvas 76 x 45cm (30 x 17¾in)
Private collection

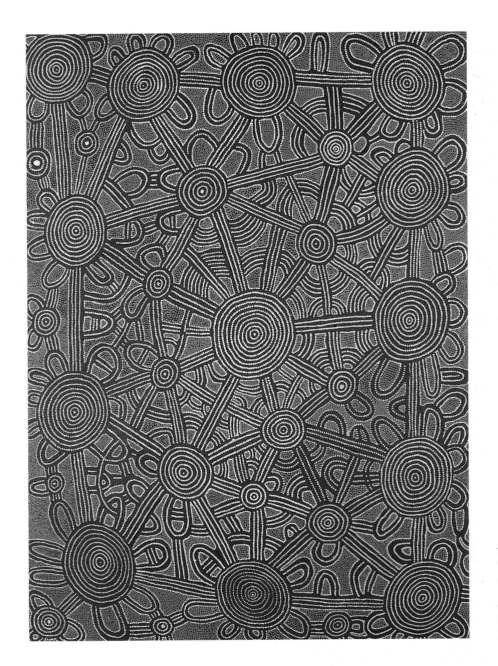

159
Tommy Lowry Tjapaltjarri
Tingari Cycle 1984
Acrylic on canvas 190 x 122cm
(74¾ x 48in)
Private collection

Tony West Tjupurrula

(date of birth unknown)

Tony West Tjupurrula is an occasional painter for Papunya Tula. No further biographical information was available for him.

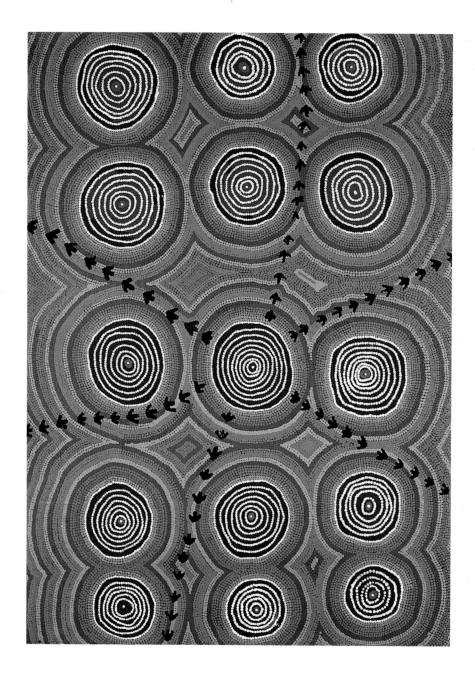

160
Tony West Tjupurrula
Emu Dreaming 1987
Acrylic on canvas 120 x 90cm (47¼ x 35½in)
Private collection

Turkey Tolson Tjupurrula
(born c.1938)

Turkey Tolson was born of the Pintupi tribe near Haasts Bluff. He was one of the youngest of the original group of painters at Papunya. While some of his work is amongst the most imaginative and figurative of all the Papunya Tula artists, he also paints in the classical, traditional Pintupi style of circles and connecting lines. The Dreamings he paints include Bush Fire, Emu, Snake, Woman and Mitukutjarrayi Dreamings from his country south of Kintore. Collections that own his work include the National Gallery of Australia, the National Museum of Australia and the National Gallery of Victoria.

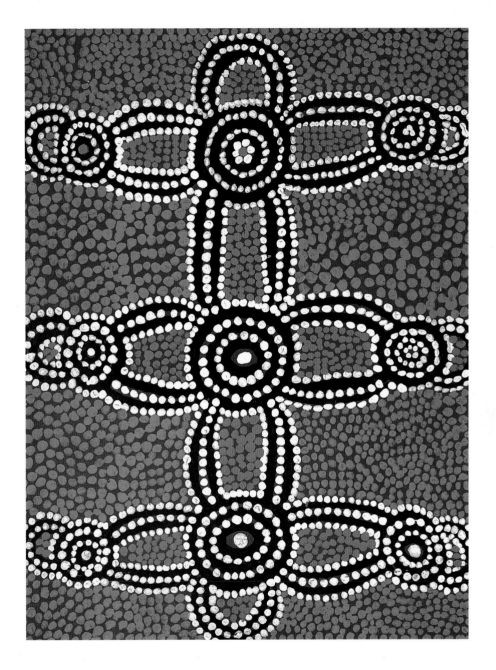

161
Turkey Tolson Tjupurrula
Untitled 1976
Paint on board 50 x 40cm (19¾ x 15¾in)
Private collection

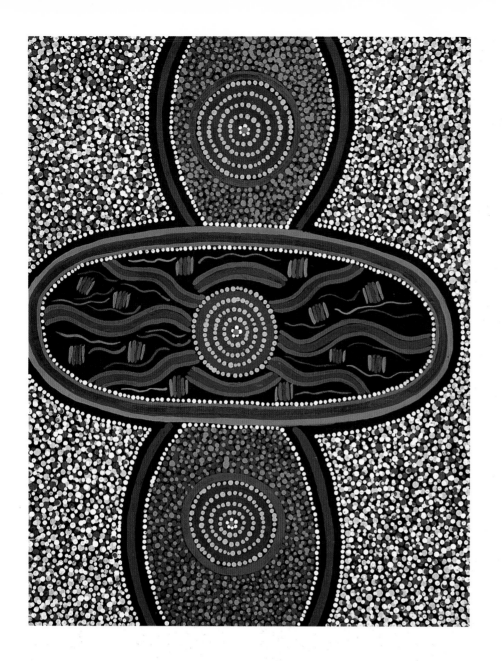

162
Turkey Tolson Tjupurrula
Untitled 1984
Paint on board 46 x 35cm
(18 x 13¾in)
Private collection

163
Turkey Tolson Tjupurrula
Woman's Dreaming 1980
Paint on board 60 x 45cm
(23½ x 17¾in)
Private collection

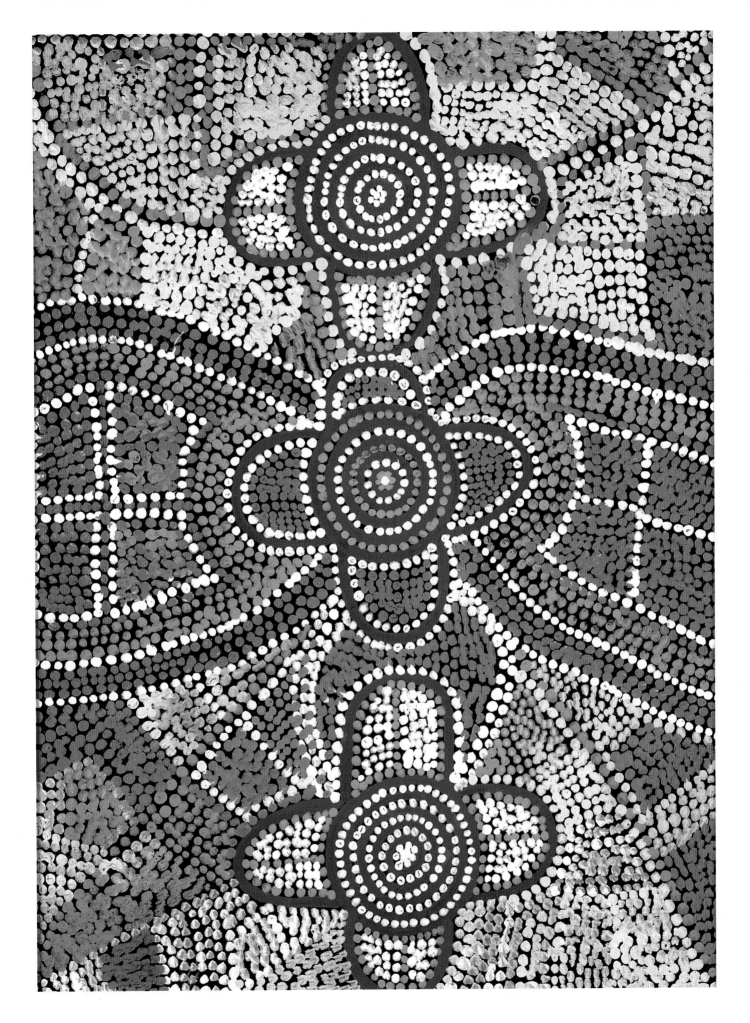

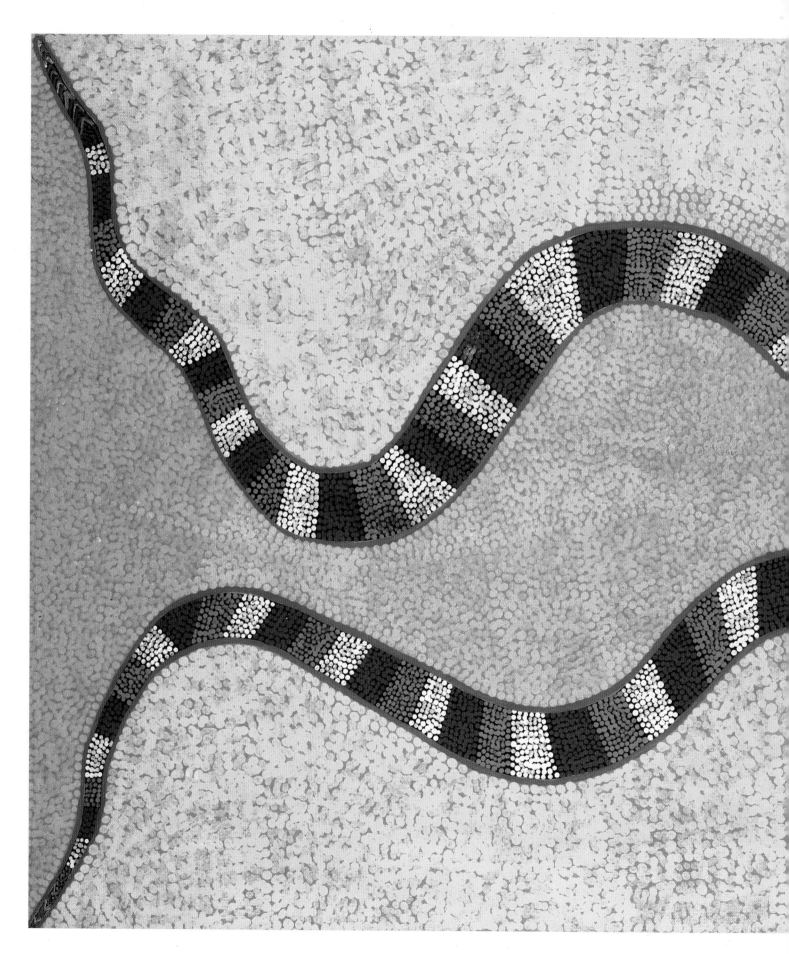

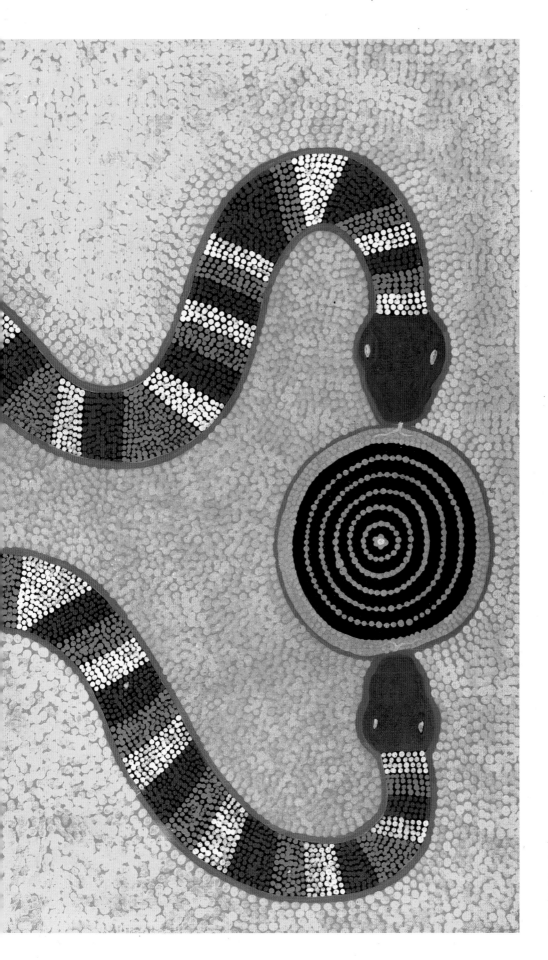

164
Turkey Tolson Tjupurrula
Snake Dreaming 1984
Acrylic on canvas 60 x 90cm
(23½ x 35½in)
Private collection

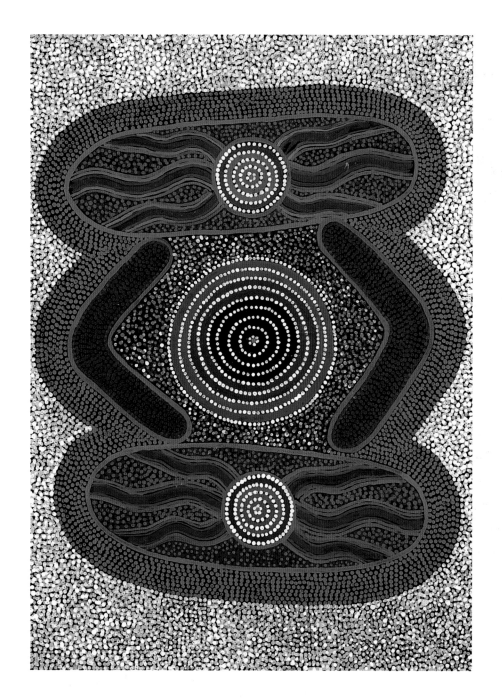

165
Turkey Tolson Tjupurrula
Untitled 1984
Acrylic on canvas 61 x 46cm (24 x 18in)
Private collection

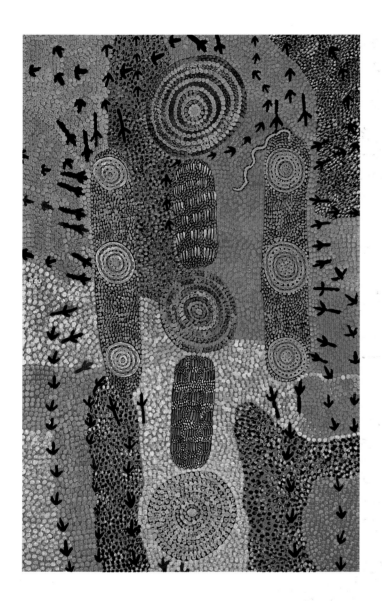

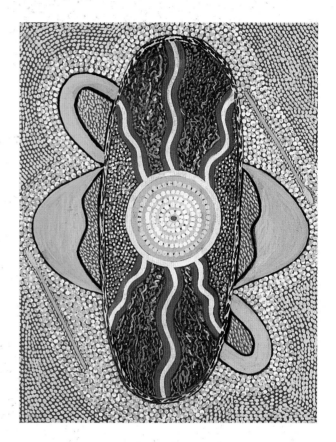

166
Turkey Tolson Tjupurrula
Emu Dreaming 1974
Acrylic on canvas 123 x 80cm (48½ x 31½in)
Courtesy National Gallery of Victoria

167
Turkey Tolson Tjupurrula
Two Travelling Women Dreaming 1984
Acrylic on canvas 41 x 31cm (16¼ x 12¼in)
Private collection

This picture depicts the ground design associated
with the saga of the two travelling women at the site
of Munni-Munni, near Kintore. Men following the
women are present but are not shown. The central
round image is the site of Munni-Munni. The 'U'
shapes are the women with their *coolamons* and
digging sticks. The sensuous line and colour in this
work indicates an implicit sexual theme.

Tutuma Tjapangati
(c. 1915-87)
Also known as *Old Tutuma Japangardi*

Old Tutuma was a member of the Pintupi/Pitjantjatjara tribe, of which he was an important ceremonial leader. He was one of the original group of artists at Papunya, and was a highly influential and prolific painter. Collections that own his work include the National Gallery of Victoria.

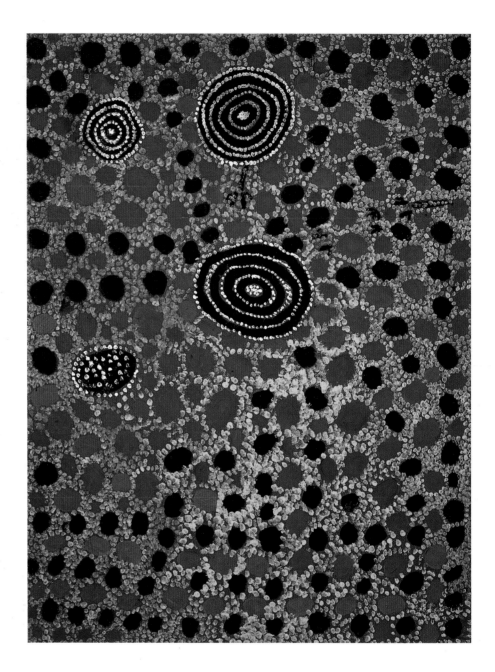

168
Tutuma Tjapangati
Mushroom and Kangaroo Dreaming c. 1975
Paint on board 120 x 90cm
(47¼ x 35½in)
Private collection

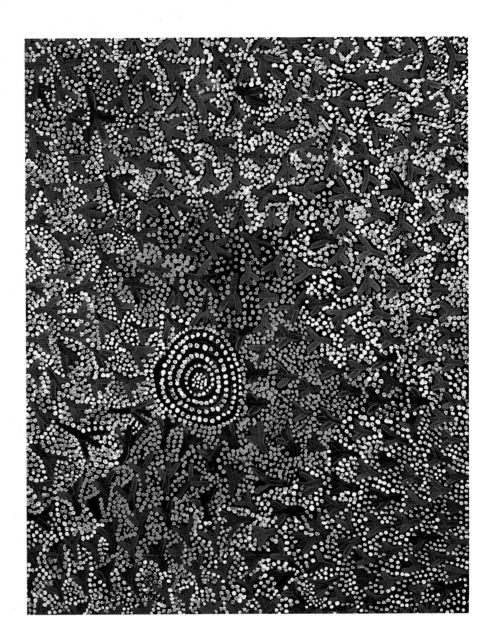

169
Tutuma Tjapangati
Eagle Dreaming 1974
Paint on board 120 x 90cm
(47¼ x 35½in)
Private collection

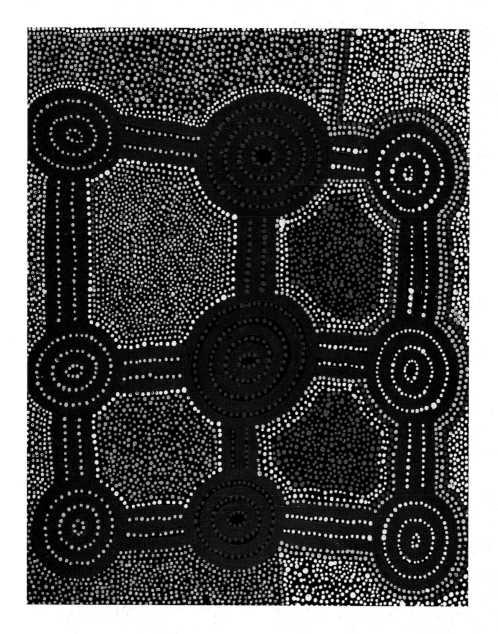

170
Tutuma Tjapangati
Tingari Dreaming 1979
Paint on board 71 x 57cm (28 x 22½in)
Private collection

171
Tutuma Tjapangati
Emu Dreaming 1977
Paint on board 67 x 47cm (26¼ x 18½in)
Private collection

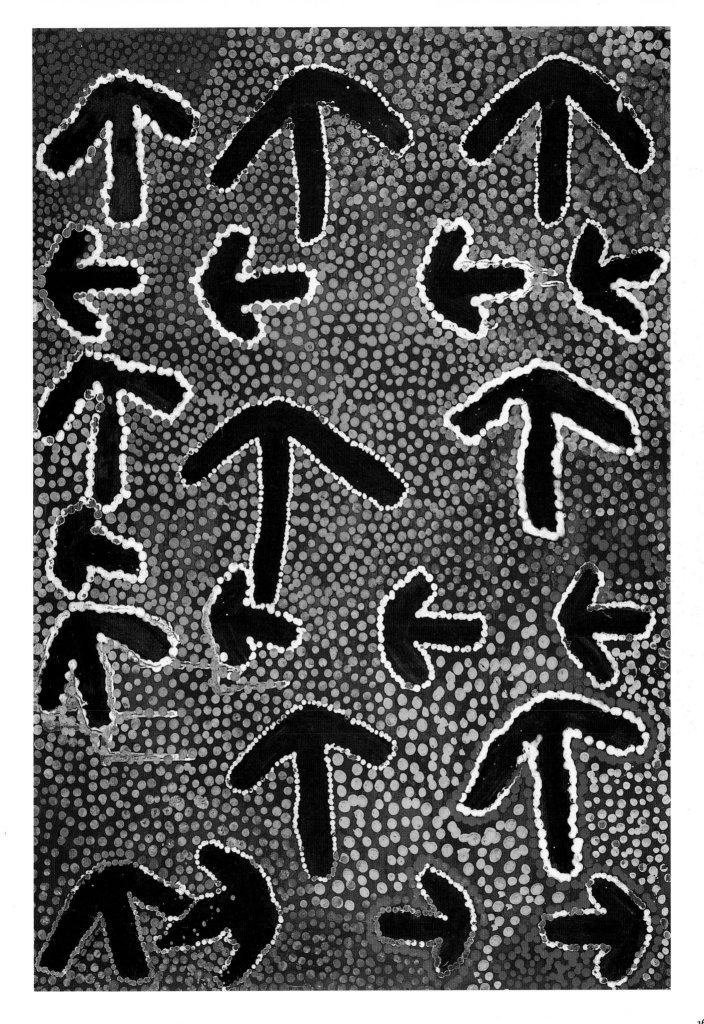

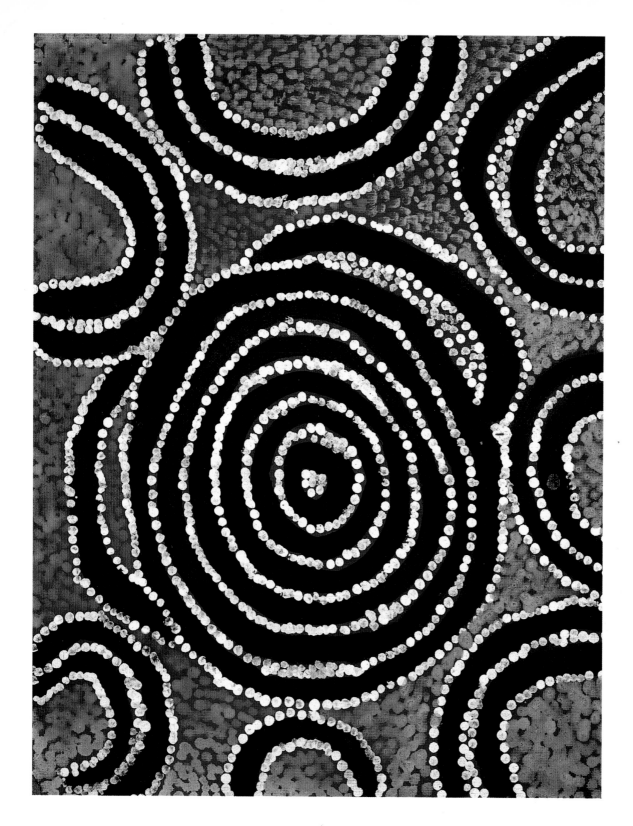

172
Tutuma Tjapangati
Tjukula Tingari Dreaming c. 1970
Paint on board 62 x 49cm (24½ x 19¼in)
Private collection

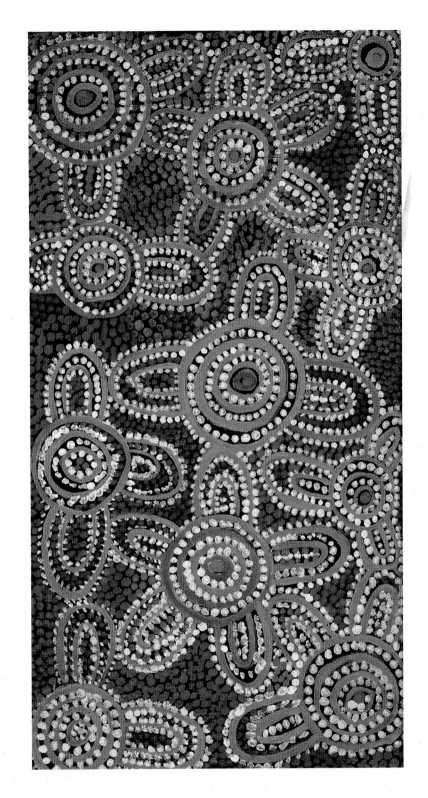

173
Tutuma Tjapangati
Woman's Dreaming 1979
Paint on board 62 x 32cm (24½ x 12½in)
Private collection

Uta Uta Tjangala
(c.1920-90)

Uta Uta was born in the Kintore Ranges of the Pintupi tribe. He was one of the original group of Pintupi men who painted with Geoffrey Bardon at Papunya at the beginning of the movement. He was a master of the pure Pintupi style of painting on a large scale, although he also produced many small works. In his 1981 painting, *Yumari*, about the site of the same name, he was helped by eleven other artists, including Anatjari Tjampitjinpa and Dini Campbell. This painting was exhibited in the XVII Bienal de São Paulo in 1983, and in the Asia Society's exhibition *Dreamings: Art of Aboriginal Australia* , which toured the USA in 1988-9. The Dreamings he painted include Emu, Carpet Snake and Old Man. He also painted Dreamings based on the Tingari cycle. Collections that own his work include the National Gallery of Australia, the National Museum of Australia and the National Gallery of Victoria.

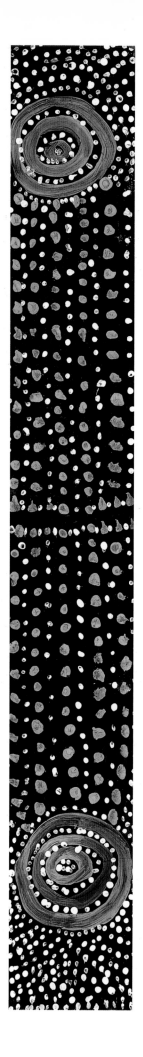

174
Uta Uta Tjangala
Old Man Dreaming 1973
Paint on board 87 x 12cm
(34¼ x 4¾in)
Private collection

175
Uta Uta Tjangala
Untitled 1984
Acrylic on canvas 40 x 30cm
(15¾ x 11¾in)
Private collection

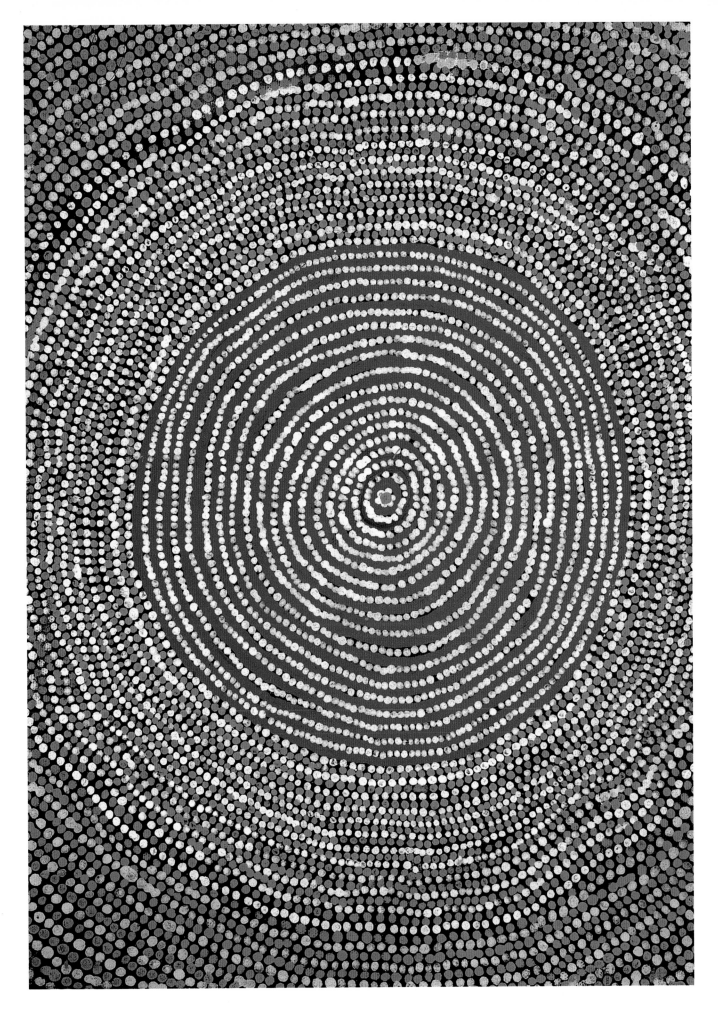

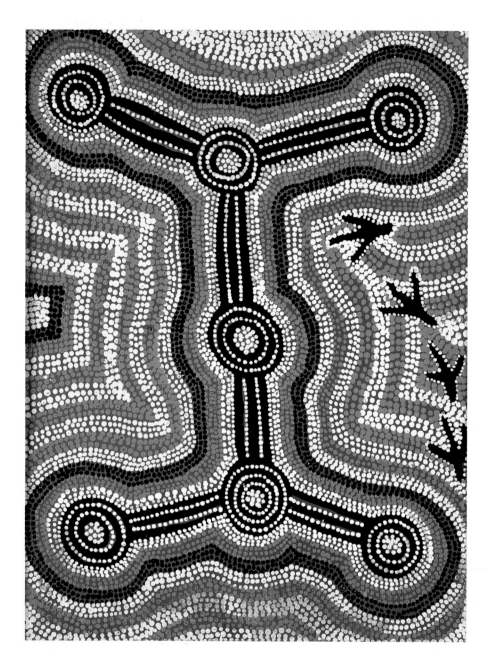

176
Uta Uta Tjangala
Emu Dreaming 1984
Paint on board 61 x 45cm
(24 x 17¾in)
Private collection

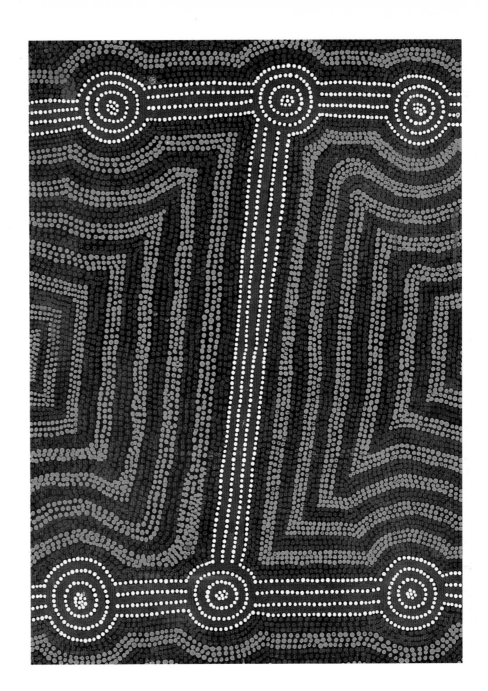

177
Uta Uta Tjangala
Untitled 1984
Acrylic on canvas 76 x 56cm
(30 x 22in)
Private collection

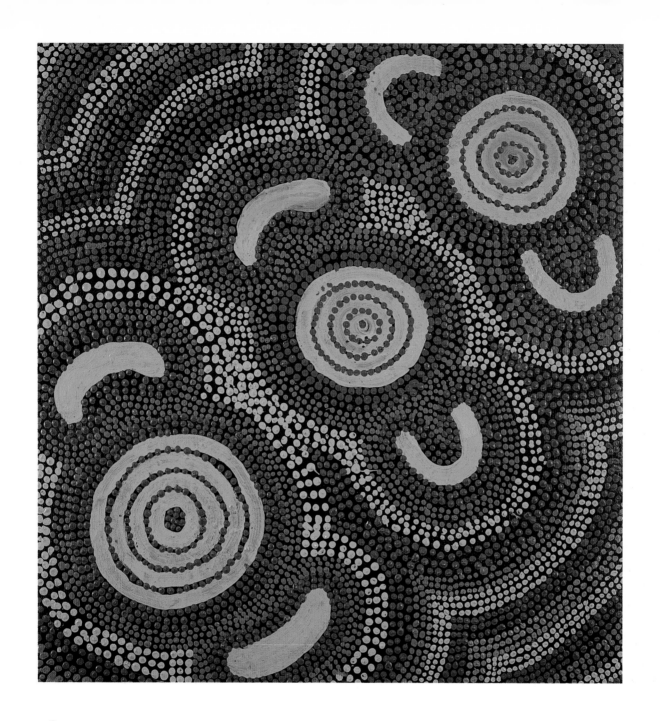

178
Uta Uta Tjangala
Old Man Dreaming 1990
Acrylic on canvas 68 x 66cm
(26¾ x 26in)
Private collection

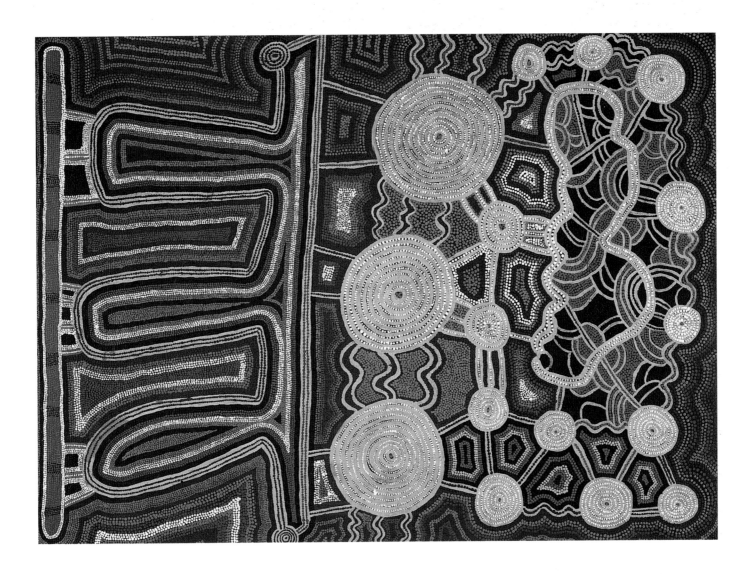

179
Uta Uta Tjangala
Tjangala and Two Women at Ngurrapalangu 1982
Acrylic on canvas 90 x 125cm
(35½ x 49¼in)
Courtesy Art Gallery of Western Australia

This painting shows the site of Ngurrapalangu, which is south-west of the Kintore Ranges, just over the Western Australian border. The three hill-like shapes represent one man of the Tjangala kinship subsection and two women, one of the Nangala kinship and the other of the Napanangka kinship. The roundels represent caves at the site, and the oblong shapes are hills. The background dots depict the vegetation of the area, the seeds of which are gathered, ground and made into damper.

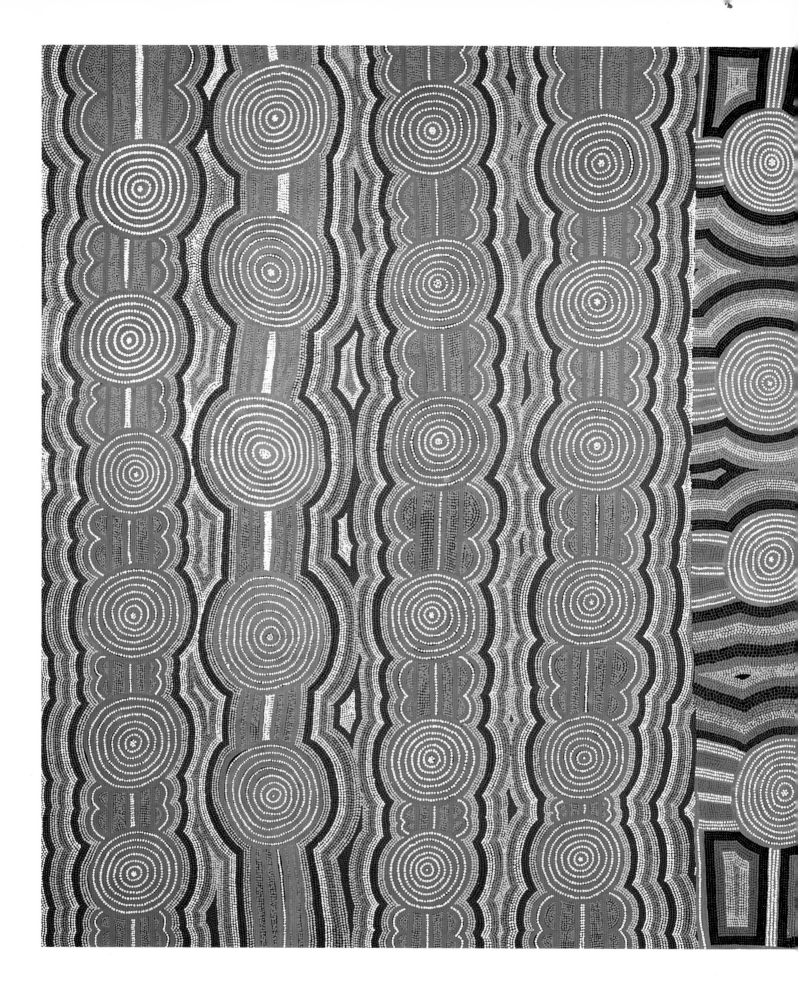

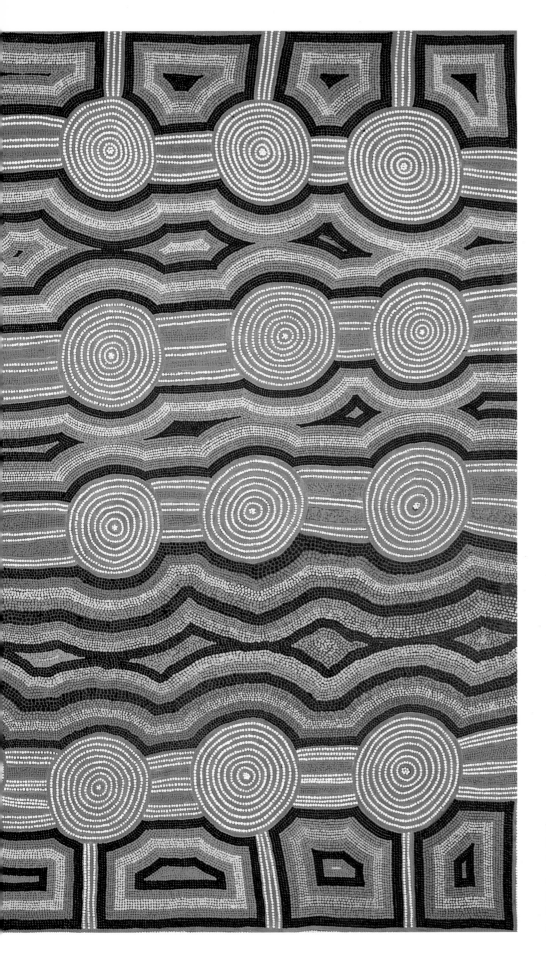

180
Uta Uta Tjangala
Tingari Man at Kintore 1987
Acrylic on canvas 240 x 360cm
(94½ x 141¾in)
Courtesy National Gallery of
Australia

Walter Tjampitjinpa
(c. 1910-81)

Also known as *Old Walter* or
Talpulpa Tjampitjinpa

Old Walter was an elder statesman of the
Pintupi community at Papunya, and was
involved in the design of the original
mural on the school house wall at
Papunya in 1971. He was the senior
custodian of the Water Dreaming that
runs through Kalimpinpa, west of
Papunya, and most of his paintings depict
the classic Water Dreaming iconograph.
Collections that own his work include the
National Gallery of Victoria.

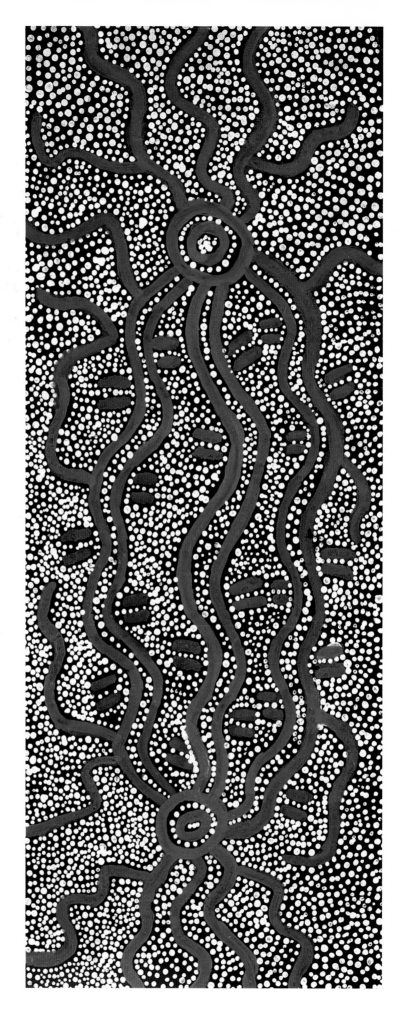

181
Walter Tjampitjinpa
Water Dreaming 1971
Paint on board 91 x 35cm
(35¾ x 13¾in)
Private collection

182
Walter Tjampitjinpa
Snake Dreaming 1971
Paint on board 40 x 35cm
(15¾ x 13¾in)
Private collection

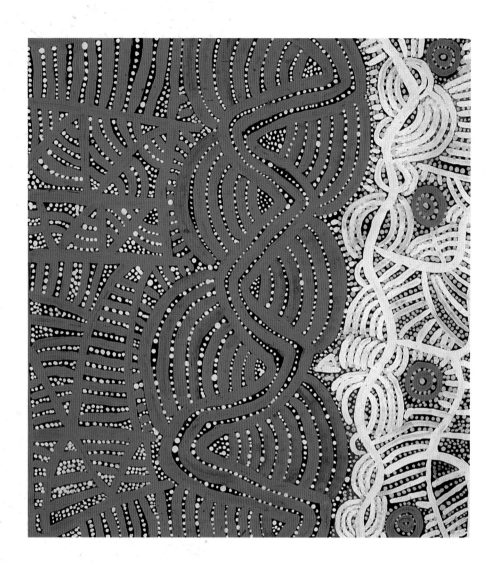

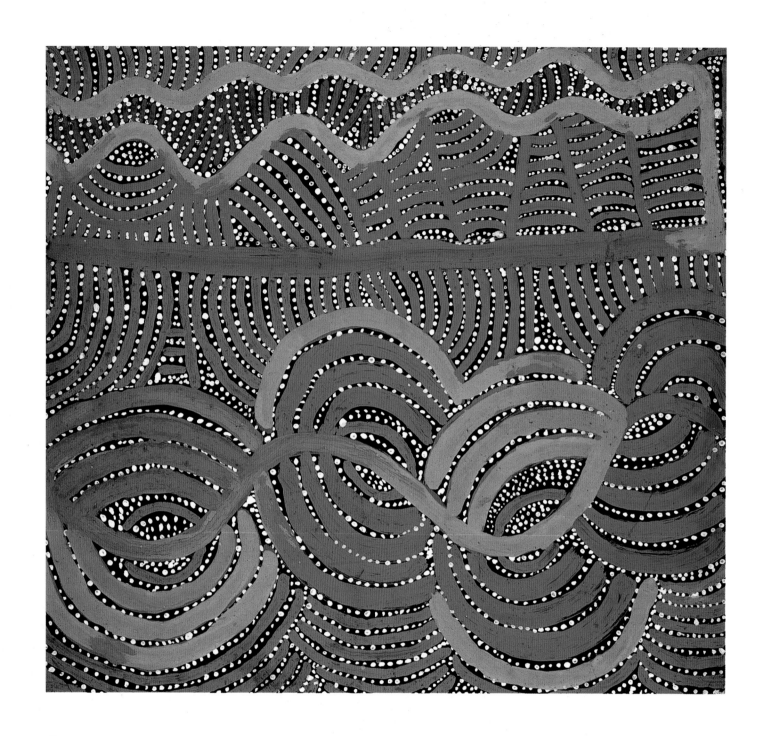

183
Walter Tjampitjinpa
Snake in the Water Dreaming 1972
Paint on board 42 x 46cm
(16½ x 18in)
Private collection

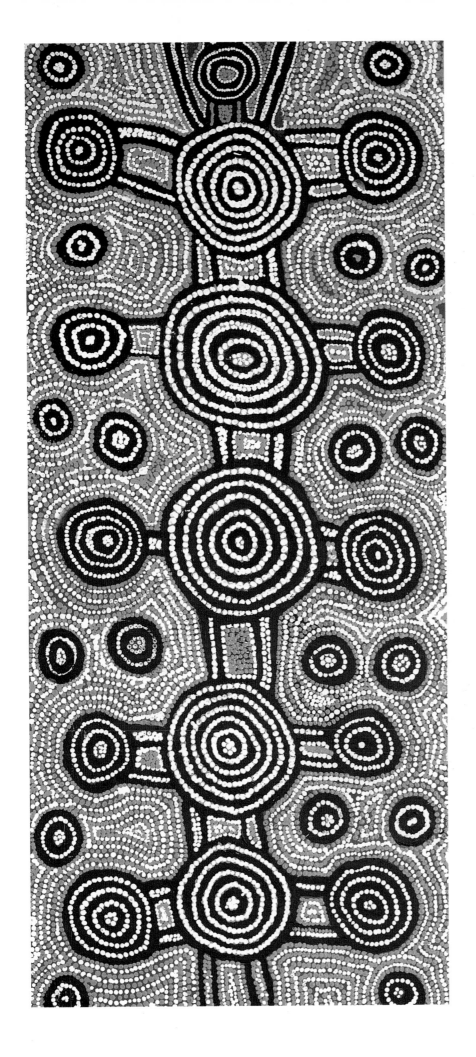

Warlimpirrnga Tjapaltjarri
(born c. 1958)

Warlimpirrnga was born of the Pintupi tribe, east of Kiwirrkura. His arrival in Kiwirrkura in 1984 with a small party of Pintupi made national headlines. He was possibly among the last group of Aborigines to come in from the desert, and until that time he had never encountered Europeans. After three years at the settlement he started to paint, and all of the works in his first exhibition in Melbourne were bought by the National Gallery of Victoria. He paints Dreamings of Tingari stories from around the sites of Marua and Kanapilya. Collections that own his work include the National Gallery of Victoria and the Musée des Arts Africains et Océaniens, Paris.

184
Warlimpirrnga Tjapaltjarri
Tingari Dreaming 1987
Acrylic on canvas 141 x 60cm
(55½ x 23½in)
Courtesy National Gallery of Victoria

William Sandy
(born 1944)

William Sandy was born in Pitjantjatjara country near Ernabella. He taught himself to paint in 1975, but did not start painting regularly for Papunya Tula Artists until the early 1980s. His work was included in the Asia Society's exhibition *Dreamings: Art of Aboriginal Australia*, which toured the USA in 1988-9. The Dreamings he paints include Dingo, Emu, Woman and Green Bean.

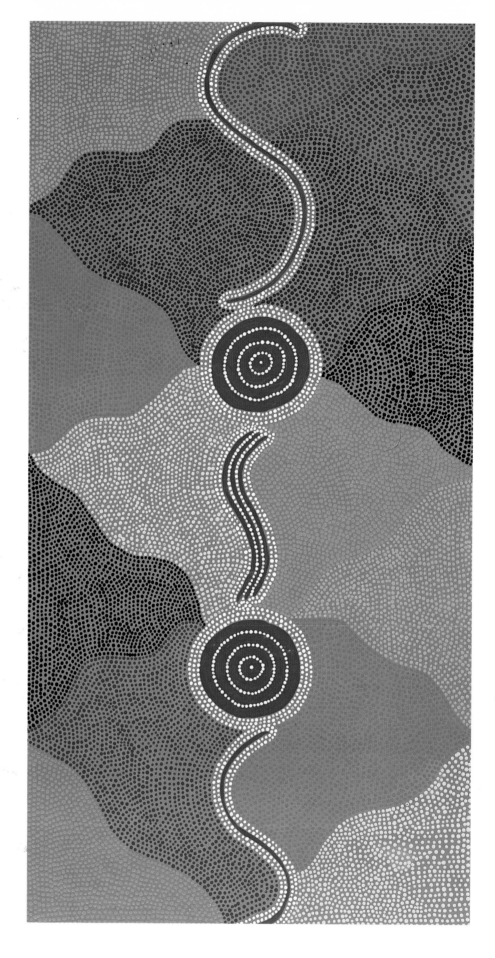

185
William Sandy
Untitled 1992
Acrylic on canvas 101 x 58cm
(39¾ x 22¾in)
Private collection

Willy Tjungurrayi
(born *c.* 1930)

Willy Tjungurrayi was born of the Pintupi tribe at Patjantja, south-west of Lake Mackay. He began painting in 1976 and since the 1980s he has emerged as one of the most important Pintupi painters. His younger brother is George Tjungurrayi. Collections that own his work include the National Gallery of Australia.

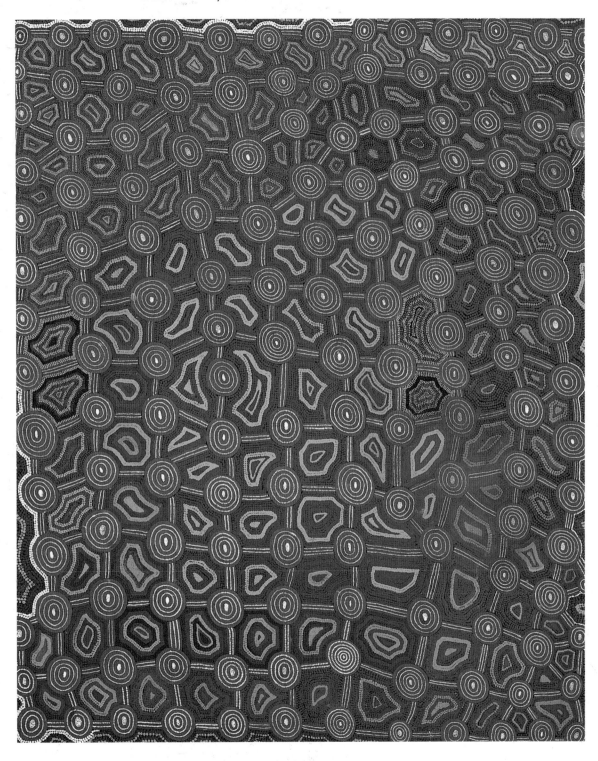

186
Willy Tjungurrayi
Tingari Circles 1986
Acrylic on canvas 183 x 152cm
(72 x 60in)
Private collection

Wingie Napaltjarri

(date of birth unknown)

Wingie Napaltjarri is an occasional painter for Papunya Tula. No further biographical information was available for her.

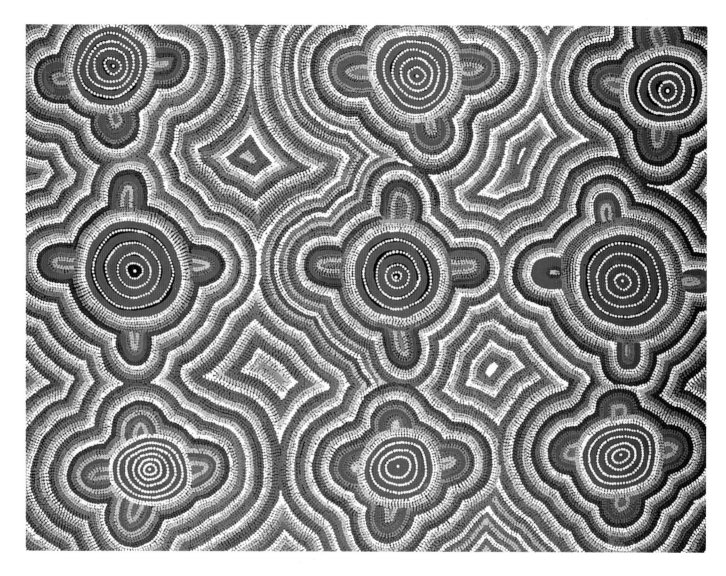

187
Wingie Napaltjarri
Tingari Cycle 1989
Acrylic on canvas 124 x 163cm
(48¾ x 64¼in)
Private collection

Yala Yala Gibbs was born of the Pintupi tribe at Iltuturunga, west of Lake Macdonald. He has been painting since the beginning of the Papunya Tula movement, and paints in the classic Pintupi style. Among the senior Pintupi men he is an authority on ceremonial matters. Collections that own his work include the National Gallery of Victoria.

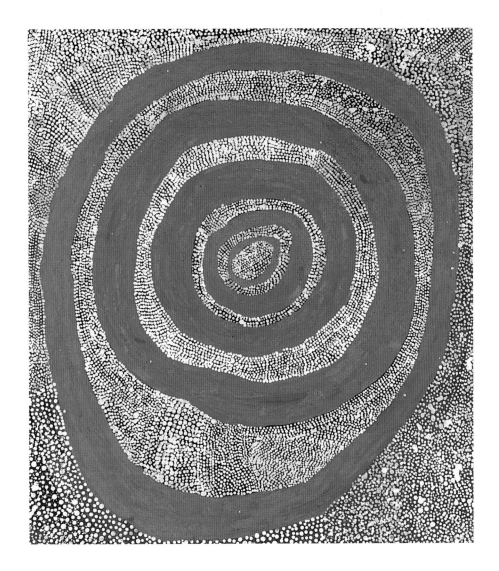

188
Yala Yala Gibbs Tjungurrayi
Home of Snake in Water Dreaming
1972
Paint on board 57 x 48cm
(22½ x 19in)
Courtesy National Gallery of Victoria

The snake is coiled up in his camp or waterhole, and the surrounding dots represent eggs or progeny. The central motif also represents his place of emergence in the Dreaming.

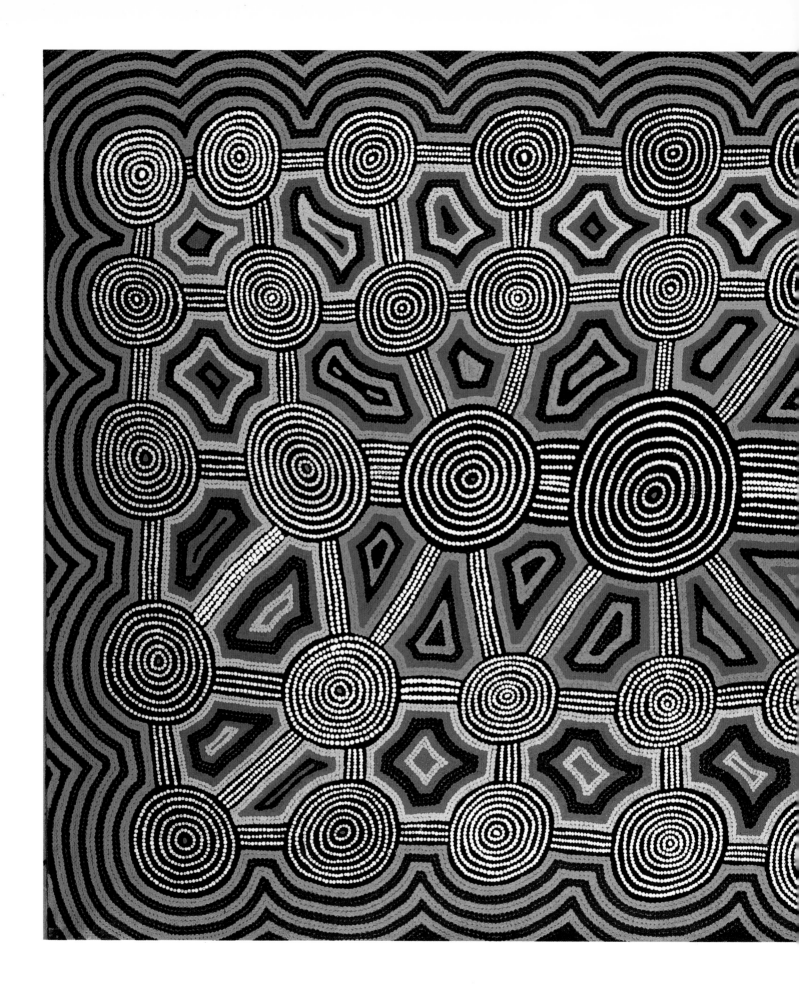

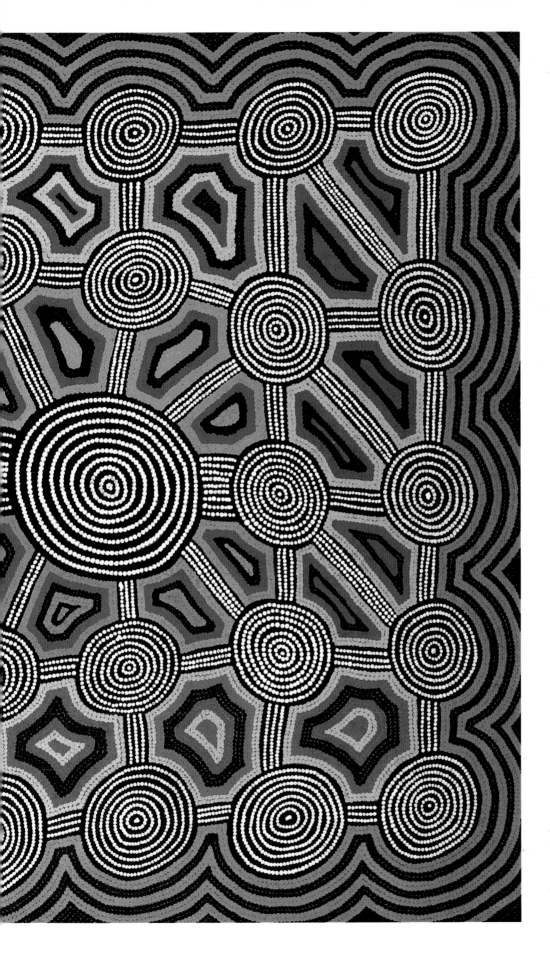

189
Yala Yala Gibbs Tjungurrayi
Tingari Cycle 1986
Acrylic on canvas 121 x 181cm
(47¾ x 71¼in)
Private collection

Young Timothy Dempsey Tjungurrayi
(born *c.*1941)

Young Timothy Dempsey was born at Haasts Bluff. He is an older brother of Barney Daniels, and gives his tribe as Luritja. He started painting in 1985, after watching Clifford Possum at work, and his Dreamings include Centipede, Spear Ceremony, Barking Spider and Hunting for Kangaroo.

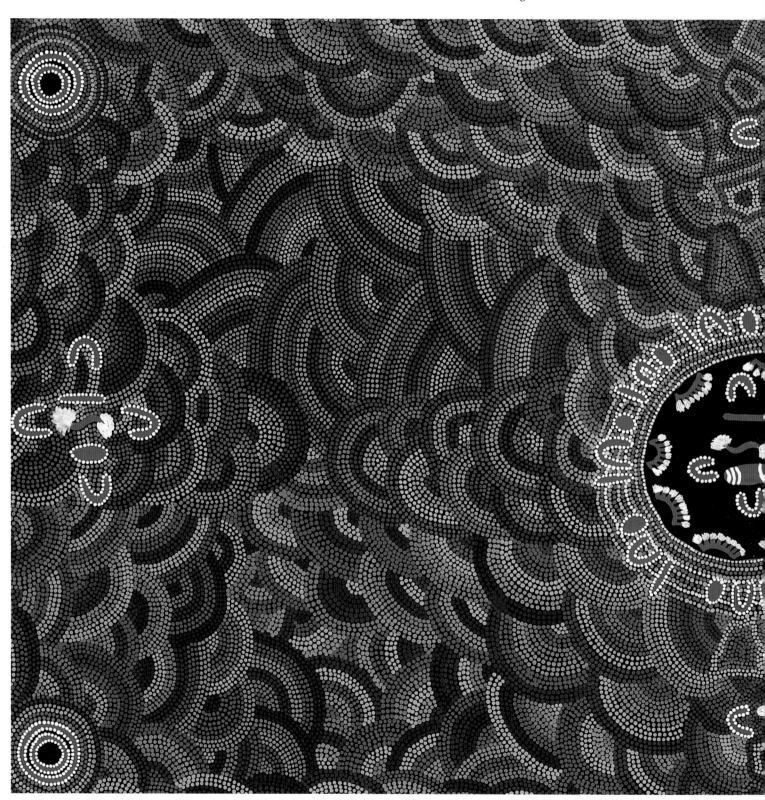

190
Young Timothy Dempsey Tjungurrayi
(assisted by Epinga Nangala)
Women's Dreaming 1989
Acrylic on canvas 124 x 253cm
(48¾ x 99½in)
Private collection

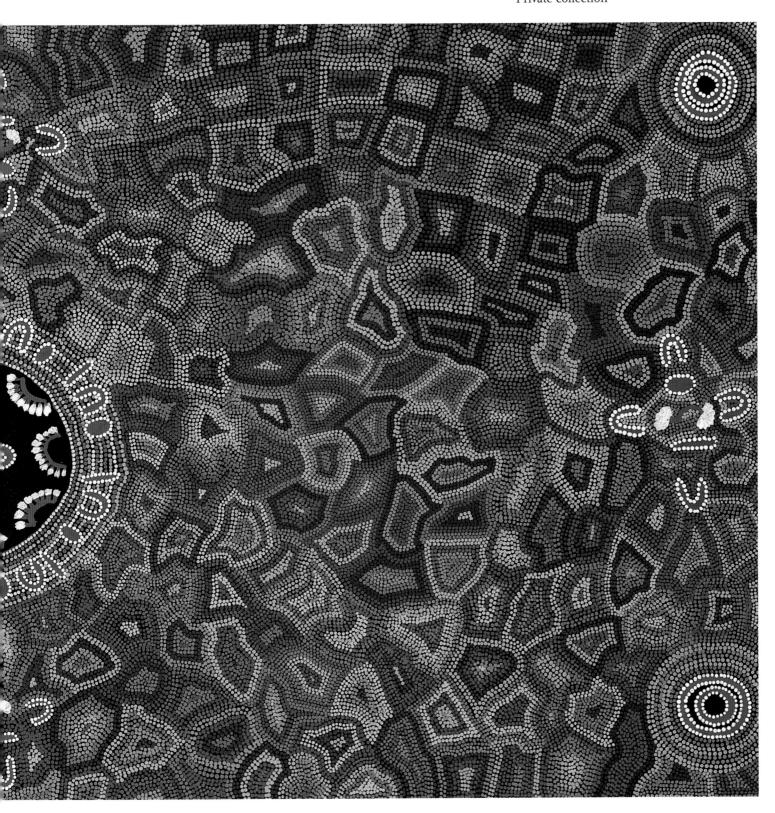

8 The Next Twenty-five Years

My hope is that this book will stimulate the interest of those who have previously thought of Aboriginal art either as ethnic craft, abstract pattern-making or simply an area of art they are incapable of understanding. Those whose interest in the subject is awakened can avail themselves of the many more detailed studies of Australian Aborigines as a race, or which deal with their art in much greater depth.

In the last twenty-five years, and the last decade in particular, contemporary Aboriginal painting has made a profound impact on the Western art world. The number of museums and private individuals who have started to collect these paintings grows all the time as the subject begins to be better understood for what it is: art with a deeply embedded mystical meaning which links the human race directly with its prehistoric past. This, and the complex stories which lie behind individual works, first excited my own interest.

As the end of the millennium approaches and more people than ever visit Australia, what will be the future consequences for Aboriginal art and people? Firstly, I believe this will be a period when more and more people will peer behind the sometimes sad façade of modern Aboriginal life and begin to grasp something of the rich culture that has endured through previous millennia. Secondly, I hope that the Aboriginals, aided by greater land rights, will work to retain and restore as much of their ancient culture as possible, and be free to enjoy it undisturbed by Western influence. Lastly, I am convinced that the next twenty-five years will produce marvellous new artists who will inherit the skills of the pioneering painters of the previous generation, and whose work may rival that of the early days at Papunya.

Appendices

Glossary

Boro circles
Boro circles or ground circles are the sacred ceremonial grounds of the Australian Aborigines.

Bull-roarer
A bull-roarer is a shaped and incised oval of wood, to one end of which is fastened a string. It is rapidly swung in certain ceremonies. There are many varieties of bull-roarer and the sacredness of the object varies from area to area. When incised with sacred designs it becomes a *tjurunga* (see below).

Bush tucker
Bush tucker describes food which grows in the bush or the desert. It includes various plants, roots, vegetables and fruits which constituted a major part of the diet of the Aboriginal people of the Central Western Desert. It is a phrase used all over Australia to describe food found in the wild.

Coolamon
The *coolamon* is an all-purpose wooden carrying dish, often used for carrying food or water, common to Aborigines throughout Australia. Sometimes they are intricately carved.

Corroboree
A ceremonial dance or festive gathering. The suffix 'boree' indicates that it refers to the boro circles (see above), or ceremonial grounds.

Damper
A kind of unleavened bread made from the seeds of a plant found in the desert.

Egret
A white heron of several species.

Euro
A large kangaroo, also known as a wallaroo.

Goanna
A species of large lizard found in Australia, Africa and Asia, also known as a monitor lizard because it is believed that they give warning of the presence of crocodiles.

Mulga
Any of several acacias, typically found in arid regions of Australia.

Perentie
A small goanna.

Tingari Cycle
The Tingari were a group of ancestral beings, both male and female, who travelled all over the deserts of Central Australia. They indulged in extremes of good and evil, sexual excess, greed, theft of sacred objects and many other human weaknesses. Certain ceremonies and rituals are based on events which happened during the travels of the Tingari. As there is a high degree of secrecy attached to these ceremonies, the artists do not divulge much of the meaning behind Tingari paintings. These paintings are often described as Tingari Cycles or Tingari Circles.

Tjurunga
A *tjurunga* is a magic weapon and a sacred object, sometimes used as a bull-roarer (see above). It is made of stone or wood and is only to be shown to the men initiated into the myths which it encodes. They are therefore the only people able to decipher the secret language engraved on them. *Tjurungas* are not only symbolic objects referring back to the ancestral beings, but they are also said to be empowered with the energy flowing from them, hence their use as a magic weapon.

Uluru
Uluru is the Aboriginal name for Ayers Rock, a sacred place of great importance to Aboriginal people.

Warnampi
An Aboriginal word for a centipede.

Willy-willy
A cyclone.

Witchetty grub
Edible grubs of species of certain moths and of longicorn beetles.

Woomera
A *woomera* is an instrument which gives the spear added impetus when thrown.

Yam
A yam is a form of sweet potato, and an important source of food for the Aborigines.

Select Bibliography

Amadio, Nadine and Kimber, Richard, *Wildbird Dreaming: Aboriginal Art from the Central Deserts of Australia*, Greenhouse Publications, Melbourne, 1988

Bardon, Geoffrey, *Aboriginal Art of the Western Desert*, Rigby, Adelaide, 1979

Bardon, Geoffrey, *Papunya Tula: Art of the Western Desert*, Penguin Books Australia, Melbourne, 1991

Caruana, Wally (ed.), *Windows on the Dreaming: Aboriginal Paintings in the Australian National Gallery*, National Gallery of Australia, Canberra, and Ellsyd Press, Sydney, Australia, 1989

Caruana, Wally, *Aboriginal Art*, Thames and Hudson, London, 1993

Chatwin, Bruce, *The Songlines*, Jonathan Cape, London, 1987

Isaacs, Jennifer, *Australian Aboriginal Paintings*, Weldon Publishing, Willoughby, Australia, 1989

Johnson, Vivien, *The Art of Clifford Possum Tjapaltjarri*, Craftsman House, Sydney, 1994

Johnson, Vivien, *Aboriginal Artists of the Western Desert: A Biographical Dictionary*, Craftsman House, Sydney, 1994

Johnson, Vivien, *Michael Jagamara Nelson*, Craftsman House, Sydney, 1996

Lawlor, Robert, *Voices of the First Day*, Inner Traditions International Ltd, Vermont, 1991

Nairne, Sandy, *State of the Art: Ideas and Images in the 1980s*, Chatto & Windus/Channel 4, London, 1987

Exhibition Catalogues

Australian Aboriginal Art from the Collection of Donald Kahn, Lowe Art Museum, Miami, 1991

Birnie Danzker, Jo-Anne, *Dreamings, Tjukurrpa: Aboriginal Art of the Western Desert. The Donald Kahn Collection*, Museum Villa Stuck, Munich, 1994

Brody, Anne Marie, *The Face of the Centre: Papunya Tula Paintings 1971-84*, National Gallery of Victoria, Melbourne, 1985

Brody, Anne Marie, *Contemporary Aboriginal Art: The Robert Holmes à Court Collection*, Heytesbury Holdings, Perth, 1990

Clifford Possum Tjapaltjarri: Paintings 1973-86, Institute of Contemporary Arts, London, 1988

Crocker, Andrew (ed.), *Mr Sandman Bring Me a Dream: Papunya Tula Artists*, Alice Springs and Aboriginal Artists Agency, Sydney, 1981

Crocker, Andrew, *Charlie Tjararu Tjungurrayi: A Retrospective 1970-86*, Orange City Council, Orange, NSW, 1987

Lüthi, Bernard (ed.), *Aratjara: Art of the First Australians*, DuMont Buchverlag, Koln, in association with Kunstsammlung Nordrhein-Westfalen, Düsseldorf, 1993

Maughan, J. and Zimmer, J., *Dot and Circle: A Retrospective Survey of the Aboriginal Paintings of Central Australia*, Royal Melbourne Institute of Technology, Melbourne, 1986

Ryan, Judith, *Mythscapes: Aboriginal Art of the Western Desert*, National Gallery of Victoria, Melbourne, 1989

Sutton, Peter (ed.), *Dreamings: The Art of Aboriginal Australia*, The Asia Society Galleries and George Braziller Inc, New York, 1988

Index of Artists

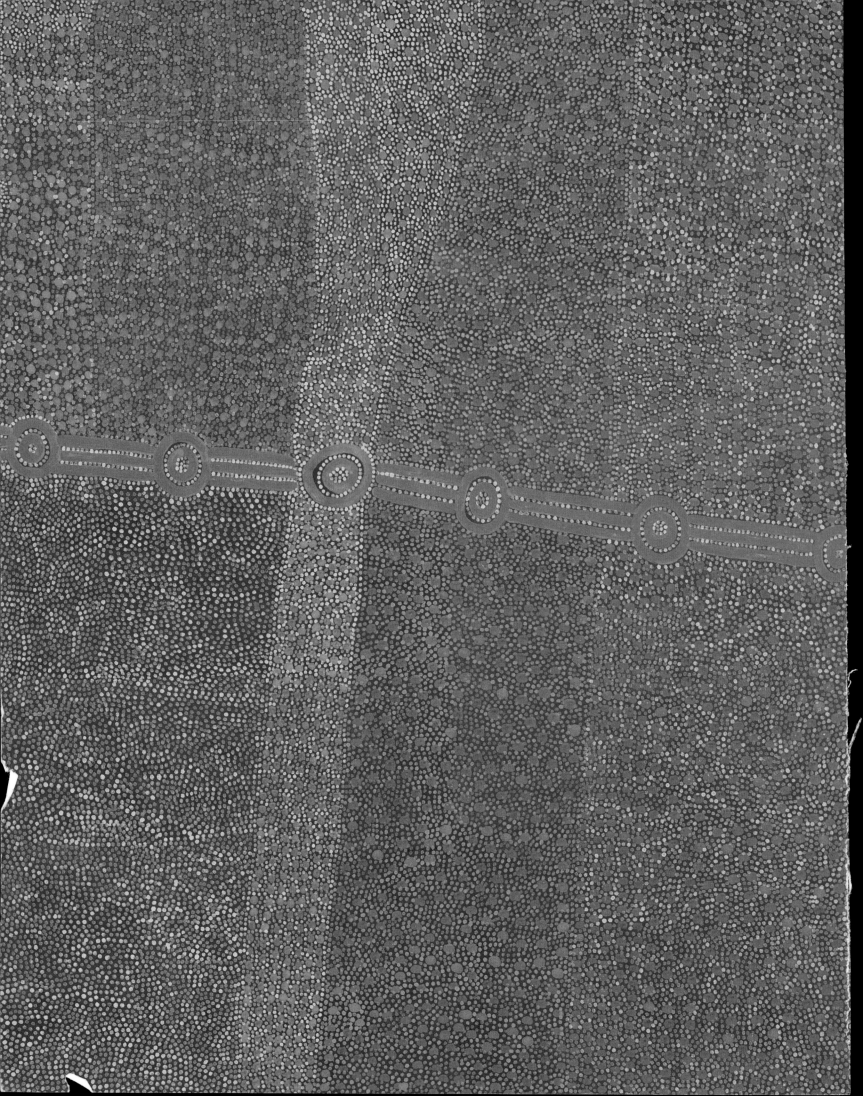